Trespassing through Shadows

VISIBLE EVIDENCE

Edited by Michael Renov, Faye Ginsburg, and Jane Gaines

Public confidence in the "real" is everywhere in decline. This series offers a forum for the in-depth consideration of the representation of the real, with books that engage issues that bear upon questions of cultural and historical representation, and that forward the work of challenging prevailing notions of the "documentary tradition" and of nonfiction culture more generally.

VISIBLE EVIDENCE, VOLUME 3

Trespassing through Shadows

Memory, Photography, and the Holocaust

Andrea Liss

 University of Minnesota Press

Minneapolis

London

Published with assistance from the Margaret S. Harding Memorial Endowment honoring the first director of the University of Minnesota Press.

Published by the University of Minnesota Press
111 Third Avenue South, Suite 290
Minneapolis, MN 55401-2520
http://www.upress.umn.edu

Series design by Will H. Powers
Typeset in Sabon and Memphis by Stanton Publication Services, Inc.

Library of Congress Cataloging-in-Publication Data

Liss, Andrea.
 Trespassing through shadows : memory, photography, and the
Holocaust / Andrea Liss.
 p. cm. — (visible evidence ; v.3)
 Includes bibliographical references and index.
 ISBN 0-8166-3059-3 (hc : alk. paper). — ISBN 0-8166-3060-7 (pb :
alk. paper)
 1. Holocaust, Jewish (1939–1945)—Pictorial works. 2. Documentary
photography. I. Title. II. Series.
 D804.32.L57 1998
 940.53'18—dc21 98-14151
 CIP

Printed in the United States of America on acid-free paper

The University of Minnesota is an equal-opportunity educator and employer.

10 09 08 07 06 05 04 03 02 01 00 99 98 10 9 8 7 6 5 4 3 2 1

Contents

Acknowledgments

The difficult psychic journeys I have undergone in writing this book have involved arduous thinking, rethinking, and sometimes, a sense of total bodily paralysis. I have experienced momentary "freizures" (feeling frozen and being seized), stunned by the utter brutality of the subject, only to be brought back to the realm of my present, renewed by the impetus to live on guard and to give love. To the many who have given so much to me, I thank you here.

I wish to express my gratitude to the people and organizations who, in different and special ways, have sustained this work. The Department of Art History at the University of California, Los Angeles (UCLA) generously granted me a Dickson Fellowship in 1990 at a crucial moment in the early development of this book. Their support was unstinting. They subsequently awarded me Dickson Fellowships through 1993. The UCLA Art Council, the UCLA Friends of Art History, and the UCLA Graduate Division have also shown me deeply appreciated assistance toward research travel and participation in conferences related to this work.

The American Association of University Women awarded this project an Educational Foundation Dissertation Grant in 1993–1994. My deepest gratitude goes to them for understanding and acknowledging the inter-twined and sometimes conflictive relations between a woman's domestic as well as intellectual labors. I was honored by their invitations to speak at numerous meetings of their southern California chapters and thank all the women I met at these occasions for their kindness.

My new colleagues at California State University, San Marcos, have shown critical interest in this book and assured its smooth completion by granting me a Faculty Course Release Award in the spring of 1997. I also want to thank all my colleagues in the Visual and Performing Arts Pro-gram, especially David Avalos for being so caring, Don Funes for being so

understanding, Deborah Small and Bill Bradbury for their wise counsel, and Laurie Schmelzer for her professionalism and efficiency. And much appreciation goes to Bonnie Bade, Stella Clark, Kristine Diekman, and Dawn Formo for being such all-around wonderful colleagues. Many thanks also to Vivienne Bennett, Oliver Berghof, Susie Cassel, and Michael McDuffie for their encouragement. My deepest gratitude goes to Peter Arnade for his engaged reading of this work and to Renée Curry for provocative discussions that have begun to propel this book into still other areas.

I would also like to acknowledge those who invited me to publish aspects of this work during its developing stages. Editors Susan Kandel and Jody Zellen of *Framework,* a publication of the Los Angeles Center for Photographic Study, included my essay "Trespassing through Shadows" in *Framework* 4:1 (1991). Portions of this early essay now appear in expanded form in chapters 1, 2, and 5. Marc deGuerre, editor at *Public,* a Toronto-based publication, sought out my work for inclusion in an issue titled "The Ethics of Enactment." My essay "Contours of Naming: The Identity Card Project and the Tower of Faces at the United States Holocaust Memorial Museum" appeared in *Public* 8 (1993). Portions of this essay now appear in chapters 1, 2, and "In Lieu of a Conclusion." My thanks also go to Jill Snyder, former curator of the Freedman Gallery, Center for the Arts at Albright College in Reading, Pennsylvania, for inviting me to write an essay for the exhibition catalog "Impossible Evidence: Contemporary Artists View the Holocaust" (1994). Portions of this essay also appear here in chapters 1, 3, and "In Lieu of a Conclusion."

Susan Eve Jahoda's invitation to contribute my essay "Uncanny Signs of History: *The Unstable Subject*" to the book *Marxism in the Postmodern Age* (ed. Antonio Callari, Stephen Cullenberg, and Carole Biewener [New York and London: Guilford Press, 1994]) gave me the chance to make correlations between feminist methodologies, the use of autobiography, and important approaches to Holocaust photographic representation. Some of this work appears in chapters 3 and 5. And at the moment when work on this book comes to a close, Sharon Rosenberg, Roger I. Simon, and Claudia Eppert of the Ontario Institute for Studies in Education of the University of Toronto offer me the opportunity to extend this work by participating in their forthcoming book *Beyond Hope and Despair.*

My thanks also go to the many people who have invited me to speak on the subject of Holocaust representation and photography at conferences or solo. I am especially grateful to Marianne Hirsch at Dartmouth College, Cheryl Younger at the Tisch School of the Arts, New York University, Robert Seydel at the Photographic Resource Center in Boston, Alvin Goldfarb at the University of Illinois, Normal, Susan Burks at Camerawork,

San Francisco, and the organizers of the Society for Photographic Education conferences in New Orleans (1991) and Washington, D.C. (1992), for the important dialogue that ensued at such occasions.

My students at the various institutions where I taught throughout this process provided lively forums, especially those at California Institute of the Arts, California State University, Long Beach, University of Southern California, UCLA, and more recently, at California State University, San Marcos.

Still others have sustained this work. Thank you to Joanna Frueh, Marianne Hirsch, Andreas Huyssen, Donald Preziosi, and James Young for offering enthusiasm and wisdom toward the publication of this work. As advisers, Donald Preziosi, Cécile Whiting, and Samuel Weber each offered their own expansive insights, expertise, and challenges throughout various stages of the writing. I thank each of them wholeheartedly for their encouragement, friendship, and trust. Saul Friedländer's seminar in the history department at UCLA, "Probing the Limits of Representation," was a profound inspiration. To the many who may not know I owe them a debt of gratitude, I single out two people: I thank John Tagg for his passion and clarity, which continue to inspire my pursuit of photographic issues, and Ken Reinhardt, who during a single meeting articulated so lucidly the core of issues about mourning that were on my mind early on—and who did so with such generosity and personal investment that it helped make my project feel real.

I am grateful to the editors of the Visible Evidence series, especially Michael Renov and Faye Ginsburg, for their thoughtfulness and care as they fostered this book into their timely series at the University of Minnesota Press. My editor at the press, Micah Kleit, has a myriad of presences within this work. I thank him for his focused and succinct thinking, which always led to stimulating and comprehensive perspectives within and beyond my book. His enthusiasm and guidance have helped immeasurably in bringing this project to fruition. The innumerable tasks involved in this project would never have been handled so smoothly without the sensitivity, professionalism, and care of Jennifer Moore and Adam Grafa. Louisa Castner's graceful copyediting also deserves special acknowledgment. And for their unusual attention to our numerous requests for photographs and reproduction rights, I would especially like to thank Genya Markon and Leslie Swift at the United States Holocaust Memorial Museum Photo Archives, Marian Goodman at the Marian Goodman Gallery, Mara Vishniac Kohn, and Crown Point Press.

Many generous others offered crucial soundings during the seemingly endless and internal work of writing. My deepest thanks also to Cinthea

Fiss, Patty Mannix, Joanna Roche, Susan Schwartzenberg, Elliot Ross, Allan Sekula, Sally Stein, Susan Mogul, Bill Short, Willa Seidenberg, Leah and Arthur Ollman, Mus and Stephen White, Norman Kleeblatt, Deborah Risberg, Kim Abeles, Mari Andrews, and Rupert Jenkins for posing the right questions and offering resources at crucial times. Michael Dawson was always there to listen and respond. And to Yaffa Eliach, my thanks for our late-night meetings, which have meant so much. My heart goes to Elizabeth Shull, Carol Young Verheyen, Leslie Krauss, and Rosalie Frankel for sustaining me with the joy and respite their long friendships continue to offer.

Well before this book came into being, Shirley Frankel gave a human perspective on the Shoah that allowed me to enter it, albeit cautiously. Also early on, Josette Bryson taught me the joys of sustained work and perseverance through her encouragement and example. Although she is far away now, I know she is winking with a twinkle in her eye.

None of this work would have been possible without the peace of mind from knowing that my son Miles was in safe and loving company during countless daytime hours. Thanks to Josephina and Harold Zuckerman for the foundation and humor they offered. Elena Cielak and the staff at Montessori Shir-Hashirim are exemplary for the intellectual and sensual environment they provided. Anne Granick, Dena Johns, the children in Orange Cluster, and the entire Open Charter School have been an inspiration.

The support my family has given is immeasurable. Special gratitude goes to my mother, Shirley Liss, who always heard what I felt, and still does. The largesse of her empathy is exemplary. My father, Sidney Liss, and my brother, Jeffrey Liss, also provided early foundation for the respect for others and the sanctity of life. My in-laws, Agnes and Muir Dawson, and my sister-in-law, Verna Li, helped me put those teachings into practice. My friendship with my grandmother, Anna Friedman, gave me the gift of connection with the past generation. My partnership with Michael Dawson has yielded the challenges and pleasures of compromise, patience, and the sustenance of life. Without Miles's innocence, tenderness, and uncanny demand for justice, I don't know how this work would have been possible.

Introduction: (Im)Possible Witnessing

I open this book as if it were a distant letter, a letter steeped in sorrow and
sent across the chasm of unknowable loss, across the pain of pounding
emptiness. This letter wants to find an addressee, named addressees, so
that its difficult posting might mediate the countless photographic images
that hover over nameless bodies, heaps of humans reduced to nothing. This
letter comes face to face with memories of photographs whose horrific
images instate the shock between my presence, my intact vulnerability, and
the utter violations done to those pictured.

This letter issues a warning to those, including me, who step into this
shadowy realm of ghosts and photographs, whose steps inevitably trespass
into the sites and traces of death, of lives effaced, of genocide. A letter to
those who are living the trespass through indirect memories, who are re-
moved from its rawest imprints. This book communicates through the in-
evitable distance of postmemories and is underlined with a plea not to re-
create the violence through the inevitable trespass.

The Holocaust conjures up debilitating photographic images of victims
seen in the most mute and degrading states of pathos. Think of Margaret
Bourke-White's photographs of extermination camp inmates at Buchen-
wald leaning against barbed wire fences, or worse, piles of human bones as
if theatrically arranged. For a generation once removed from the real hor-
ror, such photographs repel some of us and cause us to turn away. For oth-
ers, Holocaust documentary photographs shock in the opposite direction,
hypnotizing vision and luring the viewer in. In either case, we are stunned
by the photographs' blinding violence. For those who witnessed and expe-
rienced the events, they know there was much worse than what appears in
the photographs.

With the accruing distance from events of the Shoah, the passing of

direct witnesses, survivors, and those who were completely effaced, inevitable dilemmas arise about the appropriate forms that retrospective witnessing and remembrance should take. Questions about authenticity, the use of photography as evidence, the transference of events into memory, and the passage of history into postmemory constitute some of the most salient problems that underlie the representation of history. If the indirect chronicling of history always creates an inevitable divide between the past and the present, then the distance in addressing the Holocaust turns that gap into an abyss. This book revolves around a web of interrelated dilemmas about the difficulties and the possibilities of facing the Holocaust in photographic terms, what I am referring to as the (im)possibility of witnessing and representing the Shoah.

Trespassing through Shadows: Memory, Photography, and the Holocaust is centrally concerned with the uses, abuses, and transformations of photographic imagery in contemporary representations of the Shoah. I am especially interested in the rethinking of documentary discourse that results when it is faced with the uneasy intersections between the demand for historical accuracy and calls for respectful remembrance of those who were violated. This book thus focuses on the reformulation of difficult documentary photographs and how they are mediated through exhibition techniques, both at the institutional level of a Holocaust museum and in the hands of artists. Earlier, more traditional and relentless displays of Holocaust history rely almost entirely on the abject documentary photographs. Such photographs do not always bring the viewer to look, to really see, nor can they be counted on to create empathic bonds between the contemporary subject and the person from the unimaginable past. The dilemma is that these photographs offer crucial information that cannot be discounted. At stake are the ways in which the photographs are set into motion, how they are employed to stand in for wrenching, almost unrepresentable events. This book undertakes a series of interrelated critical discussions of contemporary reemployments of documentary photographs that seek to redress the lens of abjectness and the displaced claim of "obscenity" through which victims of the Holocaust have been remembered.

The sheer horror of the events of the Shoah complicates their visual acknowledgment; the trauma they imprint on survivors and the post-Auschwitz generation compounds these difficulties. The events themselves as traumatic history resist simple understanding, accessibility, and depiction. Indeed, if recounting and representing the events are lined with the desire to attain an ultimate understanding, the incomprehensibility of the Shoah would seem to defy traditional historical attempts to explain. For some historians, attempts to understand the unfathomable cruelty and hatred of

Adolf Hitler's regime, its calculated policies to exterminate the Jews of Europe and to decimate Communists, Catholics, Romas (Gypsies), homosexuals, political dissenters, the handicapped, and the mentally retarded have been wrecked. As Holocaust historian Saul Friedländer has characterized it, an opaqueness remains at the very core of the historical understanding and interpretation of what happened.

The traditional mandate of the documentary photograph to "bear witness" can thus no longer go unquestioned. Its precious if not uneasy burden to "never forget" reigns over its unarticulated occlusions. The issue here is not to invalidate documentary evidence. To the contrary, the evidence and the mandate are imperative. Rather, this book confronts the discomfort in the sometimes hollow plea to bear witness and sets out to question what images *are* remembered in the imperative to never forget—precisely what become the postmemories of the events. My concern is also to clarify that the demand to never forget is not directed at survivors, who can never forget, but at those who never experienced the events. As such, the demand that photographs have been made to carry out is always one of retrospective witnessing. They make their appeal to contemporary spectators.

Given the challenge to understanding and representation that the Holocaust presents to documentary forms of witnessing, the cruel paradox of Holocaust-related photographs is situated precisely in the demand that they perform as history lessons ("never forget") and provide sites for mourning. However, it is partially due to the utter horror of these photographs that the contemporary viewer's approach to these indispensable documents is made especially difficult. The daunting, delicate, and volatile subject of exhibiting the Holocaust calls for a reevaluation of photography in the service of contemporary witnessing. Despite the importance of photography in the education and remembrance of the Holocaust, there has been little or no work interpreting the role of photography in contemporary Holocaust representation. The contemporary literature reconsidering photography and documentary's attempt to address difficult events is resoundingly silent on this subject.

This book is motivated in part by crucial writing primarily from the 1970s and 1980s that critically considers the pitfalls of documentary photography as it has been construed as a social practice.[1] Documentary photography is a practice in which the photographer attempts to document, for an assumed public, the everyday actualities of people outside his or her intimate domain. As William Stott pointed out, the term *documentary* did not come into parlance until 1926, when John Grierson, a British film producer, used it in writing about Robert Flaherty's film *Moana*: "A visual account of events in the daily life of a Polynesian youth, it has

documentary value."[2] As this practice of visual accounts developed differently from other forms of photographic practice premised on aesthetics and the art market, it became a practice generally motivated by the aim of reform. The crucial body of writing rethinking documentary photography in the United States largely focuses on the government-sponsored photographic Historical Unit of the Farm Security Administration (originally called the Resettlement Administration) from 1934 to 1943, mandated under President Franklin D. Roosevelt's New Deal programs.[3] Contemporary criticisms about these programs pinpoint the fact that no matter how empathic the photographer, he or she pictured those who were suffering as anecdotes to the actual economic problems—problems that could not be easily summed up in visual terms. In addition, those pictured were to be projected as worthy, clean-minded, untainted by the filth that surrounded them—in short, innocent victims worthy of government assistance who fell prey to unaccountable, natural catastrophes.[4] The structural, political, and economic factors are rarely in evidence in this body of documentary photographs. Even Dorothea Lange, whose powerful photographs were among those most manipulated by Roy Stryker, the head of the agency—especially through the deletion of the conversations between photographer and photographed that Lange recorded and that served as her captions to the photographs—agreed in her own way with contemporary criticisms of documentary. Discussing the overabundance of photographic images and what a photograph might contribute, she said: "But actually, the world is not being photographed at all, because it's only the spectacular, the sharp and maybe often the bizarre episode. The underpinnings, [are] lacking."[5]

These arguments call into question the very assumptions on which conventional documentary practices are lodged. Crucial to these claims is that documentary's overarching and often knowingly skeptical goals to fully apprehend its subject only fleetingly raise and then efface the possibility of empathy for the object(s) of its representation. The gap in the difference between the reality of the photographed and the photographer creates an obscenity of representation. Further, as Martha Rosler aptly put it, the commercial vehicles of publication and the political passivity in much documentary photography create a doubled situation of martyrology in which the viewing of the image "revictimizes the victim."[6] In Halla Beloff's book *Camera Culture,* one of the few photographic histories that include photographs of the Holocaust in its purview, she refers to documentary photography as a "victimology."[7] In her study, Beloff acknowledges that documentary photographs are crucial because they call attention to realities most would rather not know of or look at:

They can perhaps become kinds of ethical reference points. For me I can see the small boy in the dreadfully big cap, coming out of the Warsaw ghetto with his hands up under the Nazi rifles. But as we have suggested, every reader will have his or her own. In our imagination they retain their power. One suspects that actually looking at copies of them would make their effect wear off, like pornography's arousal.

Surely we are proud to have these ethical reference points. Proud even of the pain they arouse. With them we are nearer the ideal of empathic humanism. We want to have a repertory of the right ideas and attitudes. We believe that if we think right, feel right, somehow things become better, even if we do nothing. Our high purpose is to know the truth. And the knowing provides its own kind of virtue.[8]

Beloff and others contend that one of the only ways to move out of the weak reforming tendencies of liberal humanism, the tendency to be satisfied to "think right, feel right," is in "giving photography away" to the very communities at issue.[9] Yet in reference to the victimology of the Holocaust this alternative, less the few exceptions such as the photographs of ghetto resistance worker Mendel Grossman, was unthinkable. Constant surveillance and extraordinary revenge made picture-taking activities rare. The larger question nagging me, indeed, in part provoking this study, bears on whether the same criticisms of documentary photography as an untenable victimology that is inappropriate to its task can apply in extreme cases where the people pictured were truly victims, where they had been so dehumanized that virtually no "alternative" applied? Have criticisms of documentary reached their limit in coming to consider the intersubjectivities among photographer, photographed, and contemporary viewer at issue in Holocaust-related photographs? We are dealing with retrospective relations—that is, the moment of direct appeal has passed. There is no small irony in the fact that urgent calls to action, which went knowingly unheeded, have now become pleas to never forget.

I argue that if we take postmodern warnings about documentary photography seriously, the implications would lead to an acknowledgment of the indispensability of the unheeded documentary photographs as well as the formulation of necessary new questions about their contemporary employment. I ask, then, through what lenses and for what contesting purposes can these difficult photographic documents be approached in a post-Auschwitz culture? What are the cultural and political implications of new forms of photographic documentation produced during the past two decades that acknowledge the often uneasy alliances between the imperative of historical accuracy and less graphic and life-affirming representations of remembrance? The vibrant photographs of people from a small Lithuanian town who are pictured in the Tower of Faces and the individual

snapshots of victims that appear on the identity cards at the United States Holocaust Memorial Museum in Washington, D.C., which I discuss in chapter 2, are accorded historical status through their presentations within the larger narrative exhibition at that museum. Yet Christian Boltanski's reappropriation of portraits of Jewish school groups in Europe during the war and assemblages of French family photographs from after the war create disturbing contradictions between historical evidence and the contemporary ability to respond empathically. Art Spiegelman's strategic and stunning use of pre-Holocaust family photographs competes with the paradoxic realism of his cartoon drawings in his *Maus* books. In chapter 3, I investigate Boltanski's and Spiegelman's strategies of employing pre-Holocaust portraits of victims, especially as they bear on similar approaches to representing the Holocaust at the United States Holocaust Memorial Museum. Thinking photographically about the dilemmas of staging history through the stark and uncanny realism of "object survivors," in chapter 4 I examine the museum's presentation of key artifacts. In chapter 5, I open up the tightly interwoven investigations of the problems and possibilities of photographic representation of the Shoah to other artists' projects. Suzanne Hellmuth and Jock Reynolds's multimedia installation *In Memory: A Bird in the Hand* and Anselm Kiefer's self-portrait photographic tableaux giving the Hitler salute, *Occupations,* re-create archival photographs in order to provoke the past into potent political remembrance in the present. In Connie Hatch's installations, Jeffrey Wolin's contemporary portraits of survivors, and Aharon Gluska's reworking of extermination camp mug shots, the artists reconsider documentary material and portraiture in order to focus on renaming and rehumanizing individual people in their respective work. Stepping into the realm of others' extreme experiences and attempting to represent them involve the artists in risky psychic and historical terrain. Contemporary concerns for personalizing the atrocities can, however well intended, turn against themselves. Through her abuse of documentary photographs and the self-involved inflection of the ambitious *Holocaust Project: From Darkness into Light,* Judy Chicago, with Donald Woodman, demonstrates the travesties and excesses that also confront representations of the Shoah. Yet in light of the contemporary pressure on the ethical demand to bear witness, postmodern warnings about documentary photography must be expanded as they are brought to bear on photographic representations of the Shoah. This is precisely where a feminist approach to history, especially in its respect for the antimonumental aspects of intimate and nonsentimentalized memories, and Emmanuel Lévinas's ethics of alterity—the places of possible touching and simultaneous distance between the

self and the violated other—have helped guide me throughout the writing of this book.

The pathways for approaching the questions I bring to this study, however, are largely uncharted. Postmodern reconsiderations of documentary practice provided a fruitful beginning and a crucial challenge. In addition, debates about the uses and abuses of both documentary and so-called imaginative forms of representation have been cogently sketched out in the arena of film. Hans Jürgen Syberberg's *Our Hitler: A Film from Germany* has engendered complex arguments about the implications of strategies that go against the documentary grain.[10] This arduous film employs notions of Brechtian theatricality, spatial dislocations in distance and time, and fragmentations between image and sound to lure, seduce, and interrogate the viewer's perceptions of history. Its central visual device is a stage on which spectacles such as puppets depicting Hitler's highest SS men as well as an invented interview with his valet play out mundane details of the Führer's life. Policies of extermination of the Jews commingle at the end of the film with an ahistorical, apocalyptic relativizing of other genocides. On a very different yet not completely antithetical register, Claude Lanzmann's reconfigured documentary film *Shoah* is rooted in the specificity of the Jewish genocide. Where Syberberg's tour de force is largely concerned with the construction of the German psyche against the filmic and suppressed cultural backdrop of the Third Reich, Lanzmann's precise raison d'être is to prove that the extermination camps existed in full force in Poland. *Shoah* fixes the irrationality of the revisionist claim that the death camps never existed without ever bringing in archival documentary images. Rather, Lanzmann relentlessly relies on the physiognomy and facial awkwardness of the perpetrators he interviews as well as the traumatic testimonies delivered by survivors.[11]

Film debates suggest that it is appropriate for extreme and horrifically unimaginable experiences to be imagined in terms that reformulate documentary evidence. The chaotic scenario of *Our Hitler* confronts the irony of narrative through its implosion, while *Shoah* maintains that the only other ethical manner of representation is through the stage of the real, through the relentless realization of contemporary documentary evidence.[12] These films demonstrate that attempts to create completely lucid, logically historicized narratives are paradoxical in light of the events' very incomprehensibility and opaqueness. The excesses of *Our Hitler* and the sobriety of *Shoah* are both represented without picturing archival documentary imagery from the Holocaust.

The appearance of Steven Spielberg's film *Schindler's List* at the end of 1993 is but a recent example of the pitfalls and surprising, stereotype-

breaking scenes in a commercial narrative dramatization of the events that for the most part ignores and unwittingly reignites the complexities of representing this traumatic subject.[13] Yet it must be acknowledged that the atrocities the film restages, and much worse, took place. The filmmaker is not to be faulted for the original crimes. Nonetheless, a strange transference occurs, something akin to blame, displacing it onto those who boldly, perhaps exploitatively, reenact the real. However different it is from *Our Hitler* and *Shoah*, the volatile restaging of history in *Schindler's List* provokes questions about the appropriation of documentary imagery and the appropriateness of inventive approaches to nonfiction subject matter that are relevant to the issues raised in this book.

My decision to focus on troubling the unelucidated dilemmas of documentary photographic representation of the Holocaust and its contemporary constructions is reinforced by photography's oscillating status between document and aesthetics. Photography's stronghold on reality differentiates it from other artistic media. That is, the question that so often arises about artwork and the dangers it holds for aestheticizing the Holocaust is not as easily posed in relation to photography. Photographs maintain a closer relation to the real and, as such, become uneasy icons. This is not to say that they represent the real more truthfully, but that their graphic relation to the lived world tantalizes the erasure of the borders between the real and its representation. Although there has been a fashionable flurry recently to simply reduce the complexities of photographic representation to the dogmatic declaration "Photographs lie," my concerns in this book are precisely to elucidate how they can be retrospectively employed to tell the truth.

Photography begs the naturalized relations between objectivity and subjectivity. It is a cruel and poignant commonplace that the photographic image lives a double life as an object of historical truth and as a foil that fixes the most intimate moments. This book challenges the boundaries that separate the supposedly objective photographic document and its polarized counterpart, the subjective photographic memento, in terms of the work they perform as historical markers.

Equally problematic are the ironclad divisions that continue to be maintained between historical representation and artistic manifestations of historical events. By critically juxtaposing the memorializing task of a Holocaust museum, specifically the United States Holocaust Memorial Museum in Washington, D.C., with the traditional eyewitness function of the photograph and contemporary artistic approaches to Holocaust-related photographs, I hope to articulate the dilemmas of photographic representation through the multiple perspectives of institutional practice. I became interested in the developing strategies at the United States Holocaust

Memorial Museum several years before it was built and opened to the public on 26 April 1993. In my initial research there, I found that the museum intimated different approaches to the representation of events other than an entirely traditional documentary methodology. Indeed, the original idea for developing some kind of a memorial to the Holocaust was initiated by President Jimmy Carter after he had watched the docudrama *Holocaust* for four days. It is possible that the mediated television series *Holocaust* had more impact on Carter than the real event.[14] Considered in a less ironic light, the museum's permanent exhibition team sensitively and intelligently confronted the dilemmas and contradictions of their task to respectfully memorialize yet unflinchingly confront the realities of the Shoah. As the museum's project director, Michael Berenbaum, expressed it so aptly, "We wanted to come as close as possible to desecration without re-desecrating."[15] This book considers the analogous tasks practiced by the museum and the artists. I want to negotiate their activities in relation to the imperative of transposed witnessing rather than reassign hierarchies to their practices. Yet it must be said that in the founding of disciplines in modernist discourse, what have been regarded as artistic activities are generally less valued than the work of the historian or the museum in representing the past. This book asserts that the lyricism and poetics usually associated with the artist also function on multiple registers as oblique yet pinpointed testimonial labor.

Keeping in mind Irving Howe's call for empathy to be "a tentative and modest solidarity with those who fell,"[16] I do not seek definitive elucidations of successful or irrevocable "solutions" to the delicate and demanding subject of photographic representation of the Holocaust. Rather than setting up transparent camera views, this book offers material and theoretical scenarios, along with their inevitable occlusions, and attempts to work in and through translucent shadows. It is my hope that *Trespassing through Shadows* formulates critical models for the use of photographs in the telling and remembering of the Shoah that will keep the memory and the trauma at once approachable and unmasterable.

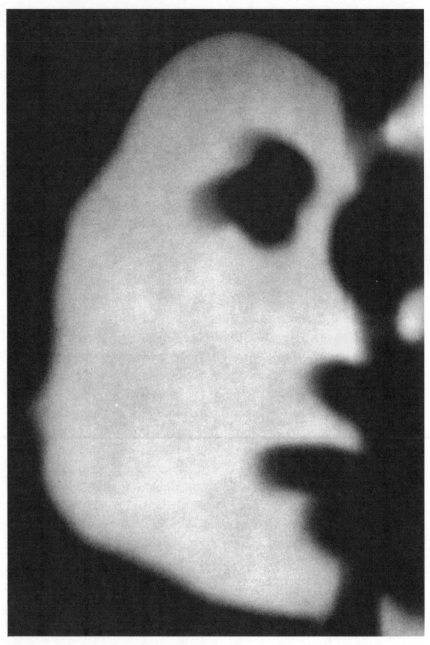

Christian Boltanski, detail from *Gymnasium Chases*, 1991. Print portfolio,
23¼″ x 16½″. Courtesy of Crown Point Press.

[1] *Photography and Naming*

Questions of mimesis, strategies of empathy, the truth in fiction, the fiction in truth, and the tension between literalness and metaphor are always at work in documentary photographic representation; these factors are all the more germane to and strained in contemporary photographic representations of Holocaust history and memory. To call photographs depicting events, moments, and lives ruined by Nazi crimes in the Holocaust "documentary" is a misnomer of catastrophic proportions. Holocaust photographs do not function solely as objective documents: on a deeper psychic level, they set up the shock of the unimaginable made visible. By the very nature of their extremity and the ways in which they test the viewer's empathy, Holocaust photographs challenge and expand the limits of documentary.

Indeed, the extreme distances between the experiences and subjectivities of the photographer and the pictured in Holocaust-related photography are capable of revealing the insidious fictions in documentary's claims of mutual relations. For example, the notion that a documentary photograph involves a transactional exchange between the subject and the photographer, the "I and thou" assumption of sameness, is rendered ludicrous in the shadow of the experiences of the millions who suffered from unimaginable pain and loss and who had no choice about their participation in the photographic event. It is crucial to remember that the individuals who have become the subjects and objects of Holocaust photographs were not accessible to the purview of just any errant, socially concerned eye. The ghettos and camps were strictly closed off to the outside world, except for the Nazis stationed there and to the new arrivals. As a result, the precious and troubling photographs that remain are double-edged; although they offer rare views inside the ghettos and camps, many were, nevertheless, staged by the Nazis. These staged photographs were orchestrated to veil the mechanisms of the Final Solution and were targeted to the (largely unconcerned)

free world to project the lie that victims of the Nazis were safe, and even gainfully employed. A published example of Nazi propaganda photography is that of the prints taken by Albert Cusian and Erhard Josef Knoblock, members of Propaganda-Kompanie 689. This unit worked under the auspices of *Signal,* the Nazis' main international propaganda magazine, with more than twenty foreign language editions and a run of 2.5 million.[1]

Another group of institutionally produced photographs contemporaneous with the events were those taken by the Allies at the end of the war, predominantly by the U.S. and British military and press photographers during the liberation of the camps. They, too, carry the conventions of their own photographic realisms. Margaret Bourke-White's photographs from 1945 of the Buchenwald extermination camp taken for *Life* magazine, later published in 1946 in her remarkable book *"Dear Fatherland, Rest Quietly,"*[2] are staged through her inclination toward close-up and action shots. The horrific real of the extermination camp scenes is pictured through the imposition of these journalistic conventions. Bourke-White's crucial photographs are also contingent on her own conception of the Nazis' failed regime and what she felt to be the United States' inadequate attempt to disseminate democratic ideas in postwar Germany. When these photographs are displayed or reproduced out of their historical and ideological frames, which they all too often are, they become staggering stand-ins to the horrors. Notwithstanding the particular nuances and power of Lee Miller's photographs of the liberation of Buchenwald and Dachau in April 1945, the same could be said of how her images continue to be used against themselves as clichés and uneasy icons.[3] As but one example among the countless, unrecognized many in which highly published Holocaust photographs are glossed over through their saturation, a photograph of liberated prisoners at the Ebensee concentration camp was recently displayed at the end of the introductory section to the exhibition "Exiles and Emigrés: The Flight of European Artists from Hitler" at the Los Angeles County Museum of Art.[4] Placed as the finale after a listing of names, crucial dates, and locations associated with Europe's most important intellectuals who mostly escaped the atrocities, this photograph is made to articulate a perverse hierarchy between the famous and those who remain part of the nameless mass of victims.

In the past few years photographs have surfaced that fall unevenly between the polarized institutional regimes of the Nazis and the Allies. Among these are the enigmatic photographs taken in the Warsaw ghetto by the German Wehrmacht soldier Heinz Jöst.[5] Without any explanation, Jöst walked into the ghetto on his birthday armed with a camera. And just as

easily, he left at the end of the day with many inside shots. The photographs that resulted from his "birthday trip in hell," as Yad Vashem titled the exhibition of these images, depict groups of people ranging from the still well-dressed to those reduced to beggars. Although Jöst's camera views never look down upon his subjects and he framed them at midrange—that is, not too close or too far away—the photographs clearly do not issue from the victims' experiences, despite the fact that they record the victims' truth. A more sustained and softly outraged photographic project is that produced by another German soldier, Joe J. Heydecker, a German army conscript who came from a liberal German family and who had begun a writing and journalism career previous to his army service.[6] He made several photographic journeys into the Warsaw ghetto before and after the uprising and after the liquidation, between February 1941 and November 1944. Like Jöst's photographs that were not published until 1983, Heydecker's photographs were not made public until 1981.[7]

Rare are an insider's own representations. Mendel Grossman's astounding photographs of the Lodz ghetto activities during the war defy the mass of horrific postmemories of the events.[8] Compelled to document the developing degradation in the ghetto, Grossman often took his photographs within domestic settings and at close range, giving them a strained yet intimate perspective. Coming full circle back to the worst of the documentary photographs, it is inside the Nazis' archives—those that were not meant for public view—where we can now find evidence of the most unimaginable acts of violence and dehumanization. It is these most graphic and difficult photographs that this book works through, not entirely against. They cast the shadows that haunt and warn second and third post-Auschwitz generations not to revictimize the victims. This is why such photographs are not reproduced here.

The extraordinary depictions in Holocaust photographs come through the lens of realism, which further heightens and estranges their function as objective documents. Noting how the documentary function of photographs further accrues in relation to Holocaust documentary narrative, James E. Young writes:

> In fact, as a figure for documentary narrative, the photograph may even be more appropriate than the documentary writers imagined: for the photograph operates rhetorically on precisely the same assumption at work in documentary narrative. That is, as a seeming trace or fragment of its referent that appeals to the eye for its proof, the photograph is able to invoke the authority of its empirical link to events, which in turn seems to reinforce the sense of its own unmediated factuality.[9]

Photography's claims to realism also lie in its double-edged capacity for holding forth the promise of honoring while marking and fixing its subject.[10] In the very moment of its giving name and face to a previously undocumented or undisclosed reality, photographic nomenclature also works to stigmatize and hold at bay the subject/object of its view.[11] The etching of photographic identities is all the more pronounced in Holocaust representation. The importance of giving back names and identities to those who were so horribly defaced in the Holocaust cannot be overestimated. For example, to approach the representation of the events is also to confront the difficult act of naming them. The English word *holocaust* perversely conveys the sense of a burned offering, from the Greek *holokostos,* meaning burned whole, as if those who perished senselessly are now to be metaphorically consigned to a legacy of sacrifice. In German, the more serious term is *endlösung* or Auschwitz and, in French, *le génocide. Sho'ah,* from the Hebrew, or more commonly written in English as *Shoah,* is a term that already existed to refer to historical precedents of destruction of the Jewish people. Although the term *Shoah* tends more toward implications of metaphysical doubt than toward punishment, it still resonates with the concept of divine retribution.[12]

Just as the preferred term *Shoah* still perversely echoes the conflation of victimization with criminalization, the risk in photographic naming of the Holocaust is precisely that the picturing implicates the pictured in the realm of inevitable victimization. At stake is the doubled victimization in photographic attempts at recuperative naming. Let us recall Susan Sontag's memory from 1945 of seeing Holocaust photographs of the camps at Bergen-Belsen and Dachau for the first time:

> Nothing I have seen—in photographs or in real life—ever cut me as sharply, deeply, instantaneously. Indeed, it seems plausible to me to divide my life into two parts, before I saw those photographs (I was twelve) and after, though it was several years before I understood fully what they were about. . . . When I looked at those photographs, something broke. Some limit had been reached, and not only that of horror; I felt irrevocably grieved, wounded, but a part of my feelings started to tighten; something went dead; something is still crying.[13]

The grave implications of responses dramatized by Sontag are precisely how these cutting incisions will rebound within the viewer and in his or her relations with others. In extreme cases when too much horror is shown, the desired retrospective bond between viewer and pictured can turn into codified positions of the pathetic and the privileged. Julia Kristeva's thoughts about the tremendous power of documentary photographs of the Holocaust confront the ways in which such images intervene in projected relations between the viewer and the pictured:

For these monstrous and painful spectacles disturb our mechanisms of perception and representation. Our symbolic modes are emptied, petrified, nearly annihilated, as if they were overwhelmed or destroyed by an all too powerful force.[14]

For, when narrated identity is unbearable, when the boundary between subject and object is shaken, and when even the limit between inside and outside becomes uncertain . . . when it tends to coincide with the incandescent states of a boundary-subjectivity that I have called abjection, is the crying-out theme of suffering-horror.[15]

Often, the debilitating grimness of the scene blinds the viewer entirely or turns him or her retrospectively against the pictured . . . with risky ramifications in the present tense. Kristeva's writing about the transgression of normalized subject-object relations was literalized a few years ago in Washington, D.C. In response to the Independent Commission's questioning in testimony on 30 July 1990, then chair of the National Endowment for the Arts John E. Frohnmayer awkwardly justified his agency's censorship policies by using the Holocaust as the most striking example of "shocking images":

There are standards that govern the time, place, and presentations of both private and public art. For example, art which was confrontational and excited its viewers to potential civil disobedience might be inappropriate for display in a public courthouse but might be fine for a museum. Likewise, a photograph, for example, of Holocaust victims might be inappropriate for display in the entrance of a museum where all would have to confront it, whether they chose to or not, but would be appropriate in a show which was properly labeled and hung so that only those who chose to confront the photographs would be required to do so.[16]

Frohnmayer's muddled explanation of the differences between public and private presentation of "difficult" images is nonetheless poignantly fraught with the complexities and contradictions that confront contemporary viewers of the most difficult of Holocaust-related photographs. The issue is not one of simple censorship but, rather, one that pivots more closely on what is crucial for public knowledge and how that knowledge comes to be considered obscene. In this regard, Pierre Bourdieu writes of photography's heightened status: "If photographic representation of the naked body leads more readily than representation in paintings to accusations of obscenity, this is doubtless because the realism attributed to photography means that it appears less capable of carrying out the operation of 'neutralization.'"[17] The difficulty in approaching documentary photographs of Holocaust victims is precisely that the horrific dehumanization the images pronounce cannot easily be "neutralized": it rebounds back onto those

pictured, as if they are obscene rather than the crimes to which they were subjected. The mirror that the photograph purports to be or, rather, that it is forced to become, lies in the face of truth. That is, to call such images disgusting, obscene, or repulsive is both to displace the dehumanizers' obscene crimes and to *excuse* them, to find a way out for them. It is as if the viewer reacts to protect himself or herself against the violence of the image, to ward off its "contamination." Writer Elie Wiesel responded very differently from the way Frohnmayer did to the challenges of difficult Holocaust imagery. Wiesel, who was the first chair for the museum council of the developing United States Holocaust Memorial Museum that is now open in Washington, D.C., phrased the dilemma of public visual representation in literal and metaphorical terms: "I would bring the viewer closer to the gate but not inside, because he can't go inside, but that's close enough."[18]

Walter Benjamin's extremely astute insight about the uncanny distance and proximity rendered by photography coincides with Wiesel's metaphor of the difficult approach to Holocaust imagery. Benjamin pinpoints the cruel paradox of photography's inscription process.[19] The uncertain spatial and temporal status of photography parallels the indeterminacy of names, which do not go far enough yet are always in excess. Benjamin referred to this impenetrable distance between signifier and signified as overnaming (*Uberbenennung*).[20] He suggested that the processes of naming and mourning are linked: "To be named—even when the namer is Godlike and blissful—perhaps always remains an intimation of mourning."[21] As Roland Barthes construed it, and one of the early functions of photography as the appropriate memento mori souvenir would confirm it, the photograph as the frozen trace of life would seem to be the fitting artifact of mourning both the life that was lived and its passing in death. Yet unilaterally conflating photography with death and mourning is rendered ludicrous in the context of the Holocaust, when both the site of the photograph and the ability to contain a natural death are but cruel shadows of an irretrievable past life. In *Camera Lucida*, where Barthes took to musing about which photograph of his deceased mother gave him the closest sense of her identity and personhood, he had the luxury of possessing multiple photographic images of her.[22] That is, he had the privilege of owning the site of memories proffered by the photographs. A single family snapshot takes on a precious imprint in the context of the Holocaust, a meaningfulness that outweighs and cuts through the usual sentimentality when such documents are taken for granted. In addition, Barthes could contemplate a fully lived life that ended in a natural death as well as the photographs that contained them. Thus, conflating photography as an unproblematic site of death and

mourning is plausible only within certain limits of cultural norms and experiences.

In Edith Wyschogrod's study *Spirit in Ashes: Hegel, Heidegger, and Man-Made Mass Death,* she identifies the "authenticity paradigm," the guiding Western philosophical discourse on death, which assumes the notion that death is integral to life and will not be in vain if life has been full and intense.[23] Wyschogrod refuses this notion of quality of death in life in relation to the phenomenon of mass death, making the point that in this case the authenticity paradigm is reduced to self-parody since the experience of life and any sense of quality in death are destroyed. She strives to think what a philosophical grieving could be, a grieving in which the work of mourning must go on not only for "the lost one" but for "the lost many." This grieving process relies on the reestablishment of poetic language and the act of recollective naming. In the face of the difficulty and importance of such recollective acts, Judith Butler insightfully queried, "Do names really 'open' us to an intersubjective ground, or are they simply so many ruins which designate a history irrevocably lost? Do these names really signify for us the fullness of the lives that were lost, or are they so many tokens of what we cannot know, enigmas, inscrutable and silent?"[24]

Butler's piercing insight about the desire to know, to feel, to find a place of intersubjectivity between the self and the victims is the dilemma facing both public and private representations of Holocaust commemoration. Her question can be directed toward documentary and pre-Holocaust family snapshots. This is because the cruel and poignant paradox of the photograph is situated precisely in history's demand that it also function as an empathic marker. Yet if empathy is taken to mean the imaginative projection of one's own consciousness into another being, this empathic merging becomes nearly impossible when the events are so unimaginable that they overwhelm the mind's ability to find a place where their representation can be lodged. Immanuel Kant's theory of the sublime offers a model for the acute difference between the enormity of a concept and the imagination's inability to fathom the totality of that idea. The incommensurability of the events of the Holocaust suggests the intangible reality of Kant's impossible reciprocities. Indeed, as Saul Friedländer urgently phrased it, we need to envision a new category of the sublime as it relates to representation of the Holocaust "specifically meant to capture inexpressible horror."[25] "On the one hand," Friedländer writes, the historian "cannot but study the 'Final Solution' as any other past phenomenon. The reconstruction of the most detailed sequences of events related to the extermination of the Jews is progressing apace. On the other hand, for some historians at

least, an *opaqueness* remains at the very core of the historical understanding and interpretation of what happened."[26]

Jean-François Lyotard takes up precisely Kant's insistence on negative presentation—in which presentation exists to point to the reality of its unpresentability—in his attempt to articulate the (im)possible and pressing demand for appropriate recognition and representation in the context of, as he puts it, "phrasing, after Auschwitz." He acknowledges the vital need for giving justice to the incommensurabilities. In his book *The Differend*, Lyotard's attack on the rationalist logic that embodies Western philosophy takes on a more specific motive than in previous work: to undercut the revisionist assaults made by so-called historians, most notoriously Robert Faurisson, who claim that the man-made mass murders that are the Holocaust never occurred because the revisionists cannot find a single witness to the gas chambers.[27] The perverse logic that makes those witnesses unavailable is of course that these victims/witnesses are all dead.[28] This is the kind of logic pushed to its ludicrous and obscene limits that Lyotard wants to discredit with a vengeance. For Lyotard, the "differend" goes further than its simple translation into English as a difference, a dispute, or a disagreement—although it encompasses all of these connotations. He uses it strategically to refer to legal procedures with their game of logical arguments and either/or modes of operation, modes based on the totality of restrictive thinking that Lyotard targets at the heart of his work.

With the extreme case of Auschwitz and the real specter of revisionist historians in mind, Lyotard asks if a wrong cannot be admitted into court because it cannot be phrased, cannot be proved, "should the victim seek to bypass this impossibility and testify anyway to the wrong done to him or to her?"[29] Lyotard seeks to move his case out of the dialectical logic of the courtroom and, in his own dialectical mode, explicitly and implicitly harbors a crucial point: the nonphrase that is silence is a resounding sentence. In the face of the revisionist's self-proclaimed victory based on the materiality of supposedly factual evidence rendered through the most tortuous of means, Lyotard counters not with hard facts but, significantly, with the reality of the referent through its very immateriality, its immeasurability. Hence, his powerful metaphor of the earthquake:

> But the silence imposed on knowledge does not impose the silence of forgetting, it imposes a feeling (No. 22). Suppose that an earthquake destroys not only lives, buildings, and objects but also the instruments used to measure earthquakes directly and indirectly. The impossibility of quantitatively measuring it does not prohibit, but rather inspires in the minds of the survivors the idea of a very great seismic force. The scholar claims to know nothing about it, but the common person has a complex feeling, the one aroused by

the negative presentation of the indeterminate. *Mutatis mutandis,* the silence that the crime of Auschwitz imposes upon the historian is a sign for the common person. Signs (Kant Notices 3 and 4) . . . indicate that something which should be able to be put into phrases cannot be phrased in the accepted idioms (No. 23). . . . The indetermination of meanings left in abeyance [*en souffrance*], the extermination of what would allow them to be determined, the shadow of negation hollowing out reality to the point of making it dissipate, in a word, the wrong done to the victims condemns them to silence—it is this, and not a state of mind, which calls upon unknown phrases to link onto the name of Auschwitz.[30]

Through his elaboration of Kant's signs of history, Lyotard is not calling for a dispersal of sense or a denial of language's ability to formulate linguistic communication. In relying on the idea of the differend he is, in fact, articulating linkages between the incommensurability of the events and their representation:

To give the differend its due is to institute new addressees, new addressors, new significations, and new referents in order for the wrong to find an expression *and for the plaintiff to cease being a victim.* This requires new rules for the formation and linking of phrases. No one doubts that language is capable of admitting these new phrase families or new genres of discourse. Every wrong ought to be able to be put into phrases. A new competence (or "prudence") must be found. . . . What is at stake in a literature, in a philosophy, in a politics perhaps, is to bear witness to differends by finding idioms for them.[31]

The differend itself is the idea of a presentation of the sublime and a bearing witness for which it is nearly impossible to find expression. Lyotard's differend is attentive to Kant's notion of "feeling." If history renders facts, then the spaces between what cannot be documented or what has been obliterated render feelings for what cannot be recalled as facts. The silences that are resonant signs of history demand phrasing and representation. Indeed, Lyotard creates a call "to bear witness to differends by finding idioms for them." What is at stake in the picturing of the Shoah is precisely what kinds of idioms are presented in the name of bearing witness.

The documentary photograph has been made to assume the uneasy burden of bearing witness to the events. In its most revelatory sense, the documentary photograph is an artifact that issues a warning: what it appears to represent is only one surface element in a deeper and more complex structure of meaning. In fact, the earliest usages of the word *document* point to its ability to teach and to offer evidence. Holocaust-related photographs have been and continue to be employed to foster the precious if not irresolvable mandate to never forget. If the photograph performs the overdetermined role of mirror and window onto the unimaginable reality,

if it stands in as part of the incommensurable and impossible entirety, the problems are compounded for the museum attempting to stage remembrance of a historically sublime event. Caught between performing as a history lesson and providing a site for mourning, the Holocaust museum's doubled, daunting, and riddled mandate parallels the burden assigned to the photograph. The work of the museum condenses, seals, and freezes the time of life experience into historical time, as does the still photograph. Bringing the photograph into the museum as monument, warning, and historical marker indeed recalls Theodor Adorno's likening the museum to the mausoleum.[32] When the web of issues confronting photography is conflated with that of the museum in bearing witness to the sublime in framing, naming, and strategically restaging mass death and the Holocaust, the crucial problems and urgent possibilities of historicizing and memorializing are even more sharply brought to the surface. At stake is the delicate question of simulating history through photography and the formation of participants, spectators, and distant witnesses in this process. A complex of questions thus arises: Can the photographs reside in the archive as objective historical documents and simultaneously work as empathic markers in exhibition spaces? Must not the stringent requirements of historical objectivity and photographic categorization be partially waived to reshape these documents into other, less defined discourses leading to cautious renaming and offering retrospective witnessing? Does not the extreme, complex, vivid, and opaque subject of Holocaust memory itself demand such loosenings of bureaucratized divisions?

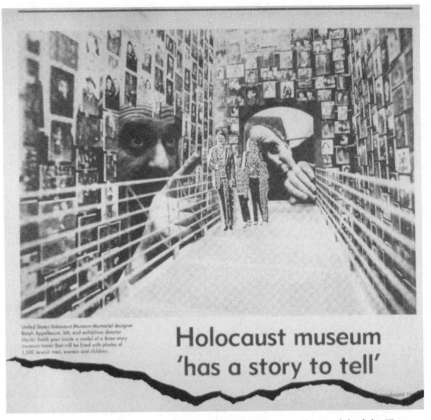

United States Holocaust Museum Memorial designer
Ralph Appelbaum, left, and exhibition director
Martin Smith peer inside a model of a three-story
museum tower that will be lined with photos of
1,500 Jewish men, women and children.

Holocaust museum 'has a story to tell'

Figure 1. Ralph Appelbaum and Martin Smith working on the model of the Tower of Faces before the museum was built. Courtesy of the United States Holocaust Memorial Museum Photo Archives.

[**2**] *The Identity Card Project and the*
Tower of Faces at the United States
Holocaust Memorial Museum

> *In the work of mourning, it is not grief that works;*
> *grief keeps watch.*
> :: Maurice Blanchot, *The Writing of the Disaster*

Upon entrance to the United States Holocaust Memorial Museum in Washington, D.C., the visitor is "invited to register" for an identity card.[1] The visitor is directed to a computer-processing area in the foyer of the frighteningly vast and hollow space of the Hall of Witness. Here preprinted cards await the visitor (fig.2). The cards are printed with a photograph and a brief text about the Holocaust victims and survivors they represent. The information is gleaned from much longer histories that the survivors or the families of those who perished have offered to the museum for public use. The cards are organized by these persons' ages and genders. The museum visitor is directed to choose from among these cards to select an identity card representing a Holocaust victim whose bare traces of identity are approximately matched to the visitor's random and impersonal statistics. The initial concept for the identity card project would have had the visitor record his or her age and gender directly into the computer. He or she would then have been "matched" by the computer with a compatible "companion" and then issued a corresponding card.

The cover of the identity card bears the logo and the organizing authoritative logic of the museum's symbolic imprint. In this guise, the name of the museum appears in full below the eagle crowned with the logo "For the dead *and* the living we must bear witness."[2] Each identity card is also marked with a four-digit number, computer printed as if it were freshly stamped. Opening the identity card and reading the inside front page reveal the vital statistics of the person who experienced the Holocaust: name, date of birth, place of birth, and place of residence. Printed directly above these

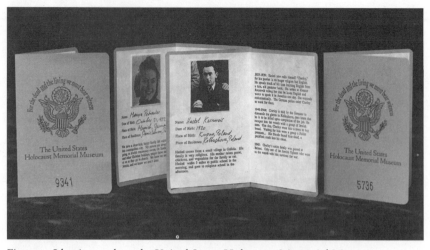

Figure 2. Identity cards at the United States Holocaust Memorial Museum.
Courtesy of the United States Holocaust Memorial Museum Photo Archives.

data looms a close-up black-and-white pre-Holocaust photograph of the
person/subject in question. The visitor journeys through the permanent ex-
hibition with this eerie conflation of passport and death sentence in hand.
As the project was initially devised, the visitor would again be invited to
enter the identity card into a computer at the end of each floor of the per-
manent exhibition to obtain further information about his or her extended
double (fig. 3). The documentation added at each computer station would
correlate with the years that the exhibition chronicles. When the museum
first opened, the computer stations positioned at each floor were still in
operation; however, like those at the entrance, these have also been de-
installed. The museum's project director, Michael Berenbaum, stated that
the computers at the end of each floor were developed to handle one mil-
lion cards. The planners never anticipated the enormous number of visi-
tors, and after three months, as Berenbaum puts it, the computers were
"used up."[3] Until the museum can reinstate the computers, visitors now
receive the full text about their identity card companion before entering
the narrative sections of the permanent exhibition. The permanent exhi-
bition is divided up into chronological sections: making up the fourth
floor, where the exhibition begins, is The Assault 1933–1939; on the third
floor is The Holocaust 1940–1944; and the second floor lays claim to
Bearing Witness 1945–. The identity card's unfolding biographical narra-
tive was designed to both parallel and intervene in the larger historical
narrative being produced in the massive 40,000-square-foot permanent
exhibition. Thus by the time the visitor had descended the exhibition's
floors, his or her card would be filled with a condensed text revealing

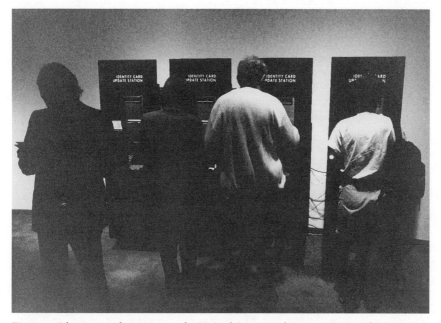

Figure 3. Identity card stations at the United States Holocaust Memorial Museum. Courtesy of Michael Dawson.

whether or not their ghost guide survived the atrocities. As the identity card now functions—or malfunctions—the visitor enters the museum and chooses from among piles of cards that are placed, almost carelessly, in two boxes marked solely by gender.

It is more than coincidence that this punctuated facsimile marking the bare minimum of a Holocaust victim's pre-Holocaust life and the un-folding ruin of his or her existence afterward echo the horror of the Nazis' actual marking of bodies. The metaphors to the brutal labeling are hardly masked. Indeed, the philosophy driving the strategies of the museum's per-manent exhibition program is based on bringing the horrors close to the surface, refusing to "sanitize" them. The museum's guiding approach was largely formulated by Martin Smith, former director of the museum's per-manent exhibition program. Significant to the profile of the United States Holocaust Memorial Museum is that Smith is not a museum professional. He was chosen to formulate the museum's theoretical underpinnings and their exposition in the permanent exhibition precisely because of his expe-rience as an independent documentary filmmaker.[4] Given the first museum director Jeshajahu Weinberg's hopes for the museum to "introduce a three-dimensional multi-media approach" that he wanted to differentiate from the more traditional ways of telling Holocaust history, Smith's past work with photographs and film footage as documents and storytelling devices harmonized well with the museum's goals (fig. 1).[5] Before the

actual exhibitions were installed, Smith reflected on his working philosophy as it guided the difficult and daunting task toward formulating the permanent exhibition at the United States Holocaust Memorial Museum:

> That any individual who wasn't part of the event can comprehend the event seems to me beyond the realm of reason. Even the survivors themselves cannot comprehend the event. They can perhaps occasionally comprehend the part and parcel of it. My own response in terms of looking at the exhibition has been affected by questions bearing on to what extent are we pushing or should we push the barriers of respectability, acceptability, horror—which has recently come up with the NEA thing about claiming you shouldn't have photographs of the Holocaust placed in front of people. If you are going to stop that sort of funding and you really believe that the arts should not engage in images of social distress, you should go around removing the crucifix in front of every Roman Catholic church in the land.
>
> I think we cannot avoid looking at some of the worst of the material. But what is the worst anyway? I find just looking at people's heads and feet when they are deceased as distasteful as anything else, like pubic hair and everything else that has caused me any number of worries. My belief is that if you do not put them on display, then you are diminishing the extent of the horror and what the experience actually meant. But I would be absolutely opposed to sanitizing it. When I first came in, they asked me what my approach would be and I said that the job was impossible, but I'm not in favor of sanitizing it. I'm sure that whatever we do is going to be offensive to very many people. I don't think that is the fault of the institution—it is the fault of the subject matter.
>
> The irony is that I don't trust the medium of documentary photography at all, and I don't even trust historical records. They are all coming through the filter system of human memory, and all memory is written to advance a particular point of view. I do, however, think that the only way to handle the event is via a documentary approach. But I don't believe either documentary films or photographs alone can do it. It was important to establish the physical reality of the Holocaust . . . which is why we've got a barracks from Auschwitz-Birkenau, which is why we've got a railcar, which is why we have a rescue boat, which is why we've got the uniforms. . . . The exhibition will be a mixture of photographs, films, documents, and artifacts. I think increasingly with time people will be more and more skeptical about visual imagery and about film, and rightly so. . . . The difference between our museum and most museums is that the photograph as object is of very little interest to us as far as the permanent exhibit is concerned. We are using photographs as evidentiary and storytelling vehicles.[6]

Note that Smith referred to his difficult task to restage the museum visitor's approach to the Holocaust as "impossible." Caught between displaying the horror of the experiences and guarding against "the worst of the material," Smith's thoughts resonate with the paradoxes implied by Berenbaum when he stated that "we wanted to come as close as possible to desecration without redesecrating."[7]

The museum's unflinching approach is even more literally tangible from the first steps the visitor takes into this mammoth edifice of simulated memory. With his or her identity card companion in hand, the visitor enters the museum's permanent exhibition via one of three thin gray elevators whose eerie steel and industrial feel evoke a claustrophobic finality. Once the elevator doors shut, the lights dim and narrated film footage enacting the U.S. liberation of the camps begins to play on two screens positioned above the doors.[8] After viewing burned landscapes and devastated bodies, the viewer as victim and witness hears these last words pronounced before the elevator arrives at its destination: "You can't imagine. Things like that don't happen." After this approximately twenty-second journey—the footage is timed to end at the moment the elevator arrives at the fourth floor—the doors open onto a view that frames a large black-and-white photographic blowup of U.S. soldiers standing before a pile containing calcinated corpses at the Ohrdruf concentration camp at the time of liberation (fig. 4). A video monitor set into the wall immediately follows this enlargement. It plays film footage taken by George Stevens (who later directed *The Anne Frank Story* [1959]) of American soldiers arriving at a camp. Both of the photographs are from the National Archives in Washington, D.C., and like the film, were taken by the U.S. military during the liberation of the camps.[9] A smaller color photograph picturing a man who survived Buchenwald follows this monitor (plate 1).

It can be argued that these photographic and filmic images, as the first artifactual evidence the viewer faces, lay the foundation for the Americans as the saviors and the silent narrators/witnesses to the viewer's experience within his or her journey through the United States Holocaust Memorial Museum. This institution's nationalistic framing of memory is hardly hidden. The multiple ways in which the museum frames the visitor as Jew, as victim, as transformed witness, and as a reborn American citizen are not accidental.[10] Yet I focus here less on a critique based on the museum's transparent subtext in order to consider more deeply its complex approaches to photographic representation. These three introductory documents make the visitor's entrance into the permanent exhibition difficult and complicated. The photographic blowup presents a wide, horizontal expanse to the horrific scene whose format suggests an environmental tableau that one could walk into—but it is an impossible invitation. In the film footage, listless bodies with graven faces wander aimlessly across the viewer's numbed lens. "Liberation" is hardly played on a triumphant note. The color photograph employed as the last image in the museum's introductory wall creates an important and unusual disruption from the black-and-white documentary rhetoric of the past brought into the viewer's present.[11] These

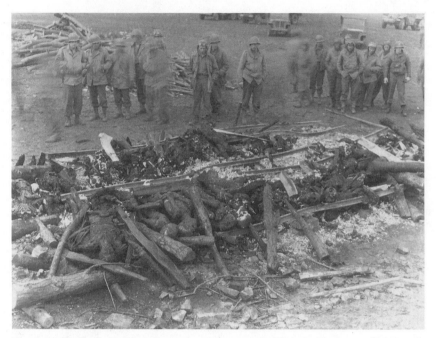

Figure 4. Ohrdruf concentration camp, Germany, April 1945. Entrance photograph at the United States Holocaust Memorial Museum. National Archives, courtesy of the United States Holocaust Memorial Museum Photo Archives.

three images function more like a punctuated epilogue transposed to the beginning of the story, especially since the "real" beginning of the museum's chronological story opens just after this wall with a sketching out of the presence of diverse minority populations throughout Europe before Hitler's rise to power.

The vital question thus brings its own pressure to bear on what remains to be told, toward what can be told. What forms of photographic nomenclature can be presented in the name of acknowledging the impossible? The Lyotardian echo reverberates "to bear witness to differends by finding idioms for them."[12] The most troubling issues for Smith at the United States Holocaust Memorial Museum were precisely those that confuse the fine line between the near-impossibility of confronting Holocaust memory and history as palimpsest, the responsibility of "telling the story," and the difficult indispensability of employing documentary photographs. One might hear echoing in Smith's concerns Theodor W. Adorno's now well-known warning from the immediate postwar years of the dangers of aestheticizing the events. In explaining his initial and often misinterpreted phrase about the inability of art to represent the Holocaust, "To write poetry after Auschwitz is barbaric," Adorno later wrote, "Through the aesthetic principle of stylization, an unimaginable fate still seems as if it

had some meaning; it becomes transfigured, with something of the horror removed."[13] Note the similarities between what came to be mistaken as Adorno's taboo on Holocaust representation and some of the reasons that fuel contemporary unease with documentary's presumptions. Both arguments are profoundly concerned that the viewer is brought into the scene under false pretenses. Furthermore, Smith's decision not to "sanitize" the events is akin to Adorno's guarding against displacing their horror. Given such warnings, to assume to represent the enormity and incommensurability of the Shoah will always be a horrible if not disrespectful reduction of the realities. What, then, are the museum's divided strategies for addressing the paradoxes of telling this history and the modes of address it constructs between the visitor and the difficult material through the identity card project?

Held carefully in the visitor's hand or nestled nonchalantly in a coat pocket, the identity card might hold out the possibility of working across the relentlessly graphic, massive, and chronological view of history projected throughout the elaborately storied exhibition. Indeed, the exhibition team devised the identity card project as a way to break down the history of the Holocaust into what they refer to as human terms, "to educate visitors by personalizing the experience." The museum's press release, issued before the museum opened in April 1993, further projected that "visitors will be encouraged to keep their identity cards when they leave the Museum as tangible remembrances of their visit." Speaking about the majority of photographic images picturing people as ghost facades of their former selves, such as those that arrest the visitor upon his or her entrance into the permanent exhibition, Smith rhetorically asked, "Why would a robust, McDonald's-fed, eighteen-year-old American *boy* have any connection to these emaciated figures? The identity card project came out of our desire to establish an immediate bonding with a person and a place."[14]

The notion of bonding is indeed key to the tantalizing concept underlying the identity card project. At stake is precisely how the texture of this bonding between the contemporary museum viewer and his or her extended double from the past will be staged. Also crucially at issue is how the photographic and textual markers that represent the Holocaust victim will formulate the proximities and the distances between that absent person and the variable identities of the museum visitor(s). In other words, how will normative positions of objectivity (in this case, the museum visitor's) and subjectivity (the person to be remembered, or in this case, the "subject" viewed) be maintained, refracted, or abridged? If it is the museum's goal that the visitor arrive at some form of empathy toward the human specter that has guided her through and across the permanent exhibition, it relies heavily on the possibility of imaginative projection. First, to write the

shadow of a Holocaust victim's experiences through the inscription of a single photograph and an attenuated text calls forth its very (im)possibility. Further, to attempt to reach across the chasm of unimaginable realities and incommensurable events and to bring in the visitor's ability to imagine, to be open to the Holocaust other, are necessary presumptions. The identity card project tantalizes precisely because it acknowledges the presence of a viewer who receives information on cognitive and emotional registers. Through its anticipation of the viewer's projection of her own subjectivity into the participatory process, the identity card project provokes the possibility of intervening in traditional documentary presentations that presume that looking is based on purely objective dynamics.

Despite the museum's rhetoric that it will "tell the full story,"[15] the actual thinking toward the identity card is more closely aligned with Elie Wiesel's notion of a metaphorical and literal gate or barrier to full knowledge. Irving Howe has also written against the possibility of full disclosure and has called for representations that work in "tentative and modest solidarity with those who fell."[16] The refusal, or the inability, to grant full disclosure to the representation of historical events correlates with the identity card's appropriate inability to create smooth mergings between the museum spectator and images of Holocaust victims. In fact, it is the identity card project's very reliance on the museum visitor's subjectivity and self-investment—the skeletal allowance of his or her own biographical data driving the issuance of the card—that mimics the notion of a perfect mirror staging. An extreme and yet probable case of a shattering of rather than a conflation with one's doubled persona could occur if the visitor refuses affinity with his or her issued ghost. Smith has given thought to the possibility of such built-in confrontations:

> Somebody may be offended by having their personal identity card represent a homosexual, to which my response is, if a Fundamentalist Christian comes in, would he be satisfied being coupled with a Jew? So if you don't issue a Jew, where do you go? Are we going to allow a Jew to say, "No, I don't want to hear about some dissenting Christian?"[17]

Although such surface disjunctures are built into the maneuverings of the identity card, the project is more conceptually driven by attempts to formulate imaginative projection tending toward empathy. What, then, are its safeguards, its soft barriers that warn against facile bonds of sameness between the museum visitor and the persons pictured and described on the cards? This crucial question might itself assume too much, might retrospectively be in vain, because a marking of differences is always already in place in the strange and unpredictable commingling of identities that the

identity card attenuates. No matter what is announced about the project's ability to pair and to compare, the workings of the identity card could never occur through seamless identifications. Everywhere in the museum — from the vague memory of the disembodied city outside, which the museum's architecture tries to efface, to the intricate workings of the simulated environments it houses — the visitor is reminded that he or she is in a vast space of articulated re-creation. To thus create a fusion of identities without gaps between the museum visitor and the remembered Holocaust victims would verge on the dangerous as well as the inconceivable.

It is the photographed face of the Holocaust victim that paradoxically promises to ward off slipping into false realisms and facile mimetic mergings endemic to the estranged documentary tradition. The photograph of the face on the identity card functions as an arbiter or a boundary zone between the interchangeable subjective and objective identities of the viewer and the memorialized other. It also creates a stopgap between the disputed terrain of the remembered and recountable historicized past of the individual to be thus commemorated and the private space of his or her unknowable and unrecountable life. In its profound visibility and simultaneous elusiveness, the hovering small-scale photographic face is a trace that obliquely excludes parts of a map to a larger history. The intangibility of the face and the photograph as both presence and absence mirrors the tensions in the photographic representation of intractable events. The employment of the face on the identity cards suggests a point of arrest bridging the utter horror depicted through the mass of Holocaust-related documentary photographs and the sheer refusal to depict the atrocities. It serves as a vital buffer zone across the unpresentable and a tentative temptation to represent. It is both perverse and appropriate that the image of the face returns in an orchestrated maneuver meant to counteract the Nazis' mass-scale elimination and extermination of bodies, faces, and identities. The photographic act of giving back identities and names takes place here through dialectic means. The identity card conflates and restages the Nazis' perverse criminalizing of innocent persons while it seeks to enact recuperative acts of commemoration. Yet the identity card's attempt to restore the personhood of the individuals who perished or who suffered immeasurably is only provisionally accomplished by the degree to which the unknown museum visitor can or will take in these memorized histories.

The uneasy point of intersection between the past and the present in the identity card's construction of historical memory is further played out through the confusion of verb tenses written into its condensed biographical sketches. For example, the identity card documenting the unfolding of Haskel Kernweis's fatal entanglement with the Nazis moves between the

present and past tenses. The text that introduces Haskel with his photograph and bare data of existence reads:

> Haskel comes from a small village in Galicia. His family is very religious. His mother raises geese, chickens, and vegetables for the family to eat. Haskel walks 5 miles to public school in the morning, and goes to religious school in the afternoon.

Having established a trace of Haskel's pre-Holocaust existence, the text is brought consecutively into focus as the visitor moves through the floors of the exhibition space:

> **1933–1939:** Haskel now calls himself "Charley," for his passion is no longer religion but English. He spends much of his time learning English from a torn, old grammar book. He writes to Eleanor Roosevelt telling her that he loves English and wants to speak it in America one day. She responds enthusiastically. The German police order Charley to work for them.

> **1940–1944:** Charley is told by the Germans to dismantle the ghetto in Kolbushova, then hears that he is to be killed upon completion of the job. He escapes into the woods with a group of Jewish men.

The present tense is unfortunate here for it works too hard and in vain to force the reality of Haskel into *our* present. The entire machinery of memory that is being so carefully constructed at the United States Holocaust Memorial Museum is being performed so that the memory of the past will be reformulated in the present. Indeed, the references to Eleanor Roosevelt and to America as a monumentalized haven are a bit too fitting, if not self-serving, to the museum's purpose. To pretend that the brutal and complete past can be written in the form of an innocent, innocuous, and intimate present verges on the absurd, without pushing it far enough for us to pause on the incongruity of the task. It is hardly fitting to the memory of the person Haskel, whom we will never know.

The past tense enters this historical-diaristic narrative indicator at the terse point where the text intimates Haskel's death, in the middle of the 1940–1944 section: "One day, Charley went into a town to buy bread. Waiting for him were a group of Polish peasants." And it then continues, more aligned to the narrative and more in justice to Haskel's memory, in the simple past: "His friends found him—dead, a pitchfork stuck into his chest. **1945–** Charley's entire family was gassed at Belzec. Only one of the Jewish fighters who went to the woods with him survived the war."

The identity card project entices the viewer because it brings photographically and textually into view realities that will always be out of reach. The presumptuous contention at work is that the identity card's strategy of bonding can, indeed, write across chasms of the unknowable to

arrive at some point of provisional fusion. The identity card experiment suggests one way to approach the inevitable dilemma of representing the unrepresentable, but in its move toward feigned intimacy it more deeply reinforces the abyss of distance it so emphatically seeks to shore up. This reaching across to the unknowable represents a desire to render present that which can never be completely absent. This poignant and haunting desire to seek idioms for the horrible sublime that gives life to the identity card project bears in it the oscillating drives animating the dynamics of mourning itself.

Sigmund Freud characterized mourning as an act that can be accomplished through the "economic" incorporation of the lost other into the self, but not without the expenditure of much psychic energy. Freud's theory of mourning was developed through his study and treatment of individual psychoses and was not conceived to embrace the extraordinary phenomena of historical trauma and genocide. The Freudian model of "successful" mourning lays potent ground for theorizing the intersubjective relationships between the self and the departed other in relatively normative situations of loss or actual death. Yet if the ability to distance oneself from the lost other and to recover from the loss is gained through deep internal psychic struggle, accomplished mourning provocatively suggests that traumatic loss of incommensurable proportion—both individually and historically—would create an ongoing if not thwarted process of mourning. Mourning and melancholy might need to be considered as intertwining psychic states in which the mourner cannot completely let go of the other. The memory of the other must hover impalpably between the self and the other.

Working from Freud in his crucial text on mourning, friendship, and unreadability, *Mémoires for Paul de Man,* Jacques Derrida weaves a discussion of a transfigured narcissism in which the self comes to understand its imprecise proximities with the grieved other through the simultaneous processes of possible and impossible mourning:

> Memory and interiorization: since Freud, this is how the "normal" "work of mourning" is often described. It entails a movement in which an interiorizing idealization takes in itself or upon itself the body and voice of the other, the other's visage and person, ideally and quasi-literally devouring them. This mimetic interiorization is not fictive; it is the origin of fiction, of apocryphal figuration. It takes place in a body. Or rather, it makes a place for a body, a voice, and a soul which, although "ours," did not exist and had no meaning *before* this possibility that one *must* always begin by remembering, and whose trace must be followed. *Il faut,* one *must*: it is the law, that law of the (necessary) relation of Being to law. We can only live this experience in the form of an aporia: the aporia of mourning and of prosopopeia, where the possible remains impossible. Where *success fails*. And where faithful interiorization

bears the other and constitutes him in me (in us), at once living and dead. It makes the other a *part* of us, between us—and then the other no longer quite seems to be the other, because we grieve for him and bear him *in us,* like an unborn child, like a future. And inversely, the *failure succeeds*: an aborted interiorization is at the same time a respect for the other as other, a sort of tender rejection, a movement of renunciation which leaves the other alone, outside, over there, in his death, outside of us.[18]

This eloquent articulation figures possible mourning as Freud's clinical description of incorporation; impossible mourning would be the refusal to take the grieved other within oneself so completely, so definitively. Derrida's plea for tender rejection counters the self's almost obscene desire to overwhelm the other, "over there, in his [or her] death." In his earlier text, "Fors," the foreword to Nicolas Abraham and Maria Torok's study *The Wolf Man's Magic Word: A Cryptonymy,* Derrida calls attention to Torok's distinctions between incorporation and introjection:

The question could of course be raised as to whether or not "normal" mourning preserves the object *as other* (a living person dead) inside me. This question—of the general appropriation and safekeeping of the other *as other*—does it not at the same time blur the very line it draws between introjection and incorporation, through an essential and irreducible ambiguity? Let us give this question a chance to be reposed. For Maria Torok, "incorporation, properly speaking," in its "rightful semantic specificity," intervenes at the limits of introjection itself, when introjection, for some reason, fails. Faced with the impotence of the process of introjection (gradual, slow, laborious, mediated, effective), incorporation is the only choice: fantasmatic, unmediated, instantaneous, magical, sometimes hallucinatory.[19]

The instantaneous and fantasmatic longing that enacts the mourning of incorporation takes us back to the United States Holocaust Memorial Museum and Martin Smith's desires for the identity card project: "to establish an immediate bonding with a person and a place." Given that the museum opted for the abbreviated version of mourning, the one that Derrida ironically yet gravely noted that Maria Torok described as "the only choice," the museum has no other choice in hoping that casual visitors—tourists, that is—would quickly come to some point of empathy with their Holocaust doubles. The notion of mourning as a process of incorporation is closely enmeshed with the longing toward figurative bonding that Smith and his colleagues hoped the identity card would attain. Incorporation and the identity card project conjoin specifically in the dilemma of the place of the other. Where is the place of the departed other, and where is he or she simultaneously displaced through the processes of incorporation set into motion through the identity card? The identity card pleads for instanta-

neous, immediate, and yet impossible bonding. It bears in it the haunted oscillations between loving proximity and irrevocable distance toward the other. As Maria Torok aptly phrased it, "The more the self keeps the foreign element as a foreigner inside itself, the more it excludes it. The self *mimes* introjection."[20] The question arises as to whether the imaginative projection of living in the name and in the place of the Holocaust other allows for a respectful taking in or incorporation of his or her memory without the concurrent process of introjection. In the enmeshed workings of incorporation and introjection, or possible and impossible mourning, the safekeeping of the other must always simultaneously participate in its veiled exclusion, its tender rejection.

The identity card calls the viewer to take in memories through the abbreviated processes of self-investment and self-effacement. The museum visitor cloaks him- or herself in the identity of the departed or brutalized other. But the level of intake may not be sustained enough to prepare for the profitable return of introjection, for the ability to find a space of appropriate distance leading to respectful and inevitable otherness. Under cover in the identity card project rests a curious inversion of investments. One particular twist to these ploys of identification, as Jonathan Rosen noted, is that "there is a reverse principle at work here, as if everyone were expected to enter the museum an American and leave, in some fashion, a Jew."[21] And as James E. Young has elucidated this mismatching, "Imagining oneself as a past victim is not the same as imagining oneself—or another person—as a potential victim, the kind of leap necessary to prevent other 'holocausts.'"[22] So much is at stake in the museum visitor's investment to take in the Holocaust other as victim that the identity and personhood of the memorialized other risk being lost in the process. Indeed, the issuance of mock identity cards could turn out to be a mourning and a bearing witness turned inside out and strained at the seams (fig. 5). This strange fusion of selves represents a desire for urgency camouflaged as a transfixed form of displaced nostalgia. The United States Holocaust Memorial Museum's attempt at empathy might better function as a reminder that the few circulating photographs documenting the Nazi ruin of the lives of the people pictured on the identity cards did little to alert the Allies or to bring them to action. Especially given the identity card's simulacrum of a U.S. passport, we might then ask how the documentary photographs featuring American soldiers liberating the camps on display in the permanent exhibition can pretend to function as warning signals on the level of lucid historical objectivity. As Rosen and Liliane Weissberg have noted, the identity card's smug assurance of safe harboring in the name of Americanism takes no account of the thousands of deliberately falsified passports and other

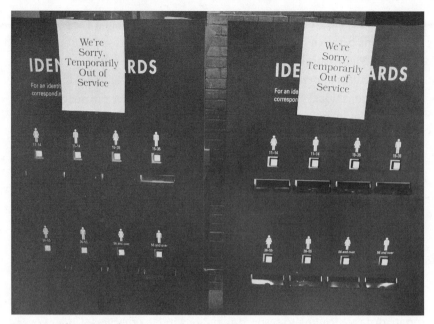

Figure 5. Identity card stations at the United States Holocaust Memorial Museum. Courtesy of Michael Dawson.

documents of feigned identity sought after by those who attempted refuge.[23] The current manipulation and presence of these images both reanimate and haunt the past lives of the people pictured. The photographs and the identity cards unintentionally yet translucently perform that lack of response as mute and potent witnesses. Thus in their tantalizing (im)possibility, the identity cards tear at the photographic wound that would make of memory a souvenir.

While the museum travelers literally traverse and descend the three floors of the permanent exhibition with their expendable identity cards in hand, a different construction of photographic memory-work is being tried in an adjoining section of the exhibition space. Set off from the main arenas of chronological articulation are four tower alcoves that are filled with intimate possessions that belonged to those who perished. These objects are also presented alongside the instruments responsible for their owners' deaths. The Tower of Faces promises to be the most effective and expansive of these metaexhibitions.[24] The Tower of Faces is a space covered from top to bottom with 1,032 photographs of former residents of the small shtetl town of Ejszyszki taken between 1890 and 1941 (plate 2, fig. 6). Eishyshok, the town's name in Yiddish, is located near Vilna in what is now Lithuania. The Jewish community in Ejszyszki, whose population was about 3,500 by 1939, had lived there for almost nine hundred years. The community was

known for its Talmudic academy and rich cultural life. The Tower of Faces is a 54-foot-high, 16-foot-by-28-foot skylit tower space designed to stage a very specific approach between the museum visitor and the photographs of Ejszyszkians pictured in a variety of secular activities. Rather than having visitors enter the alcove as if it were an easily accessible and perusable room, the exhibit designers chose to have the fifth floor of the museum removed at the point where it would connect with the tower's interior space. The visitor's journey through the Tower of Faces is thus possible only by crossing over a translucent glass bridge at the third and fourth floors. The photographs of the former townspeople of Ejszyszki are laminated over aluminum sheets and mounted on a lattice frame angling inward as it rises from its base on the third floor to its fifth-floor ceiling. As the museum's newsletter describes the effect, "Visitors will be able to peer over the side of the bridge and view the photographs from Ejszyszki seemingly floating above and cascading below them."[25] This expansive sensation also gives rise to the numbing realization that the tower also resembles a chimney.

Unlike the identity card's mode of address based on insistent self-identifications, the Tower of Faces stages the presence of the spectator in a space distinct from the sphere occupied by the Ejszyszkians. We are allowed to pass through the photographically haunting identities of the Jews from Ejszyszki; no forced attempt is made to psychically bond him or her with us as their pre-Holocaust likenesses bring us near. Absent, too, from this more gentle memory-trial are the strained anticipation and parceled telling of the brutalities at work in the identity card project. The events that occurred at Ejszyszki are recounted after the visitor passes through the photographic chamber via the glass bridge for the first time. The text panel recounts how, during the period of the Jewish high holidays in 1941, from 25 to 26 September, the Nazi mobile killing squads or *Einsatzgruppen* rounded up people from the synagogues, took them to the marketplace and then to the fields outside the town. Throughout Europe and with the help of non-German collaborators, the *Einsatzgruppen* mass-murdered more than two million Jews and still-unmeasured numbers of Gypsies, Byelorussians, and Russians before the organized plan of the concentration and exterminations camps was in place. The visitor's second encounter with the vivid photographic ghosts of the slaughtered Ejszyszkians, those few who survived, and their ancestors occurs on the third floor of the museum, at which point the visitor crosses the glass bridge yet another time (fig.7).

Within the complex of displays of dehumanization that the museum inevitably stages, the Tower of Faces is remarkable because it is the only space in the museum that implicitly rather than explicitly addresses the genocide. It pictures people fully integrated into the activities of a community run by

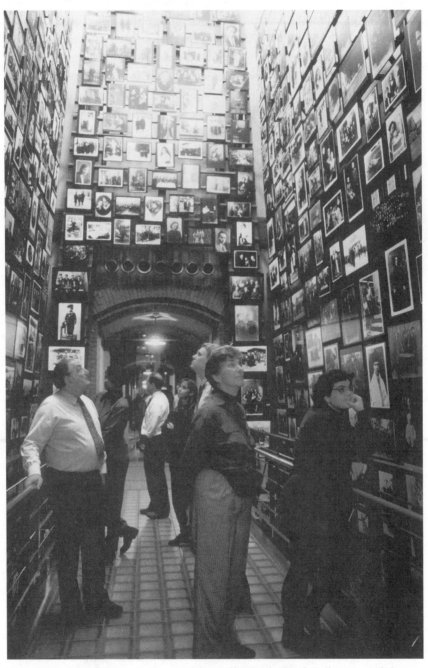

Figure 6. Tower of Faces. Courtesy of the Yaffa Eliach Shtetl Collection and the United States Holocaust Memorial Museum Photo Archives.

Figure 7. Family photograph in the Tower of Faces. The wedding of Sarah Plotnik and Pessah Avrahami, one of the last weddings in Eishyshok on the eve of the storm. Sitting at the table (right to left): Mr. Hamarski, his daughter, Dvorah, Benyamin Kabacznik, wife Liebke, son Yudaleh, Reb Arie-Leib Kudlanski, Reb Dovid Moszczenik, and Eliyahu Plotnik, father of the bride. Second row (right to left): Mrs. Hamarski, five family members, twin sisters of the bride, Mikhle and Braine, the bride, Sarah, the groom, Pessah, Zipporah, mother of the bride, and two relatives. Third row: the family youngsters. Only the bride and groom who made aliyah to Eretz-Israel survived. Dovid died a natural death; Benyamin, Liebke, and Yudaleh were murdered by the Armia Krajowa (the Polish home army); and the majority of the people were killed in the September 1941 massacre. A few were killed in Ghetto Radun and Lida. Courtesy of the Yaffa Eliach Shtetl Collection and the United States Holocaust Memorial Museum Photo Archives.

consensus rather than the most violent of force, where the said and not-said of the everyday of peoples' lives address the viewer rather than a confrontation with images that strip away any possibility of identification between the photographed and the viewer (fig. 8).

Interestingly, the Tower of Faces is preceded by two corridor exhibition spaces that emphasize the failure of what the Tower of Faces was precisely set up to elicit: the ability to partially identify with and respond to the personhood of the people pictured. The first of the two spaces is devoted to narrating what the U.S. public knew about Hitler's Final Solution and about American immigration policies.[26] The narrator's voice recounts that 97 percent of the U.S. population disapproved of Hitler's actions but that at least 77 percent did not support providing refuge. This audio and videotape section ends by inferring that these statistics were the result of perceptions in

Figure 8. Moshe Sonenson and his daughter Yaffa Eliach, 1941, in the Tower of Faces. Photograph taken by Zipporah Sonenson. Courtesy of the Yaffa Eliach Shtetl Collection and the United States Holocaust Memorial Museum Photo Archives.

Figure 9. Photograph by Roman Vishniac of a Jew peering out of a doorway at his son, who signals the approach of members of the anti-Semitic Endecja (Polish national movement). Warsaw, 1938. Copyright Mara Vishniac Kohn.

the United States that European Jews were unsophisticated rural people who could not possibly integrate into this country's modern urban texture.

Ironically, what is presented as perception and not fact in the first space is unwittingly offered as justification in the next area. On the walls of this room hang glass-framed photographs by Roman Vishniac, photographs that picture rural and urban religious European Jews in isolated, darkened, and mystical environments that emphasize otherworldliness as well as the real material world of anti-Semitism in the 1930s (fig. 9). These images seem light-years away from the "progress" and familiarity of American cities and, for that matter, from the modernity of Jewish homes in European cities and towns—scenes of which are pictured within the Tower of Faces. It is patently odd that Vishniac's remarkable photographs— whose specificity about particular religious communities on the verge of danger is often unfortunately misinterpreted as nostalgic generalizations about piousness and antiquity—could paradoxically justify the interpretive strand about American indifference that flows from the audiovideo room into this space. The room in which the Vishniac photographs dwell is further displaced within the flow of the storied units because of its physical appearance: it is fully carpeted in pastel blue, appointed with comfortable sitting chairs, and affixed to its entryway is a large mezuzah. Here is an opulent space that mimics domesticity without irony. Furthermore, its walls are lined with Vishniac's photographs framed and presented more as fine art pictures than as proof, or as Martin Smith phrased it, as "evidentiary or storytelling devices." The poshness and eerie calm of this room are a strange antecedent to the staging involved in entering the Tower of Faces, a space in which the very accoutrements of domesticity and daily life are put into question rather than simulated. Perhaps the uncanniness of this room and the way it punctures and belies the smooth flow of the narrative point out that the museum's only recourse to presenting history is as a staging. Here the staging has come loose from its own frame.

The Tower of Faces and the identity card project are both photographic strategies animated by ambivalent desires to intervene in the museum's predominantly massive, depersonalized, and chronological telling of the events of the Holocaust. The unraveling or, more precisely, the filling up of information on the identity card progresses on a path parallel to the larger narrative. Because of the identity card's plea for assimilation of the Holocaust victim's history into the museum visitor's supposedly singular identity, the articulation of the past into the present remains a story of easily separable spaces of time and memory. The visitor never returns to the same place and time again; history is told in a logically sequential frame-

work. The histories and identities of the town and the people of Ejszyszki circulate on a different register in the Tower of Faces. They are provocatively staged through repetitions of almost identical spaces that do not follow one after the other. The first tenuous crossing of the glass bridge is repeated on the next lower floor only after the museum visitor has undergone the full onslaught of the fourth- and third-floor exhibitions. The second entrance into the photographic tower creates an echoed experience that functions more in harmony with the layered way in which memories overlap and intrude on the mental time zones of the past and the present, especially involving circumstances of extreme traumatic dislocation. Chronological time stands still in trauma; furthermore, it is sealed away into a space where psychic time takes over.[27] In her book *A Scrap of Time*, Polish Holocaust survivor Ida Fink writes about her own tenuous return to the remembrance of the unarticulated and immeasurable past:

> I want to talk about a certain time not measured in months and years. For so long I have wanted to talk about this time. . . . I wanted to, but I couldn't; I didn't know how. I was afraid, too, that this second time, which is measured in months and years, had buried the other time under a layer of years, that this second time had crushed the first and destroyed it within me. But no. Today, digging around in the ruins of memory, I found it fresh and untouched by forgetfulness.[28]

The dilemmas and the interweavings between chronologically measurable calendar time and the cyclical structure of time in nature and memory—a time, however, that never returns as the same—are constant themes of tension, rebirth, and joy in Jewish tradition. The ability of the Tower of Faces to both evoke the "ruins of memory," as Ida Fink described her own internal journey, and to provoke historical memory so vividly through the resilient re-visioned faces attests to a specific tradition of Holocaust remembrance related to the larger Jewish tradition that overlaps chronological time and cyclical space. *Yisker biher,* literally "tombstones of paper," refers to the religious and historical obligation to remember annihilated communities as well as the collective and individual memorial books themselves spontaneously produced by survivors who perform this commemorative work. After the first contemporary *yisker biher* were produced following the pogroms in Central and Eastern Europe after World War I, these memorial books proliferated after the genocides of World War II. The aftermath of the Nazi mass murders and the disappearance of entire communities profoundly redefined the purpose of the *yisker biher.* Their task became ever more doubled: to chronicle the events

of destruction and to simultaneously attest to the memory and vibrancy of what was. In his essay "Remember and Never Forget," Nathan Wachtel describes the traditional format of the memorial books as including an introductory historical section on the cultural life of the community in question, followed by individual and group accounts, with photographs if they survived, of the times before World War I, the period between the two wars, and then the genocide.[29] Wachtel reminds us that the time periods composing these histories often overlap and their recounting is overlaid with the survivor-writers' own diverse and spontaneous memories. Bleeding beyond the historical edges of the *yisker biher* are the grassroots acts by survivors to enliven and reenact the spirit of the lives that made up their communities.

The Tower of Faces partakes of the *yisker biher* memorial tradition in its overlapping structure of historical and memorial narratives so that the exuberance of peoples' lives is conveyed as vividly as their destruction. Where the memorial books accomplish these doubled deeds primarily with words and memoirs, the Tower of Faces insists on the prewar vitality of Ejszyszki through its overwhelming photographic assemblage of community activity. That the archive composing these photographs was painstakingly reassembled by a survivor of Ejszyszki reaffirms the Tower of Faces' affinity with the production of the *yisker biher* books. Yaffa Eliach, now Breuklundian Professor of Judaic Studies at Brooklyn College, was a young girl when the *Einsatzgruppen* murders occurred. Her parents managed to escape from the synagogue, fled, and were reunited with Yaffa three weeks later in another town. After the liberation of the town by Russian troops, she returned to Ejszyszki with her family. On 20 October 1944, the local Polish population staged a pogrom against the surviving twenty-nine Jews, killing Yaffa's mother and younger brother. In the face of this double dying her father paid the Polish residents of the town, who had taken over the formerly Jewish-owned homes, for the few remaining photographs still housed in these occupied spaces.[30] Over the years, Eliach procured still more photographs by contacting fellow townspeople who emigrated before the Holocaust and by tracking the records of the Ejszyszki Society in Chicago. The majority of the five thousand photographs in her archive, however, were reassembled by tracing relatives and friends to whom Ejszyszkians may have sent copies of photographs before 1941. The grave irony of Eliach's re-collection process is that her grandmother and grandfather, Alte and Yitzhak Uri Katz, were the prominent town photographers before the *Einsatzgruppen* murders of 1941 occurred.[31] Their practice was then taken over by her non-Jewish competitor. None of the negatives from Eliach's grandmother's practice survived.

Returning to Derrida's reading of Maria Torok's description of the processes of introjective mourning as "gradual, slow, laborious, mediated, effective," we see how deeply at variance are the workings of the identity card project from those animating the Tower of Faces. The Tower of Faces as an effective act of remembrance is doubly maintained by Eliach's arduous task of re-collection and the deed of love underlying it. Indeed, the laborious and resilient archival work that has taken place, and which is visible only through explication, is evoked through the tempered labyrinthian passageway through which the spectator is led. The recurring glass bridge allowing entrance into the broken prism of lives and destruction suggests a slow unfolding and a tender yet unswerving approach to the events. If the small photographic semblances of persons on the identity cards buffer the museum visitor from the horrific while they also allow the accompanying text to do its narrative work, the photographs measuring one to three feet in height that line the Tower of Faces not only become performative bridges to representation but also pervade the hauntingly articulated space. While the faces on the identity cards are staged to plead for the assimilation of their identities with the visitors', the tower's accumulative photographic likenesses perform otherness not through a forced notion of sameness, but through a startling revelation of difference. That is, the faces can be construed as giving something to the viewer rather than asking the viewer to efface the subject to be mourned by abridging the acts of mourning. The towering faces mime solace and offer provocative sites of repose. Walter Benjamin's dialectic discussion of the portrait in relationship to the "cult of remembrance" touches on this double-edged dilemma of the power of the photographic face. Writing in 1936 not without some trace of regret, he was thinking about the technical reproduction of the human countenance as the last retrenchment of photography's cult value:

> It is no accident that the portrait was the focal point of early photography. The cult of remembrance of loved ones, absent or dead, offers a last refuge for the cult value of the picture. For the last time the aura emanates from the early photographs in the fleeting expression of a human face. This is what constitutes their melancholy, incomparable beauty.[32]

The vibrant images in the Tower of Faces do not fulfill the cult of remembrance through facile refuge. These are not just any anonymous mementos commemorating a life's passing through natural or even foreshortened death. They are passing figures to the cult of remembrance and even more impressive signals of the severe rupture in the notion of a natural death. Their gentle weight cuts between solace and warning (fig. 10). As Eliach has written:

Because of the events that were soon to transpire, these "survivor photos" take on a new dimension in the post-Holocaust era. To look at them now is to know that behind each peaceful image lurks a tragic tale of death and destruction. Intended simply as mementos of happy times and family occasions, the "survivor photos" now have the much weightier task of restoring identity and individuality to the otherwise anonymous victims of the Nazis. . . . the photographs "rescue" these victims posthumously, redeem them from the conflagration that left behind mere ashes and smoke in their wake. The photographs have become the only "grave" these children shall ever have, the only record of their existence, and for many survivors, the only tangible remnants of their past.[33]

As the Tower of Faces installation insinuates, the task of mourning is compounded immeasurably when the deaths and the losses surpass the normal paradigm of a life that ended naturally. In "Mourning and Melancholia" from 1917, Freud discusses the work the ego undertakes to be "set free" from the lost one in order for "the loss of the object" to be "surmounted."[34] While the workings of both the identity card and the Tower of Faces involuntarily defy Freud's notion of mastery over the lost one, they do so in very different ways. The identity card acknowledges that it can never simulate the long and arduous processes of introjective mourning. Rather than giving up the lost loved one or the "object," as Freud's model for less severe or natural cases of loss suggests, the identity card project seeks its mock adoption. The Tower of Faces, however, sets up a soft barrier between the taking in of an analogized self and keeps its distance from the trespass of sites of deaths and identities that never had the luxury of being fixed. Strategically placed out of the visitor's reach, the photographs gather around them spaces of mourning without conclusion. Indeed, many survivors are still searching for conclusive links between the people they mourn and the actual circumstances of their murders—knowing names, dates, and death sites would make the indeterminate less unsettling.

Unlike the identity card project, which gets caught between performing as a pastiche history lesson and as a device for mourning, the similarly doubled obligation of the Tower of Faces acknowledges the riddled (im)possibility of mourning itself. Rather than miming the dual processes of mourning and drawing the viewer in through crucial yet overtly artificial identifications with the lost or traumatized Holocaust other as in the identity card project, in the Tower of Faces the dynamics between museum visitor and the mourned other are at once more modest and far-reaching. The hovering photographs in the Tower of Faces challenge the viewer's sense of precarious involvement in the terror and stage the entire apparatus to perform more as a fluctuating memorial rather than as a stable and self-assured monument. The piercing portraits bring into focus philosopher Emmanuel Lévinas's difficult formulations of facing, otherness, and alterity:

Figure 10. Zipporah Sonenson, 1926, in the Tower of Faces. Zipporah, Yaffa Eliach's mother, survived the Holocaust. After Liberation, on 20 October 1944, Zipporah and her infant son were murdered in Ejszyszki. Photograph taken by her father, Yitzhak Uri Katz. Courtesy of the Yaffa Eliach Shtetl Collection and the United States Holocaust Memorial Museum Photo Archives.

This incommensurability with consciousness, which becomes a trace of the one who knows where, is not the inoffensive relationship of a knowledge in which everything is equalised, not the indifference of spatial contiguity; it is an assimilation of me by another, a responsibility with regard to men we do not even know. The relationship of proximity cannot be reduced to any modality of distance or geometrical contiguity, not to the simple "representation" of a neighbour; it is already an assignation—an obligation, anachronistically prior to any commitment.[35]

Figure 11. Christian Boltanski, *Archives*, 1987, at Documenta 8, Kassel, Germany. Courtesy of the Marian Goodman Gallery, New York.

[3] *Between Trauma and Nostalgia: Christian Boltanski's Memorials and Art Spiegelman's Maus*

"This is not a Boltanski," I remember Martin Smith emphatically assuring me as he described the museum's plans for what was then alternately referred to as the Shtetl Wall and the Tower of Faces. Inversely, whenever I discuss the subject of this book with any of my colleagues knowledgeable about contemporary art, they invariably respond by presuming a proper place for the artist in my work: "Aha, then you'll be writing about Boltanski, won't you?"

Coming to understand the museum's disclaimer about Boltanski's artistic project and situating my colleagues' reasonable assumptions about the artist's alluring work are paramount to elucidating the anxieties and tensions the United States Holocaust Memorial Museum both exhibits and disregards in relation to its own theaters of history and stagings of empathy.

It is largely a result of the photographic work French artist Christian Boltanski produced in the middle to late 1980s—work that makes sometimes oblique and other times more transparent references to the Holocaust—that the critical discourse on the artist shifted from reading him as a conceptualist trickster toying with and effacing his and everyperson's autobiographies to projecting him as an artist of ethical stature whose ambivalence about documents, truths, and illusions could somehow be resolved through his own melancholy flirtations with history. The essays in the artist's retrospective exhibition catalog *Lessons of Darkness* (1988) collaborate uncritically with Boltanski in his attempt to project an authentic sense of identity.[1] *Authentic* in the case of Boltanski must be read in relation to his previous projection of self in the 1970s in France, in which he exhibited anonymous artifacts of childhood in ironic and humorous ways to thwart the idea that they could add up to an accurate or authentic recounting of his own childhood history. Work from the 1970s was included in the traveling exhibition in the United States and Canada; however, this

work is as much a representation of postmodern conceptual artistic activity in France during that period and critical commentaries on the presentation of history in art and ethnographic museums as it is any simple reflection of the artist's autobiography.[2]

It would be difficult to ignore Boltanski's past critical stance in relation to the possibility of knowing an other's history when considering the work from the 1980s, work that harbors an ambiguous and complex relationship to Holocaust memory. Lynn Gumpert's essay in the *Lessons of Darkness* catalog displays a wholesale acceptance of Boltanski as an authentic self, even while the artist explicitly negotiates his public persona. Here, Boltanski's family history (how are we to distinguish this from Boltanski's other histories?) is dramatically played out. As Boltanski disseminates his biography, his father was a Polish-Jewish Frenchman and his French mother a non-Jew. During the war, his mother and father staged an argument that resulted, they told their neighbors, in his father leaving the family.[3] In actuality, as Boltanski recounts his own Anne Frank story and in collaboration with how the exhibition packaged it, his father was in hiding in their basement for the duration of the war. In addition, the exhibition catalog as well as the exhibition's wall labeling claimed that Boltanski's supposed birth was on Liberation Day and that his middle name is "Liberté."[4]

Boltanski himself exploded these representations of self as Jew and victim in 1989 by proclaiming, after he began to use three thousand photographs of deceased Swiss citizens in his work, "Before, I did pieces with dead Jews but 'dead' and 'Jew' go too well together."[5] Art critic Nancy Marmer's reading of Boltanski's camouflage strategies targets the heart of the dilemma:

> In the past, Boltanski has frequently relied on the photograph's deceptive capacity to function as an "authentic" trace, a convincing souvenir, or personal experience. In the "Lessons of Darkness," he explores the photo's ability to also function as a trace of large historical events, and as a trope for tragedy. It is possible, at one level, to read these works as homages to the lost generation of nameless children who were the innocent victims of the Nazi's final solution—to see them as metonyms for Auschwitz or Treblinka. . . . But Boltanski's impoverished extra-church, secular-cum-sanctified icons can also be seen more generically as requiems for the adult's inevitably lost childhood. More narrowly, they can also be taken as sheer sentimental nostalgia for the artist's loss of his own infancy.
>
> But it is typical of Boltanski's ambiguous and ambivalent method ("J'affirme une proposition," he has said, "mais je démontre en même temps son contraire") that these readymade photo-works should also sustain entirely opposite and much colder readings—as, for example, modern parodies of the Christian's memento mori, or as icy warnings from a nihilistic and efficient maker of vanitas symbols. They may even be taken as self-consciously morbid

celebrations of, rather than laments for, the idea of death, and as perverse pre-sentations of fetishistic relics of the dead.[6]

Boltanski's overdetermined generalizations that conflate the whole of the Jewish person's or any person's identity with death and absence offer their own disclaimer that his work was never only about extermination, the Holocaust, or historical specificity. Indeed, at stake here is the ease with which Boltanski substitutes one projected history for another in his chameleon game of shifting photographies and histories. The artist's ma-neuvers would seem to delegitimize the photographic project of evidence within the larger arena of history. Boltanski's moves to reconfigure the photograph as a different kind of document and as an oblique testament would, indeed, present plaguing questions to the designers and planners also staging exhibitions at the Holocaust museum. Martin Smith's warning statement about the museum's Tower of Faces, "This is not a Boltanski," may distance the museum from the artist's representation of history. Yet it may also reveal what the two projects share in relation to their exhibition strategies employing photographed faces to solicit the viewer's empathy or inability to identify with the victims.

I open a discussion of Boltanski's work associated with the Holocaust with his own and others' disclaimers about its contradictory references in order to highlight its strategic ambivalence about the risks and presump-tions involved in acts of restorative naming. In doing so, I do not set out to curtail the possibility of reading his work as a harboring of Holocaust memory. Rather, I introduce some of the criticisms of his work to point out the dilemmas and the possibilities it raises about eliciting feigned pathos and risking turning specific historical memory into nostalgia to provoca-tively engage the past with the present and to implicate the contemporary viewer. This introduction, or intervention, is crucial before entering the lures of Boltanski's *Lessons of Darkness*.

Lessons of Darkness or *Leçons de Ténèbres* is the collective title for a body of work that includes *Monuments* (1985–86), *Archives* (1987), *Altar to Lycée Chases* (1986–88), and *The Festival of Purim* (1988). Each of these series of works begins with found group photographic portraits that Boltanski reshoots in varying degrees of legibility and re-presents both sparingly and claustrophobically within the art museum and gallery space. The photographs are reproduced from the everyday archives of grammar school group portraits and high school yearbooks, photographic conven-tions that oscillate between the generality of the group and the specificity of the individual. In *Archives*, first exhibited at Documenta 8 in Kassel, West Germany, in 1987, Boltanski covered rows of institutional metal grids

with 366 small black-and-white photographs encased in glass and edged with black tape (fig. 11). Lacking textual indication, many of the portraits appear to issue from the 1930s. There seems to be no unifying hinge between the people pictured except for the unstated reference to the time period. No unifying hinge, that is, until we discern a snapshot depicting an old man on a street corner holding up a puppy for a young boy. The boy wears the paper Star of David required of all Jews by the Nazis. The photograph rivets the viewer, demanding him or her to scrutinize the image in painstaking detail and similarly to reevaluate the entire archive presented for traces that would further reveal connections to the Holocaust. At the same time, Boltanski's seemingly random dispersement of images already begs the question of whether he accords any special significance to this photograph in relation to the many others.

In *Altar to Lycée Chases* Boltanski's photographic source is more direct and singular: a 1931 graduating class portrait from the Jewish high school in Vienna, Lycée Chajes.[7] In this series, he works from the group portrait, isolates each of the students' faces, and rephotographs them. Boltanski then proceeds to affix these second- and third-generation images onto impermanent supports, creating modest sculptural monuments that are both poignant and ironic. Everyday desk lamps become ominous interrogatory devices as their harsh light relentlessly glares over these now blurred and spectral portraits. In one of Boltanski's first installations recontextualizing this psychically and historically potent group portrait, he isolated eighteen close-ups from the twenty-four people pictured and enlarged each photograph to 23½ x 17¾ inches. Exhibited at the Museum of Contemporary Art in Chicago in 1987, they were hung on the wall with no other devices except the overhanging desk lamps with their cords falling singularly over each portrait (fig. 12). In other presentations of *Altar to Lycée Chases,* Boltanski has embellished on this spare and harsh presentation, employing rusty biscuit tins either to support the photographic images against the wall or to compositionally echo the weight of the portraits, standing in as their funereal counterparts. In subsequent installations, the obliteration of the faces from the lamps' glare became more pronounced, and the mass of intertwining gnarled cords became even more massive.

At his second exhibition at the Israel Museum in Jerusalem in 1989 Boltanski installed *The Festival of Purim,* a work based on a photograph of a Purim party held in 1939 at a Jewish school in Paris. Boltanski's usual overhanging lamps evoking torture sessions were replaced in this particular installation by a mass of small graceful lights attached directly to the wall that circle around seven close-up photographs of the children. A smaller photograph of picked roses lying on the ground is repeated three times in a

triangular composition echoing the presentation of the children's portraits. The delicacy of the electric votives is outweighed by the heaviness of the gnarled and chaotic cords that hang over the largest photographic portrait. Boltanski orchestrated a similar version of this setup in *Monument Odessa* (1989) (plate 3). Calling on similar emotive responses as those conjured up by the *Altar to Lycée Chases* works, the various installations of *The Festival of Purim* mercilessly elicit the viewer's pathos (fig. 13). These are children pictured, and the 1939 date of the photograph draws them even deeper into the horrific institutionalization of the Nazis' mass death campaigns. The photograph from which Boltanski worked, showing the children dressed up in costumes and indulging in merrymaking, may well document the last time they celebrated any holiday.

The haunting pathos of the children's faces conflated with Boltanski's reasonable presumptions about what happened to them circulates the work's painful poignancy. Yet it is the very presumptions they generate — their horrible fullness simultaneously coupled with hovering absences about the realities of the people's endurances and destructions — that taunt the viewer with uncertainties. The hovering identities implied in Boltanski's memorials, like the people who are pictured above and below the viewer's sight line in the Tower of Faces, evoke the impossibility of an accomplished mourning. Similar to the Tower of Faces, Boltanski's installations refute the strategy of facile identification between the viewer and the memory of the pictured. The artist rejects such a deception of intimacy and the assimilation of the other (incorporative mourning) in favor of a strategy that thwarts that closeness (introjective mourning). Through the impalpability of the face, Boltanski's photographic monuments mourn in respect for the impossibility of mourning the trauma.

This is not to claim that Boltanski's work only sets up its mirror of (mis)identifications in order to deflect the viewer's ability to identify with the pictured. What could happen in the case of a survivor literally identifying himself or herself through the blurred and appropriated faces? This in fact occurred in 1989 at which time Leo Glueckselig, a survivor who is also an artist, made himself known to Boltanski. He wrote a letter to Boltanski, which I quote in part below, leaving his grammar and spelling intact:

> Dear Mr. Boltanski,
> Last week, quite by accident I found an article in the New York Magazine about your exhibit in The Museum of Contemporary Art. It was accidently, because at this time, I am very busy myself preparing for a show of my own artwork, and have hardly time to look at magazines. A friend of mine just handed me this page, which he had cut out of the magazine. He had not the slightest idea of the surprise it would bring me. My interest was caught first

Figure 12. Christian Boltanski, *Altar to Lycée Chases* (Chases High School), exhibited at the Museum of Contemporary Art, Chicago, 1987. Courtesy of the Marian Goodman Gallery, New York.

by the theme "Children of Dijon" and also by the way you expressed yourself. Reading on I experienced an emotional shock, when the name of the jewish Gymnasium in Vienna came up . . . "Lycee Chase" and then furthermore, the discription that you derived the faces of the young people from a book about the Jews in Vienna. This and a few more clues convinced me, that the photo in question must be the one I had lent to the writer of the book (Die Mazzeinsel). This photo is one of the photos I saved into my exile. And yes—I am one of the kids—the one who to the disstress of our Director carried on with the two pretty girls in the last row. . . . I would like to mention, that after the invasion of Austria, I survived a few deadly incidents, including the Cristall Nacht. My fiancee, a jewish student from Poland got caught by the war in Poland, where she miracously survived the ghettoes. I also went through 3½ years of Army service all over the globe and experienced the unbelievable event to be reunited with her after nine Years. We are now together for 42 Years and have an "American" daughter in her early thirties. . . . Mr. Boltanski—I don't want this letter to be a fan letter, but a plain "Thank You Note" to an Artist, who succeeded to let his work speak by itself with dignity about events in which the victims had to live and die without it. I stood in the dark room of the "Lycee Chases" (what's the difference what name is used . . ?) and got in touch—touched again the fellow-lives of my youth and with them the whole period. I salute you.[8]

I do not employ this letter as proof of Boltanski's "success," but to highlight his picturing of victims outside of the traditional documentary

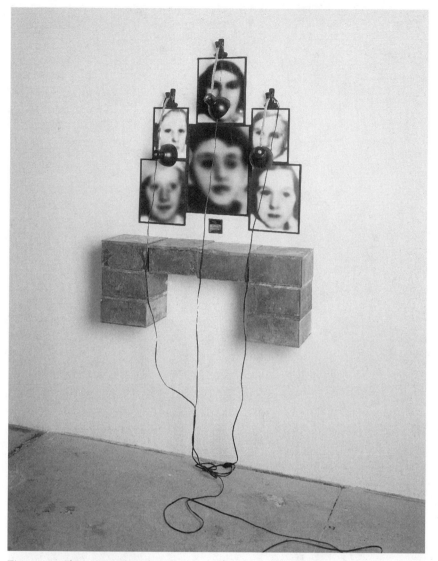

Figure 13. Christian Boltanski, *The Festival of Purim*, 1989. Courtesy of the Marian Goodman Gallery, New York.

photographic rhetoric of victimology. In his refusal to depict victims as victims, Boltanski's methodology challenges the documentary photograph's ability to function as an authentic document. He nonetheless needs the photograph as the basis on which to create a reconfigured photographic image that lives between the retrospective innocence of life before the Holocaust and the dehumanized image post-Auschwitz. It is perhaps no coincidence that after receiving this letter from Glueckselig, Boltanski embarked on a print portfolio project stripped of all sculptural elements.[9] Each page of the portfolio *Gymnasium Chases,* first exhibited in 1991, features a single

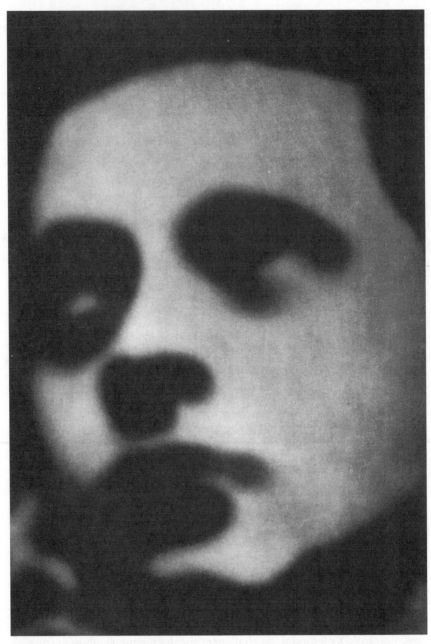

Figure 14. Christian Boltanski, detail from *Gymnasium Chases*, 1991. Print portfolio, 23¼" x 16½". Courtesy of Crown Point Press.

Figure 15. Christian Boltanski, *Gymnasium Chases,* cover page, 1991. Courtesy of Crown Point Press.

close-up face from the group portrait that includes Glueckselig and his high school classmates in Vienna (fig.14). Tellingly, for the first time Boltanski employs the high school group portrait in its entirety and without distortion. It appears as the cover sheet to the portfolio (fig.15).

Boltanski avoids directly using actual documentary photographs of Holocaust victims. To use such horrific imagery would be *sacrilegious,* the term Boltanski used in reference to artist Robert Morris's employment of death camp footage.[10] He opts instead for shrouding the unimaginable and keeping it almost secretive by relying on the site of the museum as a sacred space. Boltanski thus plays a slippery game: coaxing the viewer to both reaffirm her outworn faith in the museum as spiritual carrier and suspend her belief in the historical efficacy of the photograph. It is as if the artist wants to resurrect Walter Benjamin's description of the "cult value" and the "aura" of the work of art.

Despite the sometimes facile poignancy and predictability of Boltanski's uneasy monuments, the semiobliterated faces have a moving ability to trace the incomprehensibility of what they are made to stand in for. Remember Lévinas's acknowledgment of the other's face as a site of requested responsibility: "The face is present in its refusal to be contained. In this sense it cannot be comprehended, that is encompassed. It is neither seen nor touched."[11] Boltanski's opaque and imploring faces simultaneously embrace and evade the promise of ready-made remembrance and evidence. The faces of children and young adults, presumed to have been destroyed in the Final Solution, that he appropriates refuse to enact retrospective documentary gazes. Boltanski positions them to stand in as illegitimate witnesses—that is, as faces that have seen but cannot bear witness. They testify, nonetheless, that something has happened. It is not only the faces that complicate entrance into the space of alterity, into the vulnerable and demanding areas between self and other. The menacing wires that lacerate the space across the indistinct faces perform as retrospective traces of violence and challenge the Lévinasian concept of the face as epiphany, as a call to respond. Lévinas was aware of the difficulty of his call for the subject to respond to the other: "One can kill, annihilate. It is easier to annihilate than to possess the other."[12] But it is the face of the other that presents both the temptation and the resistance to murder. At their most potent, the subtly distorted faces of people who were presumed to have become Holocaust victims give oblique testimony and translucent immateriality to Lyotard's call to bear witness to the differend, to that "something which should be able to be put into phrases [that] cannot be phrased in the accepted idioms."[13] When his work performs most critically, Boltanski's duplicitous employment of the opaque faces is appropriate, in Lyotard's terms, to a postmodern witness-

ing that "denies itself . . . the consensus of a taste which would make it possible to share collectively the nostalgia for the unattainable."[14] Boltanski's mixed desire not to name or explicitly picture his evoked referent may well be appropriate to a move toward the formation of antimonumental memorials. It is an act toward circling around rather than smothering memory and the trauma of its representation.

Yet Boltanski's deceptive use of pathos to create identification between viewer and pictured and its simultaneous nullification make the approach to his work difficult and ambiguous. His photographic memorials negotiate documentary's dual status by making its riddled mandate the focus of his work. That is, his works intervene in photography's ability to document an authentic past and to function authentically as documents. One ramification of this strategy to create distrust between these two interwoven functions of documentary photography's assigned tasks would be to set a lure by which the viewer does not know that he or she is trapped. As Nancy Marmer commented, "Virtual exempla of the problematics of photographic transparency, these works challenge the medium's built-in claims to truth while simultaneously exploiting its documentary function. Thus, in part at least, they trade on deception."[15]

Boltanski's deceptions, however, are not completely fraudulent histories. Yet seen in relation to the austerity and historicity of the Tower of Faces installation, Boltanski's more obsessive arrangements seem almost kitsch. By likening Boltanski's work to the realm of kitsch, I am insisting here on its provocative references both to the sentimental and the inauthentic. In fact, the artist prides himself on his manipulation of pathos:

> ANYBODY who goes to my shows cries, from the cleaning woman to the curator. Some refuse, but most people respond. That is exactly what I hope for. Of course that could also be a criticism, that my art is heavy-handed, that I lay it on too thick. But I want to elicit emotion. That is difficult to say; it sounds ridiculous, unfashionable, but I am for an art that is sentimental.[16]

Boltanski animates both of these risky realms—the sentimental and the inauthentic—precisely to implicate the ease with which the viewer gets trapped in a universalized quasi-ethereal and quasi-somber nostalgia. Art historian and critic Donald Kuspit, one of Boltanski's easiest dupes, writes: "A strange transference occurs that is conducive to introspection as we search the faces in their twilight: we see the endless number of suffering people and discover ourselves to be among them—just another face in the crowd."[17] Kuspit's unwittingly cavalier response is almost welcome relief from the all-too-trusting accolades about Boltanski that invest in the faces as if they were knowable direct evidence.

It is precisely Boltanski's insistence on the viewer's awkward and often inauthentic responses and his emphasis on self-reflexivity that lay bare the difficulty of Lévinas's plea for responsibility toward the other. Yet Lévinas's demands on the subjects' (and the viewers') vulnerabilities and Boltanski's serious play on such responses critically differentiate their projects from the majority of the museum's photographic displays. True, the museum breaks conventional models by introducing the identity card project with its ploys of intersubjectivity and the Tower of Faces with its intervention in the traditional picturing of the Holocaust through dehumanized bodies. But the methodology underlying the mass of the permanent displays coyly pretends not to admit to the impossibility of comprehending the massive and horrific realities or of confronting the near-obscenity of speaking for others. If the Holocaust museum's photographic trials are caught between performing as history lessons and providing sites for sharply circumscribed mourning, Boltanski's memorials invest heavily in a wrenching complicity between mourning and photography, leaving specific historical relations hovering within and outside the frame.

In an interview with Georgia Marsh published in 1989, Boltanski responded to a question about the various reactions his work elicits in different countries and cultural contexts. It is a condensed, circular indication of his strategies:

> In the United States or in Israel people make a lot more of the association with the Holocaust, which is not true because my work is not about the Holocaust. In *Les Enfants de Dijon*, for example, I asked 200 children for their photographs and made a permanent installation of them in Dijon. Twelve years later, in 1985, I worked with these same photos again, since these children were now dead: not really dead, but my images of them were no longer true. The children in the photos no longer existed, so I decided to make a monument to the glory of childhood now dead. In New York, absolutely everyone interpreted this piece as being photos of dead children in the concentration camps. And yet they were obviously children of the '70s, little French kids. In Germany, where people tend to deny those things, people will not see that, or will see it to a lesser degree. Everyone sees what they want to see. I did a piece at the last Documenta in which the walls were covered with the kind of metal grid that one finds in the storerooms of museums, and on it I hung all the photos I had used during my artistic life, even some personal pictures. So there were about 800 pictures hung in a wire cage in a little room about three meters by two meters. I called it RESERVE. All the Americans who saw it, saw a gas chamber. Now, naturally, that wasn't completely absent from my thoughts either. But it was in no way indicated. I have never used images that came from the camps, it would be impossible for me, it would be something too shameful to use, too sacred. My work is not about the camps, it is after the camps. The reality of the Occident was changed by the Holo-

caust. We can no longer see anything without seeing that. But my work is not about the Holocaust, it's about death in general, about all of our deaths.[18]

There is in this philosophy a strange commingling of bad faith and utter solemnity. The bad faith surfaces in his mutual amusement and disconcertment that "in New York, absolutely everyone interpreted this piece as being photos of dead children in the concentration camps." Boltanski elicits such correlations by exhibiting works like *Les Enfants de Dijon* and placing them in close proximity with the works I previously described that are, in fact, based on group photographs from Jewish schools in the late 1930s. "My work is not about the camps, it is after the camps. The reality of the Occident was changed by the Holocaust. . . . But my work is not about the Holocaust, it's about death in general, about all of our deaths." In the 1989 installation of *Lessons of Darkness* at the Israel Museum, the exhibition catalog echoes Boltanski's interpolated assertions and denials. The catalog opens with a framing quotation by Milan Kundera:

> Not long ago, I caught myself experiencing a most incredible sensation. Leafing through a book on Hitler, I was touched by some of the portraits: they reminded me of my childhood. I grew up during the war; several members of my family perished in Hitler's concentration camps; but what were their deaths compared with the memories of a lost period in my life, a period that would never return?

Boltanski's overdetermined conflation of death, loss of memory, and the passing of childhood with the Holocaust revives the most troubling aspects of Roland Barthes's collapse of photography into a facile equation with mortality and death.[19] Boltanski's *Lessons of Darkness* unwittingly teaches us that a Barthian fascination with conflating almost any photographic memory and pseudoartifact with the cult of the dead yields little space for elucidating the differences between single natural deaths and mass death.

Yet Martin Smith may have been right to have feared associations between the Tower of Faces and Boltanski's duplicitous photographic installations. The generating dynamic in Boltanski's photographic monuments oscillates between veiling specificity and giving way to its evocation. Documentary photography creates a tense metonymy between the particular and the general, the intimate and what is made public. Tension around determining how much violation to make public and finding the right means to depict it undergird the working philosophy of the museum's permanent exhibition team. The museum's internal conflicts around specifying the horror and generalizing it surface in the Tower of Faces, especially in the case of the

names the permanent exhibition planners had considered for Yaffa Eliach's reassembled photographic archive. The name "Shtetl Wall," which was the term used in the planning stages of the Tower of Faces, signals an acknowledgment of the vibrant community that existed for centuries before the mass murders as well as an accession to the very material specificity of how the Jews of Ejszyszki were brutally ghettoized, separated, and murdered. Conversely, calling the installation the Tower of Faces implies a transcendent universalizing. As Eliach herself protested, "It's not a tower of faces, it's a tower of life."[20] One recent reading of the Tower of Faces criticizes it on grounds similar to those often directed at Boltanski's memorials: "These people are not represented as individuals, but as unidentified members of a local state: they remain nameless. Nothing is revealed about them except their collective status as victims."[21] Indeed, even Ralph Appelbaum, whose design firm directed the staging of the permanent exhibition at the museum, called the faces "dumb."[22] Appelbaum's acknowledgment of the photographs' inability to speak, however, is harbored within the utter specificity of everything that surrounds the portraits. Their ability to poetically evoke the terror is absolutely necessary within the overall framework of horror the museum represents. The muteness pronounced by the Tower of Faces is nonetheless successfully balanced by the vividness of the photographic portraits of a specific community as well as by the somberness conveyed through their accumulation. If the museum too easily effaces the heterogeneity of twentieth-century Jewry, as aspects of Boltanski's *Lessons of Darkness* do—a conflating and erasing of identities crucial to the Nazis' strategies—a closer look at the portraits in the Tower of Faces reveals distinct differences among economic, class, and religious backgrounds of the Ejszyszkians.[23]

Boltanski's memorials are permeated with a feigned pathos and an uneasy nostalgia that hover between the mythic and the historical. His strategy relies on the absence-presence tension of actual photographic documents of people who most probably perished. This working method is designed to obscure the photograph's status as evidence in favor of its function as a memento mori. The fact that Boltanski's chosen arena for the display and dissemination of his work is the art museum underscores his ambiguous challenge to the divisions traditionally deployed between documentation and aesthetics. His work creates anxiety about the necessity of formulating new kinds of documents, the difficulties of documenting victims of the Holocaust, and speaking in the name of others.

Art Spiegelman's remarkable *Maus* comic books are also invested in articulating the necessary tensions between documentation and aesthetics, but

his artistic approach integrates historical specificity into representing the Shoah. Although Boltanski pictures and sometimes gives names to his reconsidered subjects, his strategy relies on a dumb faith in and simultaneous canceling out of the human attraction to physiognomy. In contrast with Boltanski's blinding focus on the face, Spiegelman's pictorial approach levels all specific human characteristics—Jews are mice, Nazis are cats, Poles are pigs—in order to paradoxically open a path for the viewer/reader to identify with the characters as human beings. This seemingly childlike and indifferent pictorial strategy is especially provocative. To reiterate and literalize genocidal stereotypes is at once to risk reinscribing racist labels. In *Maus,* however, Spiegelman ironically employs animal characters to create anonymity around the very peoples Hitler massed together. He then allows the characters to live out the real stories by acting like the animals they are depicted as or by symbolically breaking free from their masks. By refusing to give specific facial traits to the victims, perpetrators, and collaborators, the artist also blocks contemporary readers from trying to identify them with particular ethnic characteristics. He subtly reminds the reader that racist marking and labeling are not things of the past. Strategically, then, Spiegelman refuses mere identification with the face.

Boltanski's employment of faces also begs the viewer to refuse mere identification: the mirror they hold up substitutes reflections of the self for blind spots about the other. But when it comes to the self-consciousness of the maker, Boltanski plays a game of hide-and-seek. Spiegelman's *Maus* books resonate with the artist's self-consciousness about his project. And if Boltanski's uneasy negotiations display references to others, Spiegelman's doubled narrative is invested from the start in alterity. Spiegelman's journey into the self, others, and the incommensurable histories occurs through his father Vladek's travails, painfully yet fluidly conveyed in the son's allegorical comic book tales. His "Survivor's Tale," the subtitle of his acclaimed books, is the coterminous bearing witness of Vladek Spiegelman's survival in and after Auschwitz and the son's bearing his father post-Auschwitz. It is also Art Spiegelman's attempt to approach the absence of his mother, Anja, whose pain and suicide bleed beneath every story in the two *Maus* books.

Saul Friedländer offers the act of self-aware commentary as a way to guard against facile explanations of the Holocaust while striving toward historical linkages. The necessity for commentary, as he describes it, underlies cartoonist Art Spiegelman's allegorical chronicles in his *Maus* books:

> The commentary should disrupt the facile linear progression of the narration, introduce alternative interpretations, question any partial conclusion,

withstand the need for closure. . . . *Working through means confronting the individual voice* in a field dominated by political decisions and administrative decrees which neutralize the concreteness of despair and death.[24]

Spiegelman's books *Maus: A Survivor's Tale. I. My Father Bleeds History* (1986) and *Maus: A Survivor's Tale. II. And Here My Troubles Began* (1991) tangle remarkably well with the dilemma of confronting the enormity of the events through chronicling and documenting while allowing the individual voices of survivors to puncture through the linear narrative.[25] At the same time, Spiegelman's orchestration of his risky venture guards against an assimilation or a reconciliation between the worlds of the past, of Auschwitz, and that of his father Vladek's guarded present in Rego Park, New York. The comic book format of his tales signals that the world of the Shoah turned reality inside out. Spiegelman uses the term *realistic fiction* to refer to his approach:

> Although I set about in *Maus* to do a history of sorts I'm all too aware that ultimately what I'm creating is a realistic fiction. The experiences my father actually went through, there's what he's able to remember and what he's able to articulate, and what I'm able to put down on paper. And then of course there's what the reader can make of that. *Maus* is so many steps removed from the actual experience, they're so distant from each other that all I can do is hint at, intimate, and try for something that feels real to me.[26]

Spiegelman's self-conscious and self-critical commentary about the discrepancies between his father's ability to witness and his inabilities to translate that witnessing nonetheless weighs toward the reality of the events. So much so that when *Maus* appeared on the *New York Review of Books* list under the category of fiction, Spiegelman insisted that it be switched to the nonfiction list. Indeed, the Pulitzer Prize committee invented a special category for *Maus,* suggesting the impossibility of categorizing it as either "fiction" or "nonfiction."[27] Yet it is the very differences between these genres and how they dovetail with the extraordinary testimonies of the Shoah that make *Maus* so compelling. In *Maus,* Spiegelman constantly brackets his self-reflexivity and the difficulty of the project. The opening pages of the second book find Spiegelman musing to his wife, Françoise, "Just thinking about my book. It's so presumptuous of me. I mean, I can't even make any sense out of my relationship with my father. How am I supposed to make any sense out of Auschwitz? of the Holocaust?" (14). And then he creates another puncture in the narrative, saying to Françoise, "You'd never let me do so much talking without interrupting if this were real life" (16).

The modest format of Spiegelman's comic books encompasses anti-

Gargantuan journeys through his father's account of his wife's and his own survival, the son's historical research in archives and at the sites of genocide, and the results of these arduous stories after the artist has edited, translated, and combined them with images. The *Maus* books are propelled by Spiegelman's interweaving desires to convey his parents' stories as accurately as possible through Vladek's memories, to give further historical and contextual framings to his father's testimony, and to put himself into the picture. What makes *Maus* so moving for many different kinds of readers is the way Spiegelman heightens the value of anecdotes his father offers about the past as well as the present, anecdotes that seem to have no direct bearing on the Holocaust. For instance, in the beginning of *Maus I*, the first sense of himself from the past that Vladek gives to his son is how he was a playboy before meeting Anja. In Vladek's words, "People always told me I looked just like Rudolph Valentino." Such a carefree and ultimately humorous representation contrasts sharply with the very opening of the book, in which Vladek responds to his son's tears after being left behind by friends: "Friends? Your friends? If you lock them together in a room with no food for a week, then you could see what it is, friends!" For Spiegelman, such stories are important precisely because they give the texture and detail of human idiosyncrasy as much as they lay out the foundation of his life. These everyday banalities and richnesses are offered with humor, often biting irony, which is what distinguishes the *Maus* books from more traditional firsthand memoirs of the Shoah. The inclusion of lighter moments of sheer living before Auschwitz and its perplexing aftereffects helps carry the weight of the unbearable historical realities.[28]

I focus here on Spiegelman's employment of pre-Holocaust family photographs and their different levels of realism because they create a heightened leitmotif to the focus of the artist's approach throughout the tragic tales. Spiegelman's spare and powerful use of his parents' pre-Holocaust family snapshots and studio portraits demonstrates how documentary material can, paradoxically, be made more accessible through more intimate modes of representation in the reconstruction of Holocaust history and memory. They also provide an eerie shadow ground in signaling the ways the traumatic past always intrudes on the present. *Maus II* opens with a dedication to Richieu, the first son of Spiegelman's parents, who perished during the Holocaust, and to Nadja, the artist's daughter and first child. This dedication is accompanied by an arresting photographic portrait of Richieu (fig. 16). He appears as a beautiful child with full sensuous lips and deep almond-shaped eyes. This is a portrait steeped in sorrow, at once dreamy and vivid, a photograph that has come loose from its time frame and reaches across the abyss of the unimaginable with its profound

FOR RICHIEU

AND FOR NADJA

Figure 16. Dedication page, Art Spiegelman, *Maus II: A Survivor's Tale*. Copyright 1986, 1989, 1990, 1991, by Art Spiegelman. Reprinted by permission of Pantheon Books, a division of Random House, Inc.

presence. It tantalizes the contemporary viewer. As the mother of a child who resembles Richieu in this photograph and who was about his age when I began this book, I am stricken by the utter sadness of this image. If it is excessive self-projection or displaced sentimentality that fuels my familial bond with Richieu's sublime portrait, Spiegelman invites such responses. His careful manipulation of empathy redefines the customarily trivializing notion of sentimentality. The sobering innocence and devastating power of this image challenge the tendency of the family snapshot to romanticize the past. Particularly in this case, Richieu's portrait lacerates sheer sentimentality because the boy's life itself was cut short. This photograph is suspended interminably between the past and the viewer's and Spiegelman's ability to memorialize Richieu in the present. Richieu's simultaneous presence and impalpability haunt the ensuing tale of Vladek's survival in and out of Auschwitz as the image hovers almost defiantly between this story and that of precamp life retold in *Maus I,* dedicated, tellingly without an image, to Spiegelman's mother, Anja.

At the United States Holocaust Memorial Museum the narrative opens, too, with the creation of a fellow ghost traveler and a mirror imaging through the identity cards. Yet this mirroring already exists intrinsically for Spiegelman through the image of his would-be brother Richieu. By introducing the massive history through the singularizing dynamic of a named portrait, both *Maus* and the identity card invest in the reader's empathy to navigate through the overwhelming historical realities of the Holocaust. It may be somewhat askew to compare the very different genres of a sustained (auto)biographical narrative with highly condensed museum and gallery installations that largely employ stylized texts and rephotographed documentary images. The point here is not so much to compare but to repose crucial questions about the role of the photographic portrait as reconfigured bearing witness in relation to Spiegelman's remarkable ability to approach and make approachable the horrific reality of Holocaust experiences. In this sense, the photograph of Richieu thus becomes the shifting marker for the cruel intersection between intimate and historical memory as well as the figure for Art's discomfort with his storyteller's role as distant brother and second son.

Mismatched family dynamics and impossible mirrorings are played out immediately after the reader encounters Richieu's arrestingly beautiful photograph as it stands silent guard over the ensuing story. The opening text situates Art and Françoise rushing from their interrupted vacation in Vermont to comfort the ailing Vladek in Rego Park. During the drive, Art tells Françoise that when he was a kid he used to think about which of his parents he would let the Nazis take to the ovens: "If I could only save one

of them, usually I saved my mother. Do you think that's normal?" These unanswerable childhood memories lead Art to musing about Richieu: "I didn't think about him much when I was growing up. He was mainly a large, blurry photograph hanging in my parents' bedroom. . . . The photo never threw tantrums or got in any kind of trouble. It was an ideal kid, and *I* was a pain in the ass. I couldn't compete." Tellingly, the very last page of the *Maus* stories shows Vladek recounting the particularly cathartic if not romanticized account of how he was reunited with Anja after the war. In the frame that closes the book, Art unfolds the telling of the past as a translucent page that inevitably covers over the present. His father confuses him with his first son: "I'm tired from talking, Richieu, and it's enough stories for now."

Maus ultimately deflates and then renders more intimate the desire to personalize history, which at the museum often occurs through infantalizing complex personal histories. If Richieu remains suspended in angelhood, it is not in the realm of the identity card's misdirected nostalgia or through the quasi-mythic proportions of Boltanski's faces. Spiegelman weaves Richieu's portrait into an appropriate realm of otherworldliness—a space outside of everyday experience—and into a past life that Art can barely gain access to, a life that also enframes him. Richieu's photograph both taunts Art's guilt and haunts him with despair. As he tells Françoise: "It's spooky having sibling rivalry with a photograph" (*Maus II*, 15).

It is the witness himself, the one whose story is fashioned through the artist-son, who undoubtedly escapes the hold of the photograph's difficult nostalgic arrest. The "heritage" of the Holocaust, its devastating legacy, is utterly confused within the person of Vladek, whose story is translated through Art. Art worries that he is exposing his father to a double violation through *Maus* by allowing the interpolated personal and historical narratives to reveal his father's sometimes stinginess, impossible demands, and egotism. Was it the Holocaust that did this to his father? he queries in companionship with so many children and other survivors of survivors. Even Vladek's second wife, Mala, reminds Art that many survivors came out of the event without being like his father. Spiegelman must ask such questions because it is he who transfers the crimes against humanity from the Nazis to his father, screaming "Murderer" at him in the last frames of *Maus I*. It is at this point in the story that Art finally finds out that his father, in a confused and depressed state following his wife's suicide, destroyed Anja's diaries and notebooks. His father is guilty of murdering his son's memory of his mother and killing the possibility that Art could enter into and translate Anja's experiences. This longing adds another underlying leitmotif to the book and hinges the father's fluid and vivid accounting with the meta-

levels of how the story is issued forth from the son in memory of the silent writing mother. If as a boy Art imagined saving his mother from the ovens, *Maus* relives this psychic performance and thus buries his father alive through Art's vain search for Anja's memories.

Photographs surface cautiously and through different orders of representation in Art's tale. The first reference to a photograph of his mother occurs when Vladek tells Art about his courtship with Anja (*Maus I*, 17). Unlike the frontispiece photograph of Richieu, this is not a reproduction of the actual photograph but Spiegelman's drawn re-presentation of it designed to fit with the markings and mood of the comic book renditions. This analogy of the original snapshot, complete with its drawn ragged edges, is treated like an object that sits outside the frame of the continuous narrative occurring around and beneath it. Vladek rides his exercise bike as he tells Art, "And then she started writing to me such beautiful letters— almost nobody could write Polish like she wrote." Writing and the forsaken mother form an alliance in the son's and the father's minds. Letters and the relay of writing are again bound together in the next photographic reference. In 1938, soon after Richieu was born, Anja suffers a mental breakdown and her parents arrange for her to recover in a posh sanitarium in Czechoslovakia with Vladek. As the two take a stroll on the grounds, Vladek tells Anja that they received a letter from home with a photo of Richieu. But the reader never sees an image; Richieu's photograph is represented by Vladek's words: "He's a handsome boy. Just like his father, yes?" Anja responds sweetly, "Yes." This reference seems casual, an unremarkable anecdote within the larger series of his father's memories. Yet this is a highly filtered tale through which Spiegelman made calculated choices. Why is this little story about receiving a photograph of Richieu so important here? The photograph of her son calms the mother, helps keep her intact. This little story of psychic communion between mother and first son through Richieu's portrait is the antithesis to Art's broken bond with his mother.

An actual photographic likeness of Anja appears only once in *Maus*: a lakeside vacation snapshot of Art with his mother from 1958, which was reproduced within an earlier cartoon he made about his mother's suicide, "Prisoner on the Hell Planet: A Case History" (fig. 17). In this photo, Anja reluctantly faces the camera and places her hand on her kneeling son's head; he grins unabashedly. Spiegelman reprints this strip within *Maus* at the historical point where the roundup of Jews is under way and his mother's and father's families are desperately trying to make survival plans (*Maus I*, 100–103). To delineate the telling of this trauma within the larger narrative, Spiegelman has deleted page numbers and replaced them with black borders. In Spiegelman's present within the narrative, he is also

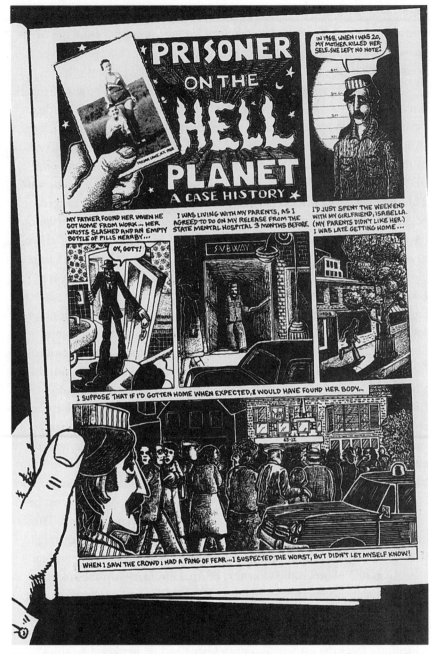

Figure 17. Art Spiegelman, *Maus I: A Survivor's Tale,* 100. Copyright 1973, 1980, 1981, 1982, 1983, 1984, 1985, 1986 by Art Spiegelman. Reprinted by permission of Pantheon Books, a division of Random House, Inc.

involved in a desperate and futile search: to find among his father's junk his mother's journals. But it is Vladek who comes across a startling find: Art's comic strip, which originally appeared in an obscure underground comic book. "I never thought Vladek would see it," Art cautions. Vladek indeed finds it and tells his son, "I saw the picture there of mom, so I read it . . . and I cried" (*Maus I*, 104). The photograph in this case presents the possibility of a site of mourning and of reconciliation. Reconciliation between father and son, yes. But also the desire to link together the estrangement between the photograph's obscured vibrancy, the "proximity with distance" of his mother's presence with the absence of any suicide note. Again the abyss of the mother's writing surfaces. Held between Art's fingers, the photograph is reproduced within the title frame. In the following box opening the strip Art is pictured in a mug-shot pose wearing the striped concentration camp outfit. He says, "In 1968, when I was 20, my mother killed herself. She left no note." The photograph is not allowed to be a mere nostalgic marker. Indeed, Spiegelman undercuts this possibility at every turn. For instance, after Vladek tells Art he read "Prisoner," he says, "It's good you got it outside your system. But for me it brought in my mind so much memories of Anja." Immediately after this, Mala, his second wife, reprimands him, "Yes, you keep photos of her all around your desk—like a shrine!" (*Maus I*, 104).

Some photos, however, Vladek covets. Toward the end of *Maus II* he presents them to Art: "I put here a box what you'll be happy to see. I thought I lost it, but you see how I saved!" An incredulous Art cries out, "Mom's diaries?!" "No, no! On those it's no more to speak. Those it's gone, finished." The denouement of the mother's lost journals inaugurates the outpouring of the family snapshots. Here the stories about Anja's family that Vladek had been recounting throughout the historical narrative become more raw, tender, intimate. Indeed, these three pages where the pseudo-depiction of photos overwhelms the frames are potentially the most psychically charged in the book (114–16), competing on a level of poignancy where the horrific retellings elsewhere arrest the senses more brutally. It is as if the reader forgets he or she is looking at anonymous little mouse faces, an approachable artificiality brought to a consummate level of understaged humor. For instance, Vladek tells Art that Anja always thought her second son resembled her commercial artist brother Josef (fig. 18), although they appear identical through Spiegelman's ironically homogeneous drawings. Spiegelman exploits other photographic clichés in this tight sequence, including blocking out the faces of people later deemed inadmissible to the family archive, such as one of Josef's girlfriends who was said to have liked money too much (fig. 19). These mundane moments

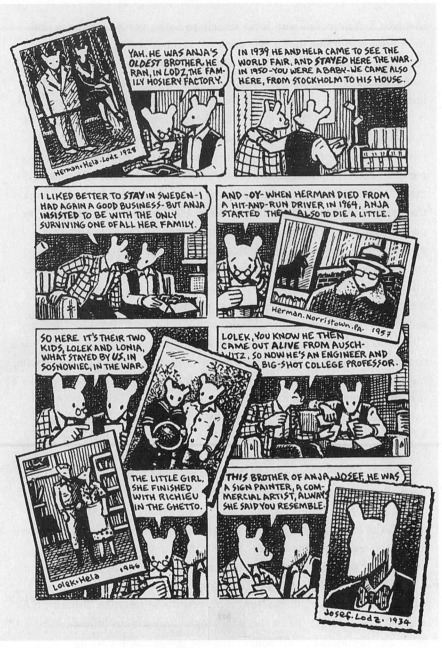

Figure 18. Art Spiegelman, *Maus II: A Survivor's Tale,* 114. Copyright 1986, 1989, 1990, 1991 by Art Spiegelman. Reprinted by permission of Pantheon Books, a division of Random House, Inc.

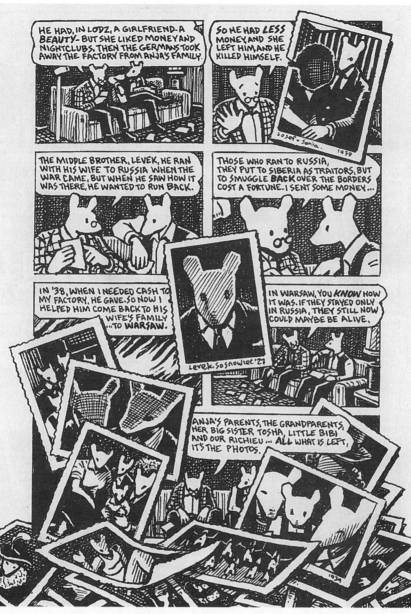

Figure 19. Art Spiegelman, *Maus II: A Survivor's Tale,* 115. Copyright 1986, 1989, 1990, 1991 by Art Spiegelman. Reprinted by permission of Pantheon Books, a division of Random House, Inc.

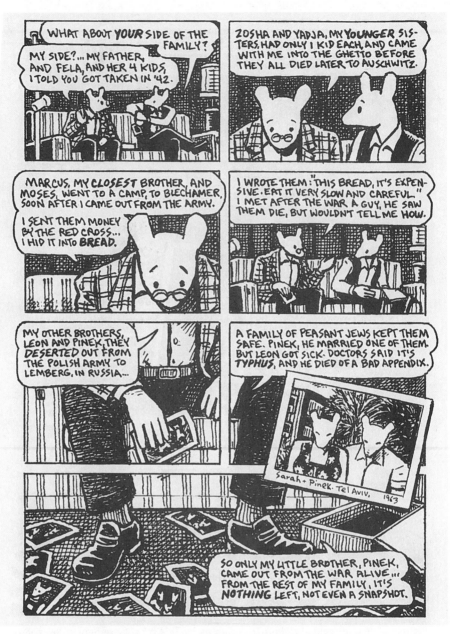

Figure 20. Art Spiegelman, *Maus II: A Survivor's Tale*, 116. Copyright 1986, 1989, 1990, 1991 by Art Spiegelman. Reprinted by permission of Pantheon Books, a division of Random House, Inc.

of photographic culture help carry the most difficult stories into representation. Vladek tells Art about his mother's only surviving sibling, Herman, and his family: "So here it's their two kids, Lolek and Lonia. . . . the little girl, she finished with Richieu in the ghetto." After Vladek has no more stories to tell, his arms hanging despondently, he concludes, "All what is left, it's the photos." About his family he tells Art, "So only my little brother, Pinek, came out from the war alive . . . From the rest of my family, it's nothing left, not even a snapshot" (fig. 20). This dense photographic encounter creates a profound if fleeting intimacy between father and son, as well as a strange and difficult handing down and letting go of the memories told through the family photographs. This section concludes with Vladek's handing over the photos to Art. But the giving is not complete; Vladek insists on keeping the cigar box.

Vladek is represented only once through the reproduction of an actual photograph. It is soon after the war and he is trying to make contact with Anja. He sends her a strange portrait; he appears healthy yet is dressed in a camp uniform (fig. 21). Vladek tells Art that he "passed once a photo place what had a camp uniform—a new and clean one—to make souvenir photos." For Spiegelman, this is the single most staggering photograph of all those among the few in his family's archive.[29] Under the guise of a souvenir, it is particularly *peculiar,* the word Spiegelman used to describe it, because his father appears so jaunty, so robust, so much like Rudolph Valentino, as his father described himself earlier in the *Maus* stories. Vladek's full appearance is actually due to swelling from the complications of illnesses left in his body from his ordeals in Auschwitz. As is the case in the earlier scene where Vladek presents Art with family snapshots of relatives who perished, this eerie portrait was presented to Spiegelman, as he characterized it, neither in the spirit of offering nor withholding. This photograph presented a riddle for Spiegelman; he wasn't sure what he could learn from it. Tellingly, Spiegelman represents this photograph as more unreal through its realism than the pseudophotographs of the family rendered through cartoon drawings in the earlier sequence. The uncanniness of Vladek's portrait joins with the incommensurability of the frontispiece photograph of Richieu, which disconcertingly returns on this page. Visible in the background of the frame immediately next to Vladek's otherworldly portrait, Richieu's image is now represented in cartoon form, signaling its momentary assimilation into the world of the living. Despite the way that Richieu's portrait looms over Art's childhood and adult life, it nonetheless achieves a mocking semblance of normalcy, a normalcy that Vladek's portrait implacably refutes. Tellingly, Vladek's photograph turns out to be that which is the most staged in *Maus.*

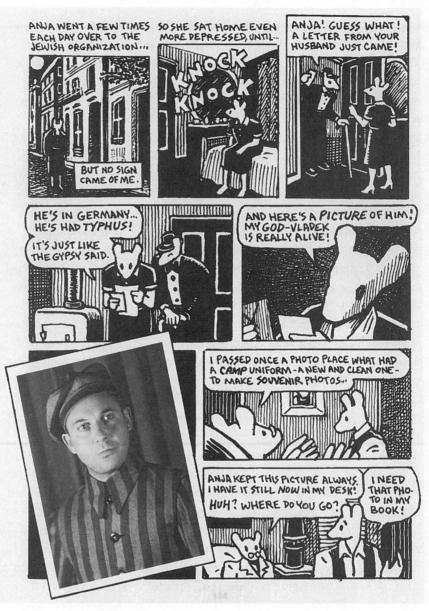

Figure 21. Art Spiegelman, *Maus II: A Survivor's Tale,* 134. Copyright 1986, 1989, 1990, 1991 by Art Spiegelman. Reprinted by permission of Pantheon Books, a division of Random House, Inc.

Within *Maus*'s different photographic registers, it is crucial that no photograph of the artist feigns his presence on the book jacket. To complete the comic book's compelling narrative realm, Spiegelman appears as a man in cartoon form wearing a mouse mask. He does not hide that he is the liaison between the realm of the present and that of the trauma. Indeed, the only times that real photographs are employed—that is, as photographs from reproductions and not drawn—are to provoke the irreality of the zone between the present and the Holocaust world, in Jean Améry's words, "le monde concentrationnaire."[30] Reproductions of actual photographs appear three times: the piercingly beautiful portrait of Richieu at the opening of the book, the disarmingly poignant snapshot of Anja and Art at the lake inserted within the fractured mosaic of her suicide, and the strange "souvenir" portrait of Vladek toward the end of the book. All three photographs are family portraits of the people whose lives and their unraveling are the most intimately and intricately linked to Art's coming to uncertain terms with the repercussions of the events. Yet they are also the people Art least understands, from whom he feels most estranged. Thus their representations appear uncannily unrelated to the two realms of memory—past and present—that are inscribed and described in the continuous narrative. Spiegelman also insists on their status as actual photographs and not cartoon depictions because of the necessity to distance and differentiate them from the realm of tellable, albeit horrific, events. In *Maus* the entire realm of representation is turned upside down or, rather, inside out. Indeed, the comic book format maintaining the structure of *Maus* stands in for what documentary photographs usually narrate. The family snapshots act as counterparts to the extraordinary documentary photographs. As such, their intense and paradoxic realism creates respectful memorials to the inaccessibility of the other's experiences. These portraits function as markers of traumatic never-forgetting and could thus only be staged as strange harborings from an irretrievable other world.

Spiegelman's use of his mother's and father's precious few photographs creates another level of arrested reality within his already personalized and interweaving narrative. If we remember the museum's hope for the identity cards, their small-scale close-up portraits also attempt to cut across the relentlessness of the historical stagings in order to restore a humanity to the victims, to "personalize" history, as Martin Smith put it. Yet Spiegelman's photographs and interrelated narrative story are not emphasized to tell a moral tale. In Washington, D.C., one of the goals of the linear narrative is to reduce the awful complexities and piercing intimacies to a celebration of good over evil in the name of the Americans as liberators. However,

Lawrence L. Langer, in his *Holocaust Testimonies: The Ruins of Memory*, points out that for survivors the moment of liberation is a zone "inverting the order of conflict and resolution that we have learned to expect of traditional historical narrative."[31] Asked to describe his feelings at the time of the liberation, one of the survivors Langer interviewed responded, "Then I knew my troubles were *really* about to begin." *Maus,* too, modestly reveals the sham of more linear and celebratory endings. One of the last sections in *Maus II* representing the liberation of Auschwitz begins with the heading, "And Here My Troubles Began."

The autobiographical genre that is *Maus* does not attempt to tell an all-inclusive or comprehensible history; its specificity cross-sections and participates in its incomprehensibility. Indeed, the comic book format holds many advantages over a staged three-dimensional presentation of Holocaust events.[32] It must be noted, however, that by employing a cartoon format rather than the false mimesis of actual photographs, Spiegelman already pardons himself from the difficulties of exhibiting horrific documentary images as well as the "Holokitsch" of strained empathy.[33] With the book in hand, the reader is drawn into the mimed realism through the narrative in a personal way; one is held captive, so to speak, by a miniaturized artificiality that intimately overwhelms the participant. The book genre does not have to contend with the horrific mismatching between events and their re-creation, a difficult task borne by the museum.

[4] *Artifactual Witnessing as (Im)Possible Evidence*

What if we think of Richieu's tender, piercing photographic image not only as the wrenching trace of mourning, but as the mute site that marks the impossibility of understanding the stories over which it stands guard? The museum, too, through its intimate photographic mode of approach and in its more insistent desire to "establish the physical reality of the Holocaust" reigns over the palpable inaccessibility of its historical trauma.[1] The museum's foundation literally lies over earth that has been infused with ashes collected from the Bergen-Belsen extermination camp and other sites. Indeed, the elaborate staging of the museum in its entirety is built over a set of oscillating presumptions and dilemmas to tell the untellable, "to *be* the story and to repeat its unrepeatability."[2]

Yet the enormous burden of the human face cannot possibly carry the entirety of the events. Employed as intimations of impossible mourning in the identity cards, the photographed faces strain the viewers' empathy and beckon them to open their consciousness. They work as barriers between the awful retelling and the viewers' inabilities to house the histories they abbreviate. The photographs in the Tower of Faces mediate and punctuate the unfolding linear narrative; they intervene in accounts of inevitable victimization through the normalcy of the everyday acts of joy they enframe. They give something to hold on to, to embrace. The photographed faces are staged as partial risks based on the fragile dynamics of self-investment and self-effacement. Retrospective witnessing as it is attempted through photographic stagings at the museum—and for that matter, as it is mimed in Boltanski's installations—revolves around and depends on the viewer.

The presence of actual artifacts within the museum's realm of re-creation parallels and augments the work of the photograph. With artifacts, the museum is in the business of exhibiting fragments of raw history wrenched from the authentic sites of destruction. Thinking photographically,

I question what the museum's displaced stagings try to achieve. Are they attempting to mirror the realities, to act as supplements to the losses they stand in for, or do they function as barriers to the events? The artifact intrudes in the realm of the present through its hyperreality, through the utter concreteness it signals. It brings one closer to the historical real, supposedly closer to the tangibility of the events and to the experiences of those who did and did not survive.

The freight car of the fifteen-ton Karlsruhe model stands gaping in a corner space on the third floor of the permanent exhibition (plate 4). It is a frighteningly quiet space for the deafening horror of its pronouncement. The railcar, with the coy innocence of its provenance, "Donated by the Polish State Railways," once transported people to the Treblinka death camp. The provenance label and text accompanying this artifact state:

> Most deported Jews endured a tortuous train journey to death camps in bare freight cars, under conditions of hunger and thirst, extreme overcrowding, and horrible sanitation. In winter they were exposed to freezing temperatures, and in summer they were enveloped in suffocating heat and stench. Many of those deported, especially older people and young children, died during the journey. This walkway goes through a 15-ton "Karlsruhe" freight car, one of several types that were used to deport Jews. As many as 100 victims were packed into a single car. Deportation trains usually carried between 1,000 and 2,000 persons, and sometimes as many as 5,000. Their weight slowed the speed of travel to about 30 miles an hour, greatly prolonging the ordeal. Frequently, the trains halted for hours or days at a time on side tracks or in stations along the way. The freight car is standing on rails and tracks from the Treblinka camp. Donated by the Polish State Railways.[3]

The freight car is now asked to work as a dramatized object within this museologized terrain that is momentarily sealed off from the contemporary reality of Washington, D.C. It is exhibited as part of the absolute proof of the events. The artifact is apprehended at this place, after a narrow pathway through displays that show the early stages of the genocide by way of photographs and films and after passageways through parts of streets and walls literally cast from ghettos that were "liquidated." This tightly packed corridor opens out onto two choices for the museum visitor in her or his continued journey: to bypass the freight car altogether, allowing the visitor to cross an almost imperceptible bridge leading to a wall of smaller intimate artifacts, or to complete the horizontal corridor leading to the car's gaping open sides.

With mixed apprehensions, I approached the freight car. The presence of the actual object, the vehicle that began and often atrociously ended people's journeys into the world of the unliving, will be more appropriate,

more "effective" than any desire to artificially re-create the artifact, I cautioned myself as I prepared for what my imaginative projections might unleash. There were no crowds at this crucial, strangely understated point in the museum excursion. I looked around, then entered the car. I stood there feeling awkward, utterly insignificant, much too visible. I waited to accommodate myself to the dimness and let it overwhelm me, making me anonymous. After a few moments, I closed my eyes. Darkness. More darkness. Then bodies. Real people crammed next to each other. Women dressed in fine suits clinging to their children, their parents, or utter strangers. People smothering each other. People trampling each other for a shard of food, a lick of water. The bestiality. The defecation. The humanness. I opened my eyes, embarrassed by my trespass. I was set up. In fact, the car is denuded of any such traces. It is clean. Too clean? I wonder. We can thank the museum for this discretion. I found myself leaning forward against the museum railing blocking entry into the recesses of the train. I wanted to touch the car's wood. To caress it. Or better still, to gouge my fingers into its cruel silences?

I had been lured into the museum's logic, reaching a critical point of trespass in the obscenity of my projections. The railcar marks this perhaps necessary point of trespass. As untenable threshold, it solicited these transgressions. To trespass is to go across, to transgress, to die—that is the bottom line. Then, to exceed the bounds of what is lawful, right, or just. To offend, encroach on another's privileges, rights, *privacy*. It is, indeed, the trespass over violated rights that justifies breaking open privacy in the name of evidence that is doubly at issue here—Lyotard's insistence on the differend, or the immeasurable injustice done to the victims and the redress that representation might enact already point to that. Yet, it is the staging of the trampling on the others' privacies that tears at me—my own little trespass and the risk that it conflates in some small way with the original act of violence, the perpetrator's steps. The complex status of the artifact itself calls forth these doubled crossings. The freight car was the Nazis' very instrument of transport to and of the destruction; now it stands in as the estranged object. The extreme circumstances of this artifact's history trouble the museum visitor's perception of whether it is a precious or a reviled object. Indeed, the freight car demonstrates the tense and difficult role that artifacts are asked to perform in bearing witness to the Shoah: to be objects of empathy and historical proof. Despite the historical authenticity of the object itself, the artifact enacts its own absolute resignation to tell. There is no a priori guarantee that it can be enacted as evidence; rather, it attests to the trauma and the posttraumatic lacerations of the resurfacing of the events. The indisputable presence yet utter muteness of the railcar—

its uncanny objecthood—signal what we can never know, what we should not imagine we could imagine. Functioning most effectively for the museum visitor, it would mark the place of its own tragic paradox as traumatic remnant.

If the artifact can be considered as a traumatic remnant (the museum planners refer to them as "object survivors"), perhaps the parallel between the artifact as remnant of the trauma and the status of human survivors needs to be made more explicit. The uncanny objecthood of the artifact stands in for deeper psychic processes that echo in part some of the experiences of trauma for the survivor. As Sigmund Freud began to understand trauma through his framework of the psyche, as a device based on the economy and depletion of energy, he wrote about it as an experience that "presents the mind with an increase of stimulus too powerful to be dealt with or worked off in the normal way."[4] These stimuli create "a breach in an otherwise efficacious barrier against stimuli."[5] Trauma would then "set in motion every possible defense measure."[6] Part of this defense mechanism is the psyche's impulse to allow the organism to mime distancing and forgetting, but this is an illusive and impossible forgetting. Yet as literary critic Cathy Caruth has noted, for some survivors, "while the images of traumatic reenactment remain absolutely accurate and precise, they are largely inaccessible to conscious recall and control."[7] As Caruth further comments on trauma's binds:

> Yet what is particularly striking in this singular experience [of trauma] is that its insistent reenactments of the past do not simply serve as testimony to an event, but may also, paradoxically enough, bear witness to a past that was never fully experienced as it occurred. Trauma, that is, does not simply serve as record of the past but precisely registers the force of an experience that is not yet fully owned. . . .
>
> For the survivor of trauma, then, the truth of the event may reside not only in its brutal facts, but also in the way their occurrence defies simple comprehension. The flashback or traumatic reenactment conveys, that is, both *the truth of an event,* and *the truth of its incomprehensibility.*[8]

Functioning on a decidedly more conscious register, the museum's mandate warrants that it render the inaccessibility of the events into explicable narratives through the uneasy availability of the objects. The artifacts are among the key phrases that articulate the sentence "Never forget." The imperative is designed for those who did not experience the events. Its emphasis on conscious and willful remembrance has nothing to do with survivors' painful and arduous processes of impossible forgetting, and thus reliving, the traumatic events. Although it is not the museum's business to mime the long psychic process of trauma's protective and confrontational

mechanisms, its urgency to describe, identify, and name does not always take enough distance from the dilemmas of its task. It must be asked whether the museum's self-assured attempt to house memory and frame history covers over what can never be properly lodged.

The museum is faced with an enormous risk, if it chooses to acknowledge it. There is always the numbing possibility that an overly insistent focus on re-creation of the events will result in the loss of their essential and crucial incomprehensibility, what Caruth characterizes as *"the force of its affront to understanding."*[9] She further notes that "the possibility that the events will be integrated into memory and the consciousness of history thus raises the question, . . . whether it is not a sacrilege of the traumatic experience to play with the reality of the past?"[10] This crucial question is rhetorical in the sense that it depends on who responds to it. Survivors know the dilemma. The question, although psychoanalytically inflected, bears heavily on the museum's task. The duplicitous invitation to enter at the edge of the train car's abyss gives rise to the museum's vexed dilemma: how can it represent the paradoxic nature of trauma and the events themselves—inaccessible yet real—while employing artifacts as the very proof of accessibility and comprehensibility?

In the discussion that follows, I want to continue to articulate the often unarticulated approaches the museum makes toward the dilemmas of representing the traumatic events through what I am calling artifactual witnessing as (im)possible evidence.

Entrance into the reconstructed barracks from the Auschwitz-Birkenau extermination camp is constructed with such ease that the visitor's passage into this space is almost imperceptible (fig. 22). A tiny text caption affixed to the interior of its open door is the only indication that the barracks and the prisoner bunks inside were transported from Auschwitz-Birkenau and reassembled by the museum for this exhibition. The structure gives out no aura of warning comparable with the one, however unsettling, that emanates from the installation and staging of the freight car. Even the mock entrance sign, cast from the actual one that remains at the museum that was the extermination camp in Poland, is but a faint echo of its sardonic cruelty: *Arbeit Macht Frei* (Work sets you free). This sign functions as a cliché in addition to being a cast reproduction. For the post-Auschwitz generation, this canonical inscription looms large in reconstructed memory. It has come to represent the threshold that separates the world of the living from the unspeakable beyond that gate. And yet the cliché trivializes the experience of the extermination camp through its misappropriation of signs. The steel gate bearing this infamous inscription did not, in fact, have a central position in the history and architectural schema at Auschwitz.[11] Very few

Figure 22. View inside reconstructed barracks from Auschwitz-Birkenau at the United States Holocaust Memorial Museum. Photograph by Alan Gilbert, courtesy of the United States Holocaust Memorial Museum Photo Archives.

Jews deported there ever saw that gate. Arriving at the train station, they were marched or taken by truck to Birkenau; later a spur rail line was laid, and they went directly there. Although the arch was the main gate to Auschwitz I in 1941, in the expansion program of 1942 it became an internal structure separating the original camp from the extended structure. The cast sign at the museum in Washington, D.C., hangs just a few feet away from the actual reconstructed barracks, dividing and announcing the space where the freight car hulks and the barracks begin.

Passage into this daunting, perhaps irresolvable space raises a complex of questions. Should its entrance be more articulated, more hyperrealized, like the punctuated and singularized area that the freight car both is and represents? Through the ease of its entry and its understated announcement, do the barracks pronounce the normalization of the history it references? In other words, do they risk losing "the force of its affront to understanding"? This juncture in the museum's pacing recalls a similar unsettling

sequence at another newly constructed Holocaust museum, one that also announces and numbs the horror of events. The entrance into simulated gas chambers at Beit HaShoah in the Museum of Tolerance, which opened on 9 February 1993 in Los Angeles, is the last session in the visitor's journey. The visitor is "invited" to enter this harrowing space where narrated videos produced from films and photographs of the camps await. The sequencing of the exhibition prior to entering the "gas chambers" moves the visitor from staged vignettes by way of bells recalling department store elevators or the sounds of a child's record indicating when to turn the page of the accompanying book. After being guided through the exhibition in a manner so incongruous with the events being narrated, visitors find themselves in a passageway leading to the "gas chambers" that creates an abrupt shift in the way the exhibition had previously posed relations between visitors and the narrative. From the more tightly controlled and timed movement of the exhibition, the circulation at this crucial point of entry into the simulated gas chambers changes to a suggestion of choice based again, like the identity cards in Washington, D.C., on gender. To hint at personal choice might be to taunt the Nazis' cruel lie about respect for the body—that is, gas chambers as showers. But the cavalier tone of the visitor's movement from one zone to the next at the Museum of Tolerance's Beit HaShoah belies the effectiveness of any sure intention. During my visit a docent was shepherding people along at this critical area. He was an older man who I imagined might be a survivor. I ventured to ask him how people responded to this chilling invitation. He spoke without any hint of European accent or irony in his voice: "Oh, they like it," he cheerily told me. Philip Gourevitch's reference to the United States Holocaust Memorial Museum as a Disneyland theme park seems more appropriate as a description of the edifice in Los Angeles.[12]

Once inside the reconstructed barracks in Washington, D.C., we are afforded the leisure of perusing through exhibitions on the oxymoron of life in the death camps. The barracks themselves, their walls and posts, become uncomfortably inconsequential. One barely senses that the exhibitions are framed from the very wood used to construct barracks at the death camp. The barracks hardly translate the horror of Auschwitz-Birkenau; they become but the housing for the exhibitions. In this instance, the ineffectiveness of the reconstructed barracks makes a case for a measured simulation of the space rather than the meticulous re-creation undertaken by the museum. The museum's ownership of the barracks, this enormous and mute artifact, does not necessarily ensure evidence of the events. Perhaps it is no coincidence that within this resoundingly hollow space some of the most horrific and dehumanizing images are housed. The viewer must peer

over a four-walled barricade, meant to restrict a child's vision, to look down on video monitors displaying filmic and photographic images of *Einsatzgruppen* murders and so-called medical experiments conducted on camp inmates, among the atrocities. It is as if the museum is relying on the utter horror of these moving images to reanimate the paradoxically empty oblivion of the barracks.

The cat-and-mouse game of realism that relays between photographic, film, and video images and the reconstructed space of the barracks is set directly opposite another exhibition strangely titled Voices from Auschwitz.[13] This is the only area in the museum where visual images are kept at a minimum. The visitor enters the Voices from Auschwitz area through a narrow horizontal zone where he or she hears the voices of survivors telling and retelling their stories as testimony. Their voices are set free from the usual color video format and are no longer encumbered by the camera's insistent and blind focus on their faces.[14] The survivors' disembodied voices are appropriate to the articulate halterings of their burden "to *be* the story and to repeat its unrepeatability." Issuing from unfathomable sources, the survivors' voices unwittingly ridicule the position of ownership and accessibility assumed by the museum in reconstructing the barracks. Their unequivocal witnessings are delivered from the remnants of survival, not from the perpetrator's artifacts of destruction.

Indeed, the fragile balancing act the artifact is asked to perform—to be evidence of the Nazis' calculated brutality and to retrospectively create empathic bonds, to stand in as a precious object—is especially acute when the artifact represents both of these functions. The display of camp uniforms is especially crucial in this regard. The uniforms themselves are the very cloaking that possessed and neutralized those forced to wear them, yet they became those persons' intimate and protective possessions. The eerie and cruelly absurd status of the camp uniforms did not escape Art Spiegelman or, inadvertently, his father. Recall the episode in *Maus II* in which, soon after the war, Vladek sends Anja a strange photographic portrait: he appears healthy, even robust, and sports a camp uniform. Vladek tells Art that he "passed once a photo place what had a camp uniform . . . to make souvenir photos." "Clean," Vladek emphasizes, the uniform was new and clean.

A single camp uniform is the first object artifact, as differentiated from photographs, that the museum visitor encounters in the permanent exhibition (plate 5). It is apprehended immediately after the museum visitor leaves the elevator and enters the exhibition to view the two enlarged documentary photographs and the film footage. Each of these graphic images represents different stages in the inmate's disintegration in the camps as well as the Allies' presence at *liberation,* a term that in the face of these

photographs takes on the force of its ineffectiveness. Like the photographs, the uniform serves as a punctuation zone before the narrative exhibition begins. The camp uniform at once confirms and belies the complete effacement of the body it once marked and protected. It is hung higher than the photographs, appearing to hover above the visitor's head. Its awkward yet appropriate placement contradicts the conventional notion of the history and art museum's employment of the object as a stable and unifying artifact. Ethereal yet weighty, the uniform's presence paradoxically lends a sense of living on to the people pictured in the photographs. Exhibited without any accompanying explanatory text, the uniform's display further projects a sense of enigma; it functions as a question rather than a declaration.

The doubled paradox of the uniform—its status as protection yet fatal naming of the body it cloaked—would seem to present an opportunity for rethinking the traditional museum practice of artifactual display and labeling that often inadvertently dehumanizes its referent. Thus, the absence of a descriptive narrative label seems fitting in this case. That is, it might at first seem cruelly absurd to accompany the uniform with a provenance caption giving the name of the person who paradoxically belonged to that uniform and number. That the uniform appears nameless, however, might indicate that the museum "missed" the opportunity to restore identity to the victim whose number would then "match" the name. Yet it also brings up precisely the problem of doubled-edged naming. Naming in this case might counteract the dehumanizing act of defacing. It might singularize the mass of generalized images—both artifactual and photographic—that only distance the viewer from the material. As it is, the single uniform artifact appears to be hovering, almost stranded, between its ethnographic function as example of relic and its aesthetic function as exception.

Vexing choices faced the museum planners in their display of these uneasy artifacts. Would the exhibition designers allow the uniforms to be strewn on the ground in aestheticized heaps of precious yet tangible refuse? Or would they revert to a more traditional, ethnographic display, relegating this artifact to the realm of the sterilized past? The task in the difficult case of an artifact that is so doubly invested in the cruel retrospective labor of naming is to negotiate between giving back the name without collectively overnaming, to be careful that the naming does not overshadow the many with the sole identity of victim that they received through their mass death. The museum designers were alert to these dilemmas. Permanent exhibition designer Ralph Appelbaum's characterization of the museum's working philosophy is particularly apt here: "Negotiating between making order out of chaos and being afraid to do it."[15] The uniform's profoundly ambiguous status is evident in the way it appears sparingly, singularly, and

yet prominently throughout the permanent exhibition. In an effort to break through the barrier of the unreal of the events and yet leave the artifact as remnant partially inaccessible, the designers have it displayed behind a black grid that is open at the sides. This display makes it possible to touch the material, to trace its concreteness, its palpability, while allowing a respectful distance.

Even if the museum designers have found a relatively appropriate way to exhibit the camp uniforms, questions continue to reverberate. For example, if the uniforms are too brightly lit, would they end up looking like some postpunk neo-Nazi fashion display? And yet it is crucial that the terrible awkwardness of display remains evident. If the display becomes too elegant, too aesthetically integrated into the permanent exhibition, it would risk losing its critical possibility to "affront understanding."

The problems are compounded when massive groupings of the same object are staged. As film historian Gertrud Koch has put it: "Pictorial documents of history have become an independent metonymy: the mountains of eyeglasses, suitcases and hair take the place of the dead; they represent the dead in a cultural symbolic system, historicizing and thus relegating them to the distant past. An aesthetic ritual of mourning is created."[16] This convention of metonymy is echoed at the United States Holocaust Memorial Museum in the display of hundreds upon thousands of shoes confiscated by Nazi guards at the Majdanek death camp in Poland (plate 6). That the experience becomes aestheticized is inevitable; what is on display is not the horrific real, but artifactual remnants mandated to bring the viewer to a place of difficult approach, a place of fleeting, overwhelming, and yet resistant empathy. The aestheticizing activities of the museum must create bridges for guarded, imaginative projections and (im)possible witnessings. So by the time the visitor encounters the exquisitely lit pile of shoes, he or she will have been asked to retrospectively witness the varied stages of extermination of the one and the many. If the visitor has retained any connection with the person pictured on the identity card whose history she held in her hands, that shard of humanity has now merged with the repetitive identities that become more indistinguishable as the eye follows the massive groupings of shoes from the foreground to the elevated background of the stylized heap. The metonymy is eerie, deadening; the theatrical effect materializes the real into its evocation. The shoes thus become an empty yet elegant metonym, like the charred landscapes that have become the trademark of the contemporary German painter Anselm Kiefer.[17] One of the stories at the museum thus reaches its crescendo on a highly aestheticized, albeit somber chord.

This mutely and mythically evoked sense of the past recalls Adorno's

especially apt phrasing of the museum as the mausoleum.[18] Adorno's con-
flation of these two words calls attention to the deadening effect of sealing
the near present into a vaulted and hermeticized past. His phrasing of the
two terms also pinpoints the ethical danger of such an enterprise. That is,
the ethical danger lies in exhibiting the history of a people as if that histo-
ricizing means pronouncing that culture's death sentence.[19] The Nazi's
Central Jewish Museum in Prague was staged precisely on celebrating the
remnants of extermination, on what they willed to be the past. Their insti-
tutionalized acts of genocide were to be knowingly and coyly muted be-
neath the elegant display of confiscated Jewish ceremonial and domestic
artifacts as precious objects—an obscene ethnographic aesthetic based on
the dialectic of extermination/preservation, in which one could not exist
without the other.[20]

The Holocaust museum's mandate could not be more opposed:
"Never forget" divides along polarized lines against the Nazis' sardonic
cover-up. The Nazis had no intention of putting on public display the ma-
chinery of extermination they practiced; they were to rely on what they
made into precious remnants to do their indecent historicizing. That is, the
mass death of a people would be covered over by the fatal and silent neu-
trality of its own cultural artifacts. As diametrically opposed as their narra-
tive ends may be, the means of display at the Holocaust museum and at the
Nazis' tortured and appropriated Jewish museum bear resemblances in
their respective explicit and implicit emphases on extermination, dehuman-
ization, and keeping the viewer at a safe ethnographic distance. It is true
that the Holocaust museum in Washington, D.C., provokes the vantage
point of safe distance between the viewer and the victimized other in strate-
gies such as those intimated in the identity cards and through the ambiva-
lent access to the camp uniforms. Nonetheless, in the metaexhibition areas
set off from the main chronological narratives—precisely where the display
of shoes is located—the visitor moves horizontally along cordoned-off
miniexhibitions where the very objects of decimation and precious posses-
sion obscenely commingle. In their awkward unity, these objects continue
to separate "us" from "them"—*them* being both the perpetrators and the
victimized. If, indeed, the museum designers wanted to "expose the graphic
realities" and "not stop at the horror," their desires become doubly vulner-
able where the artifacts on display beg respectful distance and where they
most risk becoming aestheticized. The risk of aestheticizing here is directly
linked to the project of historicizing to the point that artifactual display
can become dangerously equated with inevitable cultural extinction. In this
sense the United States Holocaust Memorial Museum in Washington, D.C.,

obliquely stands in as the silent other to the Nazi's Central Jewish Museum in Prague.

In my discussion on Christian Boltanski's installations with artifacts that follows, I am interested in reading the artist's calculated archiving not only in relation to the villainized other—the Nazis' museum plan—but as commentaries on the museum in Washington, D.C., a museum that explicitly exposes the extermination and stages the state as rescuer and hero. Boltanski began working with masses of clothing in 1988. His working method mimes the exhibition display of precious domestic objects that risks further victimizing and aestheticizing their previous owners. If his photographic installations tread on the fragile territory of evidence to make way for redefined relations of empathy, his clothing installations do so while also provoking museologized boundaries that keep the would-be perpetrators in their proper place—where the "them" of history never touches the "us." As Boltanski interprets his 1989 installation, *Réserve*, at the Museum für Gegenwartskunst, Basel, in which he literally placed the clothing in piles on the floor:

> At the Basel Museum I did a piece which had half a ton of used clothes on the floor, which of course smelled. People had to walk over them. For the spectators it was a very painful thing to do because you sank into them and it was like walking on bodies. So I turned them all into murderers. There was also a certain pleasure in walking on all that clothing, which they felt, so they were completely implicated in it. They were murderers. . . . I think the Holocaust showed us . . . that we can be killers and that the people we love the most, who are closest to us, are almost always killers too. Germany was the country with the most culture and philosophy in Europe. Maybe having that knowledge about ourselves could make us a little less killers. So the clothing was a kind of parable.[21]

The installation implicitly, if not innocently, invited the viewer to interact with the clothing, to intrude on the piles, to rifle through the mass. The metonymic play in this installation is more unsettling than the way the shoes function at the United States Holocaust Memorial Museum. Unlike the shoes, the clothes in Boltanski's installation do not have a specific referent. That is, it is not certain to whom they belonged. The poignant crescendo at the museum's installation of shoes, albeit painful and loaded, cannot occur in *Réserve*. There is no easily nameable other or others to whom the clothing can be equated. Thus, there can be no conclusion. As a result, the aestheticization process, like the implications of the used clothes themselves, remains suspended and open-ended. When we think of this obsessive and silently cacophonous installation in relation to the display

of single camp uniforms at the museum, Boltanski's mode of approach appears much more raw and chaotic.

Boltanski's first exhibition of work employing clothing was installed in 1988 at the Ydessa Handeles Foundation in Toronto, Canada, and was set up at other sites through 1989 (plate 7). Titled *Canada,* the piece was installed with the clothing hung on a large expanse of wall. Tracey Lawrence, former director of the gallery, recalled the reaction of an older woman who was stunned when she entered the gallery.[22] This woman had no words: all she could do was pull the sleeve of her blouse back to show Ms. Lawrence the numbered tattoo on her arm. Ms. Lawrence's first response was to tell this distraught woman that the clothes were not real, that Boltanski had gathered them from secondhand stores in Toronto for the installation. However, the storeroom presentation and its title, *Canada,* were not lost on this woman. *Canada* was the name used by the prisoners of the Auschwitz extermination camp to refer to the barracks where property taken from new arrivals was sorted. Although the German officers took all the valuables, some of these coveted items were in turn stolen by the prisoners themselves to use as bartering power to procure extra food, soften their daily persecutions, or elevate their status in camp life. People who continue to live in the town of Auschwitz now guardedly explain that the term was associated with the mythic wealth they imagined in North America. The term and the practice of Canada extended beyond the walls of the camps. The local population of the town of Auschwitz participated in looking for gold and jewelry after bodies were burned in forest ditches. One Auschwitz resident recalls that "the ashes were rinsed in water to recover gold. . . . Canada lasted a long time. Some people still go treasure hunting."[23]

Boltanski did not have to use the actual artifacts to make manifest the realities of human degradation. The question thus arises, what would it be like to transpose *Canada* from an art gallery or museum setting and install it within the historical frame of the Holocaust museum? This provocative possibility, we know, would be prohibited on the museum's grounds that all objects must be authentic. In the cases where it was considered to be too much of a sacrilege to cart away from the sites of destruction entire walls or architectural elements intrinsic to the structure, the museum has replicated signs, doors, and pavements from the camps and ghettos for its displays, indicating that these elements have been cast from the original. In a brochure the museum mailed out in 1989 titled "You Can Help Shape the United States Holocaust Memorial Museum: A Call for Artifacts," we read that "The United States Holocaust Memorial Museum needs your help to ensure that the permanent exhibition, which will be seen each year by as

many as a million visitors to the National Mall, tells the story of the Holocaust accurately, authentically and powerfully." Authenticity, it is understood, guarantees the reality it can but only stand in for.

The museum planners' frenzy for the real reached an extreme when it came to exhibiting hair shorn from camp victims. The hair is thought to have been taken from women and was "available" from the State Museum of Auschwitz, the euphemism for the museum display and the site itself of the Auschwitz-Birkenau extermination camp. For a group of survivors on the exhibition committee of the United States Holocaust Memorial Museum, especially the women, the display of hair represented too much exposure; it violated their deepest sense of privacy. If Boltanski's installations dangerously invite the viewer's trespass, he or she avoids doing so at the expense of the persons whose bodies are referenced by the inauthentic masses of clothing. In one of the rare cases where the museum planners wanted to go beyond museologized boundaries between the visitor and an understanding of events, they were cautioned that they were going too far. The "respectability" side of the permanent exhibition team's philosophy seems to have hit a blind spot. Raye Farr, who replaced Martin Smith as the permanent exhibition director, declared that she was doing the entire exhibition to show the ultimate degradation the hair represents.[24] She asked, with pain in her voice, "Why does the hair do anything different?" As if answering her own question, she continued, "It cuts through the denial. We even had a rabbinical clearance that the hair is no longer considered part of the body. It's the end process. It needs to be shown. There's a power in showing the hair that does not exist in the documentary photographs. By not using the actual hair, you lose the power." Arnold Kramer, the staff photographer, agreed: "The hair is very disturbing. It has a tremendous charge. Pulling back from the brink, you deprive the visitors from understanding."

I would respond by asking whether it is really possible to "understand" through the body's most private and intimate spaces. Is it really necessary to hold up this vulnerability, this double violation, as proof to the hateful revisionist groups that probably delight in such continued acts of cruelty? I hear Elie Wiesel's exhortation: "Listen to the survivors and respect their wounded sensibility. Open yourselves to their scarred memory, and mingle your tears with theirs. And stop insulting the dead."[25]

The dilemma was "resolved" by using a large photographic mural of the hair rather than displaying the hair itself (plate 8). Thus what was considered absolutely realist elsewhere—the photographic document—became only a meager substitute at this crucial area. Perhaps it would have been better to have shown no imagery at all and to have made the photographic

caption visible in large type against a black background. In the absence of the palpable yet ethereal horror of the hair, the museum planners might have relinquished all desire to show and to use evidence so as to avoid the risk of the obscenity rebounding on the victims. To let it relay in our own minds. To allow the viewer intelligence. To allow the victims fitting yet impossible recompense.

In the first chapter of Umberto Eco's book *Travels in Hyperreality,* he discusses the phenomenon of history and regional museums as well as theme parks across the United States. He states that he is

> in search of instances where the American imagination demands the real thing and, to attain it, must fabricate the absolute fake; where the boundaries between game and illusion are blurred, the art museum is contaminated by the freak show, and falsehood is enjoyed in a situation of "fullness," of *horror vacui.*[26]

The United States Holocaust Memorial Museum's mandate is situated at the farthest remove from the game of illusions at play in a site such as Disneyland in Anaheim, Calif., where, for example, the hyperreal of that space serves to conceal how much its feigned falseness actually participates in the realness of everything that is outside of its seemingly artificial frame.[27] Where the illusion of the real fuels the desire for the absolute fake in places of amusement and recreation in the United States, the Holocaust museum's obsession for the real demands the absolute real in its drives toward re-creation. To reverse Eco's estimation of the art museum and theme park and yet reveal its connectedness with the Holocaust museum's different form of the hyperreal, we can say that the latter takes in its illusion of "fullness," of comprehensibility, indeed, of *horror vacui* within the absolute real of its displayed artifacts.[28] The hyperreality and repetition of the artifacts most closely associated with the intimacy of the body and the loss of personal identity—such as the shoes and the hair—are those that risk trespassing too far into already violated spaces. The museum planners' drive toward rendering the events palpable to the viewer through access into survivors' defensive and protective spaces and their presumptions of ownership over the events deeply preclude acknowledgment of the central paradox of trauma over which they lay their ground. In the museum designers' desire for the artifacts to give voice to the ineffable pain of effacement and extermination—for those who were defaced by it and for those who remain—the museum may be obscuring responses that, paradoxically, can never be housed.[29]

At the United States Holocaust Memorial Museum the artifacts that

appear intact, such as the railcar and the camp uniforms, appropriately perform as representations of the historical trauma as well as echo the effects of psychic trauma. They function as markers of the trauma through their status as representation—that is, as lack and loss yet also evidence of the real—which signals their potent and ambivalent inaccessibility. The railcar and the uniforms are displayed in less aestheticized and less fetishized fashion than the exquisitely horrific mass of shoes. The shoes confront the visitor frontally, as an iconic tableau from the distant past. Yet the railcar and the uniforms can be apprehended through multileveled sensory and perceptual registers, through approaches that project tentative bridges to the events. The visitor can guardedly engage with the artifacts, touching them, walking across and around them in charged spatial arenas in which some sense of trauma's relentless yet masked contiguity between the past and the present is insinuated.

Although the museum is invested in the artifacts' ability to testify, the artifacts defy their transparent realism through their ambiguous status as precious objects and historical proof. The mute and powerful resonance of their inability is not a marker of the collapse of evidence; it is a sign that the articulation of events calls forth an acknowledgment of the extreme difficulty of the task. Indeed, it is not a matter here of discrediting artifacts or photographs, but of reformulating assumptions about their status as transparent evidentiary devices. In Lévinasian terms, like the enlarged documentary photographs at the entrance to the permanent exhibition, the museum planners have staged the artifacts so that the visitors become transposed witnesses. The representational traces of trauma demand that we face them. This awkward set of confrontations is both the displacement of the museum's retrospective task as well as its contemporary utopian project.

The Provocation of Postmemories

*The mission that has devolved to testimony is no longer to
bear witness to inadequately known events, but rather to
keep them before our eyes.*
:: Annette Wieviorka, "On Testimony" in *Holocaust Remembrance*,
ed. Geoffrey H. Hartman

Reconsidering the demand to bear witness is not, indeed, to discredit arti-
facts or photographs, but to rethink the ways they are made to perform
as transparent evidence of the events. A reevaluation of how the Holocaust
is represented through the realism of photographic representation is espe-
cially germane and strained because of the extreme subject matter and
what it tests in terms of what is humanly possible to face. The issues are
also so tense because of the perceived assault on authenticity. In the passing
of survivors and direct witnesses, the inevitable dilemma arises not only
about the appropriate form that representation should take but also about
who can legitimately voice and recount the events. The very issue of legiti-
macy, the use of photography as historical proof, and the translation of
traumatic memory into postmemories are some of the most perplexing issues
that confront the representation of history. The indirect chronicling of his-
tory always crosses an inevitable distance. But the abyss in understanding
that the Shoah produces only deepens the chasm between the ones who ex-
perienced the events and distant witnesses.

There is urgent concern about the impropriety of anyone speaking
for the events beyond the voices of direct witnesses. Yet to adhere to this
prohibition would renounce the telling of the events to yet another
doubled realm of silence. The doubled realm of silence to which I refer is,
first, the silence that surrounded the survivors and the trauma of events
after Auschwitz, and second, the silence that the law of the voice of the

legitimate witness would impose on the inauthentic voice of the post-Auschwitz generation. According to this logic, any later commentary would only diminish the aura of the truth. This doubled realm of silence is thus also double edged. If we followed this reasoning in relation to the representation of the Holocaust, any post-Auschwitz recounts would be considered invalid. Yet the inauthenticity of the postevents' speaker is inevitable, indeed necessary, for stories and memories to become public, to become part of the historical record. Cartoonist Art Spiegelman incorporates the very risk of his position as distant witness and inauthentic chronicler into the *Maus* stories. His second book, subtitled *And Here My Troubles Began,* begins with his recognition of this inevitable dilemma. Recall Art picturing himself driving with his wife, Françoise, to visit his Auschwitz survivor father while he muses on the difficulty of working on *Maus*: "Just thinking about my book . . . it's so presumptuous of me. I mean, I can't even make any sense out of my relationship with my father. How am I supposed to make any sense out of Auschwitz? . . . of the Holocaust?"[1]

Working with this necessary presumptuousness, some artists who are children of survivors and other artists of the post-Auschwitz generation have taken on the task of attempting to face the Shoah through photography and its postmemories. *Postmemories,* as I employ the term here, refers to the artists' distance from the events as well as their relation to the fallout of the experiences.[2] Postmemories thus constitute the imprints that photographic imagery of the Shoah have created within the post-Auschwitz generation. Artists and museum planners have developed ways to respond to these memories, to give new life to the representation of the events, and to provoke respectful remembrance for its victims.

In the absence of direct experience with the events, the artists are nonetheless equipped with the legacy of cultural and familial affinities as well as mobilized by savvy awareness—often absent in the museum's strategies—of what it means to speak for others and to stage history in a museum setting. It is precisely the precarious status of documentary photography—its potential to provoke historical memory and to confront the viewers' subjectivities—that is at issue in considering contemporary artists' photographic representations of the Holocaust. Furthermore, much contemporary work that addresses Holocaust memory and history through photography, like the stagings at the United States Holocaust Memorial Museum, employs three-dimensional installations that have a guided narrative direction, artifacts, and archival photographs. In the following discussions, I will consider projects in which the artists' various photographic reconfigu-

rations formulate new avenues for provisional access to the events as well as pitfalls that trespass too heavily through postmemories.[3]

American artists Suzanne Hellmuth and Jock Reynolds, with their installation project *In Memory: A Bird in the Hand,* filter the presentation of documentary photographs in order to retrieve difficult images of Holocaust histories that have often been reproduced like rehearsed clichés. The museum planners working in the realms of factuality and documentation under the mandate of bearing witness and these artists dealing with provocative reconfigurations of Holocaust memory each rely on installations that invite the viewer to "walk through" and, to some degree, imagine the events that are being cautiously retold. If the philosophy underlying the permanent exhibition at the museum is, as Martin Smith put it, "to evoke the physical reality of the event," *In Memory* is suspicious of the possibility of such an elaboration. Rather than avoiding the task and shunning access to the reality of the Holocaust altogether, *In Memory* works to conceptually and sensually provoke details of the event's reality in a mediated exhibition that also acknowledges its irreality.

The installation was first conceived and produced when Hellmuth and Reynolds were invited to participate in the 1987 Steirische Herbst International Avant-Garde Arts Festival in Graz, Austria. The artists were intrigued with the possibilities of presenting an exhibition in this medieval city that was one of Hitler's favorite spots. The overall design of the multi-chambered installation in Graz was in the form of a crucifix. Although the installation's general configuration inevitably changes depending on its particular site, its interior flow remains consistent. Its first room is designed to a child's scale. Here the visitor encounters a Lionel train on a miniature track set on a vast and desolate wall. Three framed pages from a German grammar school arithmetic book from 1941 are hung above the train track. These images demonstrate the fundamentals of counting through the laden signs of axes and freight trains, with a photograph of a Nazi rally in the background. Hellmuth and Reynolds work with the neutralized violence of these "arithmetic lessons," tailoring the child's scale and impact of this environment to an adult's level. After following the lesson and the track, so to speak, the visitor encounters a peephole at the far end of the wall. This clandestine eye opens onto a reproduction of an archival photograph depicting four male inmates facing the wall of a Gestapo prison yard as they await the next horrific stage in their transport (fig. 23). Standing upright yet slightly hunched over in order to look through the peephole, the viewer is placed in the uneasy situation of realizing that her body posture echoes that of the men pictured in the photograph. To ask the viewer to

Figure 23. Anonymous photograph used in Suzanne Hellmuth and Jock Reynolds, *In Memory: A Bird in the Hand*, 1987. Reprinted with permission.

awkwardly peer through this peephole is to confront her presence as a privileged voyeur or as the embarrassed guardian of a now-public secret. Indeed, the photograph places the viewer in uneasy binds. This photograph is among the sparse seven picturing the atrocities that the artists employ in the installation. Throughout *In Memory,* the artists create encounters between the viewer and the photographs in which the images are not allowed to be taken for granted.

From 1975, when they began their collaborative work in dance, sculpture, theater, and performance, Hellmuth and Reynolds have been concerned with how photographs work on and through the residue of human memory. Their wide-ranging projects attempt to reorder how learning traditionally occurs as they allow for different harborings of one's perceptual apparatus. Thinking about reconfigurations of historical documentation and the presentation of traces of public memory, Hellmuth and Reynolds have analyzed their project in the following terms:

Suppose that the photographs are all fabricated, suppose you accept that there were no atrocities to the Jews, to the Catholics, to the families who had to send their kids as soldiers, suppose that you didn't accept any of that. Even if there were people who entered the installation who denied the Holocaust, they might walk through it and find things that might be provocative in ways that are different from an installation that's didactic all the way through. We don't work in terms of doing storied narratives. We like to suppose that the photographs allude to a kind of nature of knowledge that isn't completely documentary, that has no concrete connection. These are dream images, but we know that they are real. These images are part of domestic life, they're part of dream life. They're not separated off as past history.[4]

The artists' methodology in *In Memory,* especially when they refer to their stagings as "part of domestic life . . . part of dream life," "not separated off as past history," is perhaps most closely related to an earlier project, *Speculation* (1984). This project addressed the connections between the economic stimulation of World War II and the development of MIT as a major research center. In reference to this earlier project, they wrote:

The installation demands interpretation; how we see and perceive meaning depends upon the framing devices of light, composition, spatial definition, cultural references and visual conventions. . . . Like partially erased lessons on blackboards, the film of history provides the hazy settings for this stage.[5]

The multiple and "partially erased lessons" and "hazy settings" projected through the stage of *In Memory* were not so oblique to have been considered inappropriate by an official tour group for Chancellor Kurt Waldheim's viewing when the installation was first part of the Steirische Herbst festival in Graz.[6]

One of the artists' most powerful strategies is to place archival photographs in contexts in which they never *literally* appeared, a practice that provokes the ideological and psychic relationships between the events referenced in the photographs and the settings in which the viewer now encounters these images. The elegant and stark environments they design are armed with targeted metaphors. One telling environment mimics the domestic space of a middle-class living room—be it in Germany or in any other Western nation—replete with golden yellow walls, a working cuckoo clock, and live geraniums in a planter box set at the foot of a fireplace (plate 9). Strategically hung and framed above the mantel are two archival photographs that the artists have rephotographed and printed on the same page: a camp inmate standing upright in front of a dug grave and a bombed-out building, both transformed into shells of their former selves. By framing these images in the manner of works of art and then hanging them above the home's fireplace, its center, its hearth, the artists scathingly

indict the feigned ignorance not only of the German bourgeoisie, but of every country that claimed not to have known of the atrocities. The artists' methodology also suggests the ideological relationships between politics, photography, and the cultural recognition of—or refusal to acknowledge— events. A few years before the critical discourse on documentary photography surfaced, Susan Sontag aptly articulated these relationships:

> There can be no evidence, photographic or otherwise, of an event until the event itself has been named and characterized. And it is never photographic evidence which can construct—more properly, identify—events; the contribution of photography always follows the naming of the event. What determines the possibility of being affected morally by photographs is the existence of a relevant political consciousness. Without a politics, photographs of the slaughter-bench of history will most likely be experienced as, simply, unreal or as a demoralizing emotional blow.[7]

In addition to employing the rawness of the images to provoke how the events were so cruelly misrecognized, Hellmuth and Reynolds's interjection of these images into an idyllic domestic scene also points to the obscene division that continues to be enacted between the myths of sacred home and heroic civic duty. In this instance, the installation also ironically replays how these myths were performed by Hitler's highest and lowest officials. The insertion of these photographs into a psychically portrayed environment redefines the literal meaning of documentary. Indeed, in the punctuated settings Hellmuth and Reynolds have devised for the photographs, the images retrospectively act out defiance through their singular and uncanny reassertion into the scene of the familiar. Crucial to a rethinking of documentary practice, the artists acknowledge and warn that any attempt at publicly remembering and staging history can only be performed through provoking what is cordoned off as the past with the ironic repetition of feigned blindness in the present.

Hellmuth and Reynolds accompany their ironic employment of juxtaposing and reframing Holocaust-related photographs with a strategic use of cropping. Martin Smith encouraged enlarging archival photographs and was opposed to cropping them in their presentation in the museum's permanent exhibition. Hellmuth and Reynolds favor a more intimate scale not only in the reproduction of photographs themselves but in their rhythm and pacing in relation to the staged artifacts. And for them cropping is not taboo. The installation's leitmotif—the image that inspired its title, *In Memory: A Bird in the Hand,* and that appears on the exhibition's announcement as well as in the installation itself—is a reproduction of an archival photograph taken by an anonymous photographer showing Warsaw inhabitants trying to salvage their belongings from the ruins of their

bombed homes (fig. 24).[8] Hellmuth and Reynolds have cropped out the woman seen at the left in the original photograph, creating a composition whose emphasis is more centrally focused on a close-up image of the young boy carrying a caged bird (fig. 25). The original photograph also pictures a man standing to the right of the boy with his left arm outstretched and draped in white. The artists have cropped the man's figure so that only his unflinching hand remains, seeming to lead the boy into his care in an an-gelic, almost God-like gesture. The photograph's reworked focus on the imploring hand and the boy emphasizes the qualities of love, care, and com-passion. However, the gentle memorializing work the artists have under-taken in re-visioning this documentary image walks a fragile line. Through the artists' emphasis on the child and their insistence on the hierarchic sym-metry of a Renaissance composition, they risk romanticizing and aestheti-cizing the chaos of the actual scene. The image of the woman at the left that they cropped out is crucial: with her face turned outward, she is the only figure that disrupts the paradoxical reverie of this scene of concen-trated labor. Indeed, for all their crucial emphasis on the presence of a viewer in reworking the documentary image, the artists seem to have for-gotten the unexplained presence of the anonymous photographer.

If I point out areas in Hellmuth and Reynolds's installation that risk neutralizing the power of the original photograph, it is certainly not to align myself with criticisms that would discredit the entire project on the grounds that any reworking of documentary images trespasses too far into subjective projections. It is precisely the risk that is involved—a risk that the museum does not fully acknowledge but that it also performs, however differently—in being courageous enough to ask the viewer to look at the difficult images again, to allow themselves to be implicated, to be involved with embarrassment.

In Memory also embraces a redefined meaning of documentary—to document, that is, to give evidence and to teach—by intermixing the use of archival photographs with family snapshots. In one of the last rooms of the installation, the artists place unidentified snapshots of a Jewish family at the base of an upright shovel (plate 10). The viewer only knows the family is Jewish because of the Hebrew writing visible on the back of some of the photographs. The photographs have been carefully strewn on the ground, disseminated but not completely dispersed as bodies and ashes would be. These artifactual remnants of life coupled with artifacts of death—the shovel and the gray bits of gravel that form the ground—insinuate refer-ences to gravesites and markers. The care and elegance given to this instal-lation suggest the recuperation of a proper burial and a retrospective site of mourning.

Figure 24. Anonymous photograph that was the inspiration for Suzanne Hellmuth and Jock Reynolds, *In Memory: A Bird in the Hand*.

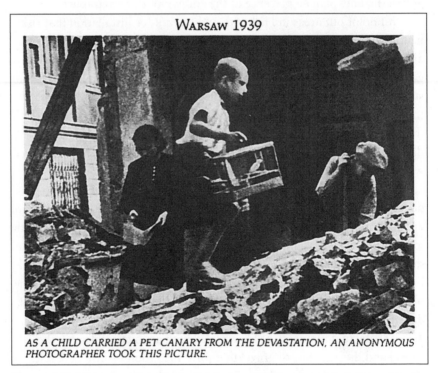

WARSAW 1939

AS A CHILD CARRIED A PET CANARY FROM THE DEVASTATION, AN ANONYMOUS PHOTOGRAPHER TOOK THIS PICTURE.

Figure 25. Exhibition announcement for Suzanne Hellmuth and Jock Reynolds, *In Memory: A Bird in the Hand,* 1987. Courtesy of the artists.

If the family photographs in *In Memory* were used in association with less extreme human events, these disarming snapshots would run the risk of conforming to a codified notion of the sentimental—that is, sentimental in the sense that they rely too much on clichéd memory, that they are invested with too much emptied sentiment. In *In Memory* these domestic snapshots are riveting. The utter normalcy of the benign joys bracketed by these images—a baby in a bathtub, a woman at the seashore, single and group studio portraits—takes on a recharged vibrancy. These largely domestic images of the mundane and relatively uneventful transform the sentiment of singular personal attachment into potent collective signs of irreducible existence and retrospective resistance. They counter the legions of horrific photographs picturing people stripped of their humanness, images that have been archived, reproduced, and codified into unaccountably familiar yet blinding postmemories. As Marianne Hirsch has written:

> It is precisely the displacement of the bodies depicted in the pictures of horror from their domestic settings, and their disfiguration, that brings home (as it were) the enormity of Holocaust destruction. And it is precisely the utter conventionality and generality of the domestic family picture that [make] it impossible for us to comprehend how the person in the picture was, or could have been, exterminated.[9]

Through their redefinition of the sentimental and their employment of the family snapshot as retrospective evidence, Hellmuth and Reynolds's project bears a crucial relationship to the museum's employment of the photographs in the Tower of Faces. Both projects frame a different point of reference for the viewer's identification with Holocaust victims, that is, different from the positions of pity, horror, disgust, and even indifference that the most difficult of the documentary photographs so terribly risk disseminating. The sheer mundane simplicity of living grants dignity to those whose memories are evoked in the family photographs. These photographic commemorations in the shadow of atrocity are based in the sentimentality of the everyday, of the domestic, of the family—as distinct from the traditional monuments of history that generally are solely based on the lives of individuals and public events. As in the original meaning of a monument, these photographic memorials serve the function of *reminding*—not only recalling the deaths and the atrocities, but bringing to public mind the vibrancy of the lives that were extinguished.

The archive from which Yaffa Eliach's photographs of the townspeople of Ejszyszki were so painstakingly re-collected for the Tower of Faces is both deeply personal and intrinsically historical. Hellmuth and Reynolds's snapshots were given to them by a Sephardic family that was not harmed during the events. The unfolding buildup of emotional investment with the

townspeople of Ejszyszki staged for the viewer through the photographs in the Tower of Faces cannot be compared with the more distanced and geographically unidentified sense of loss articulated through the snapshots employed in *In Memory.* However, the contextual disjunctures engaged by these latter snapshots—that is, the absence of distinct reference points between the Holocaust and the people pictured—are imperceptible. Although Hellmuth and Reynolds employ these photographs as though they were markers of a family that perished, they do not insist on their status as direct evidence. Rather, they orient these snapshots to confront the viewer with displaced traces of evidence meant to heighten the recognition of the real.

Although the methodology of *In Memory* does not rely on the viewer's ability or desire to be deceived by the forced authenticity of feigned photographic artifacts, it recalls Christian Boltanski's flirtations with photography. In this context I am referring to his project *L'Album de photographies de la famille D., 1939–1964* (1971), in which he did not technically manipulate the photographs, rather than to the looming rephotographed faces of children and young adults from Viennese and French Jewish school yearbooks in the *Lessons of Darkness* series. In *L'Album* Boltanski reused 150 snapshots from different family albums that chronicle middle-class French families on holiday. He dispersed them from their respective albums, reassembled them, and then framed each photograph individually to form a large grid pattern. Again, there are the familiar yet potent pictures of children at the seashore, interior shots of a family relaxing around a dining room table, group portraits of women strolling along the boulevard, and wonderfully ill-composed interior shots of people in conversation. In themselves, this assemblage of photographs signifies nothing more than haphazard memories of anonymous and seemingly unremarkable people. Rather than emphasizing the projected victimhood and vulnerability of those pictured as he did with the Jewish school portraits, Boltanski particularizes and at the same time further neutralizes the emotional impact on the viewer of the fictionalized *famille D.* by adding to the work's title the dates "1939–1964." Without the supplement of the dates, the viewer could easily fall into Boltanski's trademark trap of overinvesting one's identification and empathy, imagining all kinds of knowable yet unimaginable fates for these people pictured on holiday. Yet by bracketing these snapshots with the dates 1939–1964, as critic Nancy Marmer has noted,

> combining nostalgia and irony, Boltanski's distanced position in this work has recently been read as political commentary: when images from everyday life in mid-century France are considered in their historical context (they span the years 1939 to 1964), they seem to tell another now familiar story—the story of that amazing continuation of an unruffled, ordinary surface of life in

France during the Nazi occupation, and of the widespread denials of knowledge and responsibility that characterized the immediate postwar years.[10]

The reading suggested here by Marmer, that Boltanski incriminates those pictured as silent witnesses who are complicit in the crimes, would hold for many other faux narratives drawn from albums from other countries, spanning Poland to the United States. Boltanski's emphasis on what is not seen, however, is only possible because he focused on the dates beginning in 1939. Clearly, families who were harmed during and after that year would have no such abundance of documentation depicting mundane or joyous moments. Their only means of representation, save the clandestine photographs taken by Resistance groups,[11] were wrested from them and taken over by the documentation and propaganda dictates of Hitler's officials. If one chooses to read Boltanski's *L'Album de photographies de la famille D., 1939–1964,* as a provocative memorial to the victims of the Holocaust, it is a brilliant and understated one. It casts doubt on unnamed people without pointing to explicit crimes because it is more concerned with unnamed collective indifference rather than with monumentalized individual cruelty. If the work can be interpreted on these lines, it is also crucial that Boltanski does not target public figures associated with the crimes. Indeed, by picturing the lives of people publicly unassociated with the events, the artist implies different and multiple relationships between guilt and innocence.

The faux environments and re-presented photographs that Hellmuth and Reynolds set up in *In Memory* also open up the debilitating gap between *us,* the good people, and *them,* the Nazis. The spaces the artists allow for the viewer to speculate on contemporary personal responsibility do not mean, however, that they avoid historical specificity in reference to the past. The installation indeed pictures Hitler, but in ways that divest his figure of the monumentality that often inevitably becomes reiterated in more traditional attempts to tell the history of the Holocaust. Tellingly, his image occurs in *In Memory* only once. It is seen in a startling photograph with Eva Braun looking over his shoulder as the two of them peruse one of her family's photographic albums (plate 11).[12] Hellmuth and Reynolds placed this eerie photograph in close proximity to the Sephardic family snapshots in order to implicate the disparity between power conveyed through the control of official images and the renewed strength of family photographs in the construction of historical identity.

In Memory employs documentary photographs not as sheer proof of past events, but as devices to shock and to collapse the polarized realms between the past and the present, reality and irreality, self and other. Their

spare reemployment of photographs serves to punctuate, and this punctuation is paced at intervals—to emphasize and to break apart, to allow room for feeling yet not overwhelm. The project allows a reconsideration of what documentary evidence can be. It does this by strategically dealing in the present and by involving the viewer in the embarrassment, in the trespass. In fact, the entire floor of the labyrinthian installation is covered with small gray and white pebbles that physically and auditorally acknowledge the viewer's awkward presence. *In Memory* recuperates images from cliché and performs oblique testimonial labor—false labor, if you will, but not performed to falsify the task of documenting.

The West German artist Anselm Kiefer, largely known for his monumental paintings based on German history and the myths that fueled the mass attraction to Nazi aesthetics and ideology, embarked early in his career on a more self-reflexive and antimonumental performance and photographic project. In his *Occupations* (*Besetzungen*) series, carried out during the summer and fall of 1969, Kiefer rehearsed the National Socialist *Sieg heil* gesture in public spaces in France and Italy. The public sites he "occupied" are associated with Roman history and, by implication, with the Nazis' appropriation and occupation of those spaces. Kiefer inhabited these sites rather like an anachronistic German madman on holiday, a trip abroad to both recall and exorcise Hitler's ghost. The photographs documenting his excursions resemble vacation postcards. They play on the convention of the idealized, serene landscape, the picturesque, and are then interrupted by the insistent, annoying presence of the displaced tourist. In Sète, Paestum, and Rome, his figure in the photographs is barely visible, a waning speck against the landscapes of sea, ancient ruins, and modern apartment buildings. For example, giving the *Sieg heil* salute amid the vast emptiness of the Colosseum in Rome, Kiefer's Hitler pathetically occupies this locale while a disinterested passerby pays him no heed (fig. 26).

The photographs' reliance on the function of acting out implicates Kiefer's private fantasies of self-identification with the figure of Hitler. They also individually act out the collective giving up of individuality and responsibility for the self. At the same time, *Occupations* acts out in order to evacuate and exorcise such desires. Kiefer claims he wanted to "transpose history directly onto . . . [his] life."[13] Andreas Huyssen, Kiefer's most astute critic, recognized that, indeed, the artist's stance in this project is not simple identification but is aligned with critical examination of German culture and his own psychic participation in Nazism. Nonetheless, the actions and photographs from *Occupations* prompted Huyssen to respond:

Figure 26. Anselm Kiefer, *Occupations*, 1969. Courtesy of the Marian Goodman Gallery, New York.

But even this consideration does not lay to rest our fundamental uneasiness. Are irony and satire really the appropriate mode for dealing with fascist terror? Doesn't this series of photographs belittle the very real terror which the *Sieg heil* gesture conjures up for a historically informed memory?[14]

Indeed, with its uneasy conjuring of the artist as buffoon and historical figure, *Occupations* combines sophomoric, satirical posturing, and sophisticated, ironic implications. Huyssen refers to Kiefer's actions as "image-spaces." These image-spaces—landscapes, historical buildings, and unidentified interiors—the very sites where Kiefer performed the *Sieg heil* salute, stand in for the sites of German history that Nazism effectively tainted and thus made taboo. Huyssen claims that *Occupations* was the first sign of a provocative disruption in the self-enforced calm of image production of the 1970s, a breaking open that was necessary for the post-Auschwitz generation to begin to deal with Germany's recent Nazi past. The work's provocation also rests on its self-conscious directorial mode. That is, the criticality of the project is based on its staging as a staging.[15] The only proof of Kiefer's culturally specific and politically inflected acts of giving the *Sieg heil* salute is held in place by the photographic nonevent. Acting in tandem with the staged sophomoric pronouncements, "I am Hitler," "I am not Hitler," Kiefer insinuates that the post-Auschwitz generation in Germany needs to feel implicated in the real events of the Holocaust. His photographs challenge the traditional, objective presentation of evidence. In addition to proclaiming, "Hitler was here. This land was conquered," the photographs also hesitantly acknowledge the erasure of the recent past: "Something happened here, and I am trying to get a sense of it, to document it only through its apparent nonoccurrence." Kiefer's *Occupations* photographs act as oblique visual corollaries to Hitler's own decisive move to keep silent and ephemeral the fact of his orders to expedite the extermination of the Jews, to put into action the Final Solution. As Saul Friedländer put it, "Then comes the decision, in silence; the setting in motion of the machine of destruction, in silence; the end, in silence. . . . That's all. Sinister hints, horrifying in what is left unsaid, what is left to the imagination."[16] In *Occupations,* Kiefer sets into play the critical tension between the historical status of silence, mystification, action, fact and documentation.

American artist Judy Chicago, with Donald Woodman, has undertaken an enormous work, *Holocaust Project: From Darkness into Light* (1993), a series of large photolinen canvas panels with photographic imagery and painting. This project insists on the artists' seemingly unmediated ability to

take the visitor on what Chicago refers to as their educational and spiritual journey. The back jacket copy from the book accompanying the project proclaims that it is

> a fiercely personal record of Judy Chicago's quest to imagine the unimaginable—the most nightmarish event in our recent history and the one that most defies all attempts to envision it. In 1985 Chicago, with her husband, photographer Donald Woodman, began an imaginative journey into the grim terrain of the Final Solution. The descendant of twenty-three generations of rabbis, she brought with her the growing artistic and intellectual vision that has resulted in such internationally renowned exhibitions as *The Dinner Party,* the *Birth Project,* and *PowerPlay.* This is her account of the artistic process, and a stunning display of the art that emerged from it. As art and autobiography, as a moral inquiry and a moving record of an artist's discovery of her Jewishness, the *Holocaust Project* is a work of rare courage, candor, and beauty.[17]

Despite the jacket copy's clichéd and indulgent language of praise, it clearly announces the underlying methodology of Judy Chicago's project: that the Holocaust in her *Holocaust Project* is overlaid with *her* discovery, *her* process, *her* account. I would certainly not undermine how crucial it is for any artist dealing with this difficult material to incorporate into his or her project the very dilemmas of what it means to confront its numbing enormity. Yet the "courage" and "candor" that Penguin Books' publicity department grants to Chicago is directed entirely toward how the artist chronicles her own emotional states while working on the project. Documented through the artist's journal entries, these chronicles rarely address the dilemmas of representation itself. The empathy and understanding (the latter already a dubious goal) that Chicago wants to evoke from the viewer toward the events of the Holocaust compete with her own claims to emotional investment. Chicago disseminates a similar story to the media. In one of the first published articles about the *Holocaust Project,* a journalist from the *Chicago Tribune Magazine* dutifully reported:

> Chicago admits she was "crazed" much of the time. To unwind, she worked out two hours a day at a no-frills spa taking back-to-back aerobics classes or swimming a fast and furious backstroke. Far more important than keeping her hard, wiry body fit was releasing the tension brought on by facing the horrific content of the "Holocaust Project." Woodman unwound by fixing old cars, skiing, taking snapshots, cooking gribbines (fried chicken fat and onions) and riding with his wife on a bicycle built for two. And, Chicago interrupts with a grin, "bedroom aerobics."[18]

This grotesque conflation of Judy's everyday traumas and tribulations is sustained throughout the *Holocaust Project* itself through the artist's insistence on "discovering" the Holocaust through her own desire to venture

into her "Jewishness."[19] Without any questioning of her own assumptions about the ways she generalizes and neutralizes the complex and specifically North American notion of "Jewishness," Chicago proceeds to graph her newly burgeoning Jewish identity onto the Holocaust, as if an overdetermined identification with Holocaust history is the only way to venture into the long and varied history of Jewish cultures. In the following excerpts from her chronicle of the *Holocaust Project,* I sample but a few of these repeated themes:

> It was interesting to see *Shoah* with Donald, who, like me, *is* Jewish. It was one of the few times in my adult life that I had an experience in which my sense of self was not gender-based. As Donald and I sat together in the theater, sharing this confrontation with what had happened to the Jews during the Holocaust, I felt bonded with him as a Jew. This was a new experience for me and one I want to explore. . . . Since seeing *Shoah,* beginning to think about my Jewishness and learning about the Holocaust, I keep asking myself certain questions. When I am shocked by human behavior, as I was by the revelations in *Shoah,* I realize that it's because I start from the assumption that human beings are basically good or at least benign. When confronted by what people did to each other in the Holocaust—if I maintain my assumptions—then I cannot comprehend the Nazis' actions. . . . What if human beings are not "good" at all but are actually capable of an enormous range of behaviors, most of which are held in check only through social structures and institutions? Strange that I had never thought about all this before. (15)

Strange, indeed, given that Chicago's reputation rests on her particular brand of feminist art that purports to redress gaps in the patriarchal record of Western history, an approach that would seem to take to task the foundational structures and institutions of violence and genocide on which that very history is based. Chicago offers her own explanations for her naïveté:

> My surprise at this probably comes out of the fact that I was so protected as a child: from my father's death, from the reality of female oppression and Jewish persecution. And I guess that spending so many years in my studio, grappling with problems associated with making art, hasn't dramatically altered my childlike approach to the world. . . . I have always seen the world as innocently as a child (and one who had never thought about Auschwitz, that's for sure); and now Auschwitz (as a metaphor for Nazi evil) is forcing me to lay aside my childish notions and face a level of human reality so much more complicated than anything I've ever comprehended before. (25)

Whether Chicago's outlook on the world is childlike or childish (two very different attitudes whose specificities she does not note), she attributes her ignorance to isolated years of "grappling with problems associated with making art"—despite the rightful claims her feminist work makes to

addressing social and political issues, as well as aesthetic problems. However, some of this seeming innocence stems from her confusion about her own identity as an artist. In a phone conversation with Chicago, she definitively stated, "My work is not political. I am an artist."[20] So the transformation she assumes in the *Holocaust Project* is that somehow she will not maintain her previous innocent perspective. That is, from the outset, she will confront herself with the brutalities of what she is beginning to learn, such that, by April 1987, as she makes her journey through Germany, she can write in her journal:

> Today Donald and I were photographing in the woods that surround our hotel, and a train went by. I imagined myself back fifty years and wondered if we had been walking in the woods and a trainload of desperate people went by on their way to God knows where and they were screaming and crying for help, what would I have done? . . . This whole subject is steadily becoming much less simple than it seemed when we began. (32)

To remedy her simple-mindedness, then, Chicago extends the format of the journal to an actual journey. Yet the journal itself, with its feigned naïveté, was never written to be notes to herself. Chicago's journal hardly resembles the complexity of a woman's private diary, a place to investigate her divided selves in a psychic space far from public eyes.[21] Chicago's journal is specifically written for others to read, for others to follow along with her as she journeys forward, "descending into Hell" (36). The affectations with which Chicago poses herself as a mediator making the comprehension of the events accessible recall Steven Spielberg's strategy in the other large-scale public excursion into figuring the Holocaust in the early 1990s, his film *Schindler's List*, released in the winter of 1993. I am thinking particularly here of Spielberg's employment of the little girl wearing a red coat as a singularizing indicator of the loss of real human lives. The camera first shows her to us during the liquidation of the Kraków ghetto; her deep rose-colored coat stands out against the grimness of the scenes filmed in black and white. The last time we see her it is metonymically through the image of the red coat, heaped amid a pile of clothes at an extermination camp. As kitsch a device as this is to personalize the genocide through the director's feigned naïveté to capture the viewer's attention and to ensure that he or she is following the narrative sequence, Chicago takes kitsch to the point of the ridiculous in her posturing somewhere unevenly between innocent girl and foolish woman. In a series of exchanges about *Schindler's List* engaged in by film critics and artists who have focused on representation of the Holocaust in their own work, Art Spiegelman rather nastily likened Spielberg to the simple son in the story of Passover:

In the Passover Haggadah we're told of four sons, one wise, one wicked, one too young to ask why the Jewish exodus from Egypt is celebrated, and one too simple to ask. The Haggadah says the stupid son is to be told the short simple version of the story so he can at least grasp something of what happened. Clearly Spielberg has the simple-son market sewn up.[22]

Yet if Spielberg asks questions too innocently, Chicago poses them as she displaces them, setting herself up as a surrogate for the little girl in the red coat. The presumptions in this stance are played out in photographs Donald Woodman took of Chicago during their "Holocaust journey," in which her questions conflate the "What would I have done?" to "Look what they did to me."[23] In a particularly egregious photograph taken in the crematorium at the Natzweiler extermination camp in the Alsace-Lorraine region of France, Chicago literalizes her self-investment of victimization as she lies on the enormous shovel that carried bodies into the oven. The insistence of such a brazen act of retrospective self-projection, the insertion of an act of will and literal presence, should give this photograph a startling impact. Yet the artist's staging deflates the enormity, the pain, and the horror that the act suggests. Perhaps this flattened effect is because Chicago's questions are misdirected. Earnestly, miming piousness, she poses questions and revelations to herself in a public forum, assuming that her questions echo those lying unelucidated in her audience. This photograph is doubled with its revelation, which also serves as the photograph's caption: "I realized that, had I lived in Europe during the war, this would probably have happened to me" (36). However undeniable and terrifying her statement is, its obviousness also stultifies any further analysis. Indeed, Chicago's layering of herself as Jew-victim-woman does not provide a foundation for connecting the institutional racism and hatred that fuel those conflations.[24]

Despite her overstatements, Chicago is working in potentially provocative territory by offering herself as projected victim in the actual site of genocide: working between the presentation of sheer proof and awakening her own subjectivity (as well as the viewer's) to the reality of events. Her breach with a more formal objectivity, as in a photograph that would document only the oven, is crucial. Yet her insertion into the scene of totalizing death is too piously didactic, if not misleading. Chicago appears in this photograph laid out on the shovel with a bandanna on her head, which refers to the Orthodox Jewish custom in which women are obliged to cover that part of their body, among others, that would tempt men to sin, to wander from religious thoughts and discipline. Given Chicago's usual eagerness to comment, her silence about depicting herself as victim/woman and as an Orthodox Jew is confounding and misdirected. Hitler's ovens pulled in millions of assimilated secular Jews as well as religious Jews,

strategically making no difference between them. Irony need not become the artistic prerequisite de rigueur, yet recall Kiefer's insertion as victimizer into the sites of hatred and aggression. Chicago also poses herself as the transposed tourist, but she ignores the awkward position the casual visitor occupies when trespassing in the place of the departed. For Chicago, it seems that putting herself in the place of the victims goes without comment. It is assumed she can occupy that untouchable place. It is as if she proposes herself as an intermediary messenger from the victims to the actual tourists who visit these sites. She admits that she is a tourist, with all the innocent curiosity that implies; yet she also assumes the perverse role she has created for herself as privileged victim.

In another photograph taken by Woodman along their journey, Chicago also appears prominently in the garb of a religious Orthodox woman. She stands at the entrance of Meah Shearim, the Jewish Orthodox area in Jerusalem. However, her commentary in her journal now passes judgment on Orthodox practices:

> I feel ridiculous; in order to blend in this time I wore a long dress and a scarf. As soon as I put on these clothes I immediately felt subdued, as if I were "disappearing" into my "uniform"—and this even with a scarf that doesn't completely cover my hair and a dress that, compared to what women here wear, still has a lot of individuality. (81)

Chicago gives this commentary about being deprived of individuality without noting the irony in her own willingness to cover her head in the previous photograph of the oven, an image that attempts to stand in for mass genocide and the raping of individual identity. One may well ask why this photograph at the entrance of Meah Shearim even figures into this project. Perhaps as a displaced commentary on the misogynist character of Jewish Orthodoxy? Paradoxically, the photograph itself belies none of Chicago's criticisms. Instead, it represents Chicago as the little waif obliging to the sign above the entrance to Meah Shearim, which reads in part, "married women having their hair covered, etc., are the virtues of the Jewish woman throughout the ages." Playing the part of the dutiful Jew, it is as if Chicago is now more than willing to align herself with her family's history, in which she is, as the book's jacket copy told us, the descendant of twenty-three generations of rabbis.

For all its convenient piousness and facile Jewishness, Chicago's project is nonetheless attentive in part to what normally falls outside the purview of accepted cultural traditions and standards for representing the Holocaust. In this sense, her research into what she aptly refers to as "iconographic voids" is crucial (4). For example, in the exhibition of the

Holocaust Project, representation is given to the persecution of homosexuals, an aspect of Holocaust history that has rarely been a part of the museum's institutional memorializing task.[25] In *Lesbian Triangle,* the bottom panel of this photolinen canvas is made up of Chicago's painting from a historic photograph of women at a lesbian café, rendered in a hybrid style that turns a Max Beckmann painting into a Rockwell Kent scene. This image is supposed to read as the "before" scene to the one above it, in which the women are pictured as concentration camp inmates. Their stripped and uniformed bodies are trapped within a triangle of light whose outer edges are blackened. This triangle is enclosed within a square; photographs taken by Woodman of a guard tower from the Majdanek concentration camp in Lublin, Poland, occupy its left corner and one depicting prisoner barracks from Birkenau in Auschwitz fills its right corner.[26] The juxtaposition of Woodman's photographs with Chicago's paintings only further stylizes the relationship set up between "reality," boldly proclaimed in the black-and-white photographs, and her caricaturish projections. Since there is little attempt in this panel to pictorially integrate the insistence on photographic reality into the prismacolor lackluster of Chicago's painted representations, one may well wonder why the photographs are used here at all. Chicago explains the reasons for combining photography with painting:

> We were vitally interested in seeing the ways the Holocaust was presented visually and looked at many exhibits. Usually the "story of the Holocaust" is depicted through text, photo-documentation, and artifacts. I found myself questioning whether any form of art could be more eloquent. But I soon decided that, as powerful as the photographs were, it was difficult for me to make a personal connection with pictures of piles of bones or to visualize the abstract statistics and numbers (like six million) that were frequently repeated in Holocaust presentations. . . . I became convinced that painting could convey this human story and thereby provide a bridge between the abstraction of the statistics and the larger, *universal* significance of the historical event. But I *intuited* that in order for the paintings to be effective, they had to be rooted in historical reality, which was something that only photography could accomplish. Combining painting and photography seemed to present a unique aesthetic form for my intentions, and, *of course,* it was also a way to combine both my own and Donald's skills. (7, emphasis added)

Chicago unwittingly acknowledges the complex relations between the viewer and the pictured in abject images of those murdered. Her admission, "as powerful as the photographs were, it was difficult for me to make a personal connection with pictures of piles of bones," dimly echoes Martin Smith's concerns to personalize the history through the identity cards at the museum. Yet Chicago simply resolves the dilemma by conveniently becoming "convinced that painting could convey this human story." And despite

the difficulty of what photographs so graphically convey, Chicago "intuits" that photography, as the historic conveyer, had to be brought back in. The story of combining painting and photography is happily resolved because, of course, it rebounds back onto Judy and Donald, bringing them together in the way that they combine their media to "present a unique aesthetic form for [Judy's] intentions."

Through her misuse of photographic images of extermination camps and other Holocaust horrors, Chicago ignores the travesties of blithely reiterating the same old strained yet complacent approaches to equating photography with actuality. In *Double Jeopardy,* a photo-painting that sets out to address women's particular experiences as Holocaust victims, Chicago has no qualms about reproducing familiar yet difficult photographs, further rendering them into clichés. Despite her previous statement that would appear to indicate the risks in continuing to force such photographs over the complex visual field of historical memory, Chicago wants only to "expand" that visual repertoire in the dubious name of inclusion: "By the use of familiar photos that appear in almost every exhibit or book on the Holocaust, the standardized method of recounting the Holocaust event is expanded to examine the particular ways in which women experienced this tragedy."[27]

Chicago inadvertently proceeds to further abuse the memory of those pictured in the archival photographs she reproduces by bluntly juxtaposing them with her paintings of imagined scenes between women. The visual and conceptual implications are that the men in the photographs are to blame for the women's "exclusion," that they are responsible for the absence of women's representation.[28] *Double Jeopardy* thus insists on making gender divisions between sufferers in this fragile arena that is already so deeply tainted by the kind of hate and fear that breeds categorization. In one of the panels in *Double Jeopardy,* Chicago has painted a scene of women being raped by German officers. She has placed these images above the reproduction of a harrowing photograph of men in their barracks inside an extermination camp, their heads and bodies strained toward the photographer. In another panel, the women take center stage. The painting of a woman whose baby is being torn from her by a Nazi soldier is literally applied over the photographic image of a man standing inside a dug grave. The import of Chicago's messages, too, are regrettably conflated. She confuses the rethinking of women's history, "Remember our particular experiences," with "Take me, too, into the mass grave."

Chicago's misplaced emphasis on "inclusion" and "equality," already perverse in this context, ultimately begs the question of what a feminist methodology of history and a feminist approach to representation are.

Feminist philosopher Elizabeth Grosz lucidly responds to the misdirected goals of a feminism based in the myths of inclusion, equality, and sameness:

> In abandoning such attempts to include women where theory had abandoned them, many feminists came to realise that the project of women's inclusion as men's equals could not succeed. This was because it was not simply the range and scope of objects that required transformation: more profoundly, and threateningly, the very questions posed and the methods used to answer them, basic assumptions about methodology, criteria of validity and merit, all needed to be seriously questioned. . . .the a priori assumptions of sameness or interchangeability, sexual neutrality, or indifference, the complete neglect of women's specificities and differences, could not be accommodated in traditional theoretical terms.[29]

In *Forced to Disappear: A Display of Visual Inequity* and *After the Fact . . . Some Women,* ongoing photographic installations begun in 1987, feminist artist Connie Hatch addresses the difficult issue of inclusion in relation to the archive and women's history. These projects do not primarily picture people who perished or who were indelibly marked by the Holocaust. Rather, *Forced to Disappear* is an enormous research project in which Hatch has assembled hundreds of case histories and photographs of people who have been targeted as political, religious, or social deviants by their governments and silenced through physical violence or by less visible forms of abuse (fig. 27). *After the Fact* follows the same methodology but focuses only on women.[30] *Forced to Disappear* is important to this study not only for its representation of the construction of Anne Frank's history, but because of its attentiveness to the cruel paradox of "inclusion" when the events involve the worst of the human spectacle rather than celebration. Hatch's work navigates through the conflicts between postmodernism and documentary traditions, fueled by the belief that it is not mutually exclusive for photography to mourn the referent and to function as an active and analytic signifier. Her rethinking offers approaches that bear on facing others in direct and indirect relation to Holocaust representation.

In *Forced to Disappear* and *After the Fact* Hatch proposes a critical juxtaposition of photography's traditional heroizing and victimizing obligations in order to scrutinize the logic that sets these oppositions into repetitive gear. Her installation work defies a facile reading of photography's clichés while it cogently investigates the cruel and poignant borders on which the supposed polarities of subjectivity and objectivity and discourses of the past and the present both overlap and disengage.

One of the ways Hatch questions these traditional documentary conventions is by metaphorically alluding to the troubled double status historically assigned to photography. Like Boltanski's theaters of mourning,

Figure 27. Connie Hatch, installation shot from *Forced to Disappear: A Display of Visual Inequity,* 1987. Courtesy of the artist.

Hatch's installations evoke both the sacred hush of memorials as well as the cruel and mundane facticity of criminal lineups. Each person referenced in the series is represented by a close-up photographic likeness printed as a positive transparency and mounted on the wall to project a twin ghost image. Hatch interrogates the use of documentary evidence and its authoritarian inflections by implicating the viewer's own identity and personal investment in the political and photographic economy. This unsettling interweaving of the viewer and the viewed is partially achieved through the use of lights that are directed up toward the positive transparency portraits. Haunting shadows of the people's faces project their presence more disturbingly than the matrix images do. When the viewer moves between the lights and the mounted photographs, the ghost image disappears—an apt metaphor to describe the viewer's desire, capacity, or inability to acknowledge the existence or devastation of others. The point at which the viewer intervenes between the light and the photographed faces allows a startling Lévinasian revelation of difference. By blocking the deceptive ploy of connectedness between the viewer and the viewed endemic to the documentary tradition while at the same time attempting to engage the viewer in uneasy communion with named and unnamed others, Hatch subverts facile bonds of sameness that generate false empathic relations. Nonetheless, her visual

and theoretical plays on difference warn against the formation of a distance that could become indifference. This indifference, in its very lack of touching the other, could come close to perpetuating the avoidance of relations that often hides behind the humanistic rhetoric of documentary's social concern. Hatch's connotation of "victim" defies documentary's traditional framing of the subject's plight as inevitable and pivots on the reality of social contingencies. She examines photographic coercion and the micropolitics of power to construe open-ended forms of resistance. Hatch's project thus conjoins sorrow with action and argues for photographs to perform potent remembrance.

If Boltanski's installations function in ways similar to the Tower of Faces by commemorating mass death through collective portraits and by keeping the photographic faces at a remove from the viewer, Hatch's photographic nomenclature can be understood as working in ways strangely similar to the museum's identity card project. That is, she allows the viewer to know the particular life circumstances of each of the "victims"; she invites empathy without, however, the assumptions of bonding and assimilation at work in the identity card project. Her "Briefings/Legends," like the text on the identity cards, recount the details of each person's life/death circumstances. Both are conveyed in a standardized format that plays on textual conventions of fact-finding and identity papers. The identity card evokes a passport; the "Briefings/Legends" pages evoke sheets from the postal office Wanted list as well as pages from memorial books. The information headings are marked as follows: name of subject, nationality, source of photograph, original photographer, where the subject was last seen, and circumstances of disappearance. A small photograph of that particular subject—a facsimile of the same that is displayed on the adjacent gallery wall—appears at the upper right corner above his or her name on the "Briefings/Legends." These chronicles appear to read like the logistics of a public record. Their sheer information can only recount; they cannot explain.

Like the data provided on the identity cards, Hatch's "Briefings/ Legends" merely trace the circumstances of atrocity. Here is how Hatch's "Briefing/Legend" on Anne Frank reads:

> Anne Frank and her family originally lived in Germany, but when Hitler came to power, they fled to Holland to avoid persecution, . . . When the Nazis invaded Holland, they were forced to flee again. For want of another refuge, they remained in Amsterdam, hiding in the abandoned half of an old office building. . . . After they were exposed, her family was taken to the death camp at Auschwitz, where her mother died. Anne and her sister were moved to the

concentration camp at Belsen, where they both died from typhus in March of 1945. In May of the same year, the war ended.

And the museum's identity card on Celia Petrankes:

> Celia's family has lived in Poland for many generations. She is the youngest daughter within a happy, close family. She plays with the German and Polish children in her neighborhood and attends a private Jewish school. . . .
>
> **1940–1944:** The Germans occupy Stanislawow in 1941. Celia is assigned work as a scrub girl for the Gestapo. From the window of the Gestapo office where she works, she looks down into a courtyard and sees a group of starving Jews from Hungary, brought into Poland for slave labor and killing. She tosses her sandwich down to them; a Nazi sees her. She is taken away, abused, and shot.
>
> **1945:** Celia's mother was one of hundreds of Jewish townspeople rounded up, brought to the cemetery, and shot in 1941. Her father jumped off a train to Belzec Death Camp, only to be shot by the Germans. . . .

Although Hatch's filtering through the available printed material on Anne Frank avoids the museum's forced "before" approach, the seemingly neutral and unproblematized text nonetheless reiterates the disembodied voice of documentary's feigned authority. The tone in the "Briefing/Legend" thus seems to contradict Hatch's desire, so well conveyed in her redefinition of photographic naming, to rethink a neutralized practice. It could be, however, that her very reliance on publicized sources subtly refuses the notion of facile access and provokes the accountability of sheer yet powerful facts to go beyond their codified frame. Yet her employment of the facts amounts to more than a sophisticated dismissal. At once rethinking documentary conventions and calling for empathy toward the people whose stories are being recounted are difficult and delicate strategies, involving a double bind that Hatch takes seriously enough to disclose, perhaps unintentionally, as one she cannot escape.

The force and pointed poignancy of Hatch's work to perform both remembrance and active, retrospective resistance is based in a feminist redefinition of traditional documentary subject and object relations. In *Forced to Disappear,* as in other artists' projects considered in previous chapters, vital documentary information is stunned, shattered, or made more legible by the uncanny arrest of intimate photographs. Recall Spiegelman's portrait of his never-known ghost brother Richieu, who stands mute guard at the entrance of the stories in *Maus II.* Or Boltanski's largely unnamed faces of both victims and those who went unharmed, which he re-presents in varying degrees of poetic evocation and understated political provocation of the events. The portraits in Yaffa Eliach's Tower of Faces, too, convey an overwhelming sorrow that, rather than giving a passive aura to the victims,

challenges the viewer's position of mastery. These works refuse a heroic sense of history both in their reconfiguring of scale and in repositioning the place and psychic space of the viewer. They are part of recent cultural production fostered by feminist attention to the antimonumental moments of the everyday in which reconsiderations of historical representation and the use of family photographs are figuring into newer scholarship and art practice.[31] This new practice presents challenges to older forms of documentary representation. For instance, when Eliach first offered her collection of photographs to Beth Hatefutsoth in Israel years earlier, the director at that time refused them, implying that no one would want to look at little snapshots.[32] The timeliness of the Tower of Faces and its inclusion in the contemporary Holocaust museum in Washington, D.C., are only part of the larger issues now emerging in the gendered politics of memory. Recognition of and profound investment in the undervalued realm of the domestic, the intimate, and the autobiographical, traditionally codified as "feminine," demonstrate how a feminist methodology to history can expand intersubjective approaches to the representation of the Shoah. Such provocative feminist approaches to history are not restricted to women artists/re-collectors. Indeed, we must keep in mind that women and men can be caretakers of memory, lest we risk refeminizing, undervaluing, and thus overlooking the realm of tenderness in representing delicate and daunting histories.

In closing this chapter, I want to briefly focus on two projects that employ portraits and insist on the human face in ways that differ from those already discussed and that suggest yet other productive approaches to restorative naming and alterity. Jeffrey Wolin's *Written in Memory: Portraits of the Holocaust* (1993) and Aharon Gluska's *Man and Name* from the *Reframing and Reclaiming* series (1996) emphasize the incommensurability of the face of the violated other and the articulation of spaces of difference yet proximity between the viewer and the pictured other.

Jeffrey Wolin's *Written in Memory: Portraits of the Holocaust* is a series of individual black-and-white photographs of survivors today (fig. 28).[33] Rather than focusing on their personhood previous to the Holocaust through earlier photographs, which he interestingly includes in his book of the same name, the artist creates contemporary post-Holocaust portraits. Yet gauging from the title of the project, it seems that Wolin intends, not unproblematically, to have their aging faces stand in for the entirety of the Holocaust, as if every line of their countenances were etched with this history. The prints are displayed in a format endemic to the traditional exhibition of still photographs and are more akin to the conventional documen-

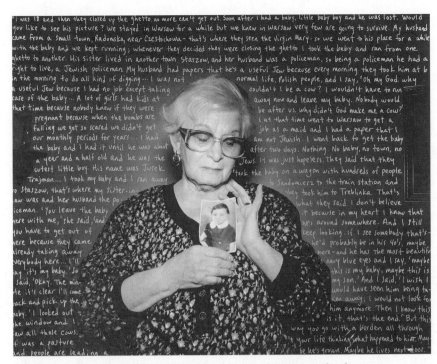

Figure 28. Jeffrey Wolin, *Rena Grynblat, b. 1926, Warsaw, Poland*, 1993. Photograph with silver marker. From *Written in Memory: Portraits of the Holocaust* by Jeffrey Wolin. Copyright 1997. Courtesy of the artist and Chronicle Books, San Francisco.

tary picturing of individual "subjects." Yet in alignment with postmodern critiques of "capturing" individual subjects, Wolin does not offer the portraits solely as dumb insistence on the sitter's physiognomy or as emblems of the pathos he hopes they will draw out from the viewer. Wolin has conducted interviews with each of the survivors, has edited them—sometimes unfortunately losing the individual rhythm and detail, indeed, their stark accuracy—and has then written these excerpts directly onto each print with a silver marker. Certainly mediated, Wolin's approach nonetheless allows each person the means of her and his own voice in their representation, which further complicates and expands postmodern warnings about picturing the subject. The peoples' stories are often filled and bursting with the loss of or continual search for other family members. Wolin often arranges the words to appear as if they are crowding and trapping the pictured survivor, which heightens each person's sense of struggle against the repercussions of the events as they are played out on their aging faces and bodies. Against this overwhelming pictorial and psychic backdrop, the domestic settings within which he has photographed most of the survivors seem to disappear into an otherworldly, distant realm. In the most effective

photographs, the uncanny juxtapositions between the survivors' words and the artist's portraits of them convey unbearable sadness, tension, and resistance against complete psychic decimation. The portraits attest to the survivor's apparent semblance of wholeness and the resiliency of the body, a paradoxic container that can barely hold within its borders the traumatic stories of annihilation, incomprehension, and utter bleakness that issue from it.

Wolin's *Portraits of the Holocaust* echo the question that resonates throughout the different projects addressed in this book: What does it mean to "face" the other from a retrospective position? Interweaving the force of the literal face with the psychic and philosophical implications of the question, Emmanuel Lévinas's alterity would respond that the other's face is a plea for responsibility toward the other: "The face is a fundamental event. . . . It is an irreducible means of access. . . . The face is in search of recompense, an open hand. That is, it needs something. It is going to ask you for something."[34] Like Wolin's portraits of survivors and their excruciating stories, it is the other's utter frailty and destitution that paradoxically represent its activity in passivity. If, according to Lévinas, the other's face holds the promise of calling the subject to responsibility, the other would no longer be solely the victimized. The other's face, its "appeal," conveys a forceful demand on the subject to open the tense and impalpable space between self and other.

For Lévinas, the face of the other is both a literal and a nonliteral representation. It stands before the self in its visualness, in its presence; but Lévinas attempts to safeguard it against exclusiveness by thinking of the face as resisting totalization. That is, the face is not one, it is limitless. It is not only an individual, but an event — an event of facing that tests the response-ability of the intact self looking on:

> The face is present in its refusal to be contained. In this sense it cannot be comprehended, that is, encompassed. It is neither seen nor touched — for in visual and tactile sensation the identity of the I envelops the alterity of the object.[35]

The implications of Lévinas's philosophy of alterity and facing are paramount to rethinking the assumptions of knowledge and promises of touching that are embedded in documentary photography. Lévinas's thinking is crucial here in negotiating the sheer importance and existence of the face and the event with postmodern warnings about what the "truth" of documentary photography covers up. Postmodern and feminist concerns about the falsity of totalizations and the impossibility of understanding the plight of others dovetail with Lévinas's concept of alterity as an incommensurable space between self and other. Alterity does not call for compre-

hending; it makes a plea for acknowledgment and responsibility. In the Shoah's web of cruelty and incomprehension, the relations between the pictured victim and the photographer—and the pictured and contemporary viewers—were and still are so severely asymmetrical. Lévinas's rethinking of the neutralized relations of I and thou recognizes their impossible reciprocities while conceiving of memorializing as a mutual confrontation between the contemporary subject and the imposing trace of the other.

Aharon Gluska brings forth the possibility of responsibility toward the Holocaust other—that is, the formation of a responsible representation of the Holocaust other from a retrospective position of witnessing— through a conception whose starting point is wholly different from Wolin's contemporary portraits. *Reframing and Reclaiming* is a series of portraits in which Gluska gives face to both survivors and those who perished. The artist begins with identification photos or mug shots of extermination camp inmates from Auschwitz, which show people in the beginning stages of dehumanization. He enlarges the photographs up to about five feet in height, attaches them to canvas, and applies hundreds of layers of pigment to them. Slowly, he wipes the paint away at each application, as if caressing each face, transforming the person's victimization into a relentless gaze directed outward. Gluska completes this careful act of rehumanizing the victims by refusing to identify the people by the numbers forced on them in Auschwitz. Rather than leaving the photographs visible with the cruel nonidentity of the Nazi numbers, Gluska conducted painstaking research at Yad Vashem to reconnect each person with his or her proper name. Now their names are attached to plaques Gluska has made for each portrait and has placed at the base of each one, creating highly symbolic and moving acts of restorative naming (plate 12).

Akin to Lévinas's alterity, Gluska's portraits depart from their original function to mark and to name unequivocally; they work against the dehumanization by refusing to recognize the other through the blind and frontal acknowledgment upon which the cruel naming of photography and less malintended documentary photography represent the other in order to involuntarily dismiss him or her. Gluska, in concert with Lévinas, nonetheless admits to the vast spaces between knowing and representing:

> The relation between the Other and me, which dawns forth in his expression, issues neither in number nor in concept. The Other remains infinitely transcendent, infinitely foreign; his face in which epiphany is produced and which appeals to me breaks with the world that can be common to us.[36]

In the artists' projects considered here—Hellmuth and Reynolds's *In Memory: A Bird in the Hand,* Boltanski's *L'Album de photographies de la*

famille D., 1939–1964, Kiefer's *Occupations,* Chicago's *Holocaust Project: From Darkness into Light,* Hatch's *Forced to Disappear: A Display of Visual Inequity,* Wolin's *Written in Memory: Portraits of the Holocaust,* and Gluska's *Reframing and Reclaiming*—each provokes postmemories through varying and multifaceted strategies that attempt to reformulate the traditional documentary voice by introducing the viewer to an intersubjective relation to the events. They do this by eliciting the viewer's subjectivity and, in the case of Kiefer and Chicago, by relying on their own, in order to breach the often debilitating barriers between the past and the present. Through their varying effectiveness and excesses, the artists negotiate documentary and postmodern issues about photography in order to expand the urgent and troubled task of confronting Holocaust history and memory. Their approaches are necessarily far from conclusive. What is crucial is that they suggest approaches—tentative passages and partial access— rather than claiming mastery over the impossible.

In Lieu of a Conclusion:
Tender Rejections

We can only live this experience in the form of an aporia; . . .
Where the possible remains impossible . . . and then the other
no longer quite seems to be the other, because we grieve for
him and bear him in us, like an unborn child, like a future.
And inversely, the failure succeeds: an aborted interiorization
is at the same time a respect for the other as other, a sort of
tender rejection.
:: Jacques Derrida, *Mémoires for Paul de Man*

A respectful postmodern approach to representing the Shoah through
rethinking documentary photography and its difficult mandate to speak
for others, to bear witness, to teach, and to warn is to attempt the task yet
acknowledge its inevitable (im)possibilities. In their assigned roles as
guardians over and translators of the events, the museum planners are
granted little space to acknowledge the tortured task of presenting artifacts
and photographs as stand-ins for the traumatic history of mass murder and
irretrievable loss. "Whether it is not a sacrilege of the traumatic experience
to play with the reality of the past?"—the question Bessel A. van der Kolk
and Onno van der Hart pose in relation to the role of psychoanalysis in
confronting survivors with their trauma—echoes throughout the staging
of the museum's permanent exhibition.[1] Ralph Appelbaum's anxieties
about transforming trauma into a narrative story, what he characterizes as
the problems of "negotiating between making order out of chaos and being
afraid to do it," murmur the ambiguity of the task.[2] The exhibition team's
need to distance the institution from what they perceived as the artist's free
play was more explicitly stated by Martin Smith when he elaborated on the
problem of creativity in the museum's project:

I don't feel nice working here. This is not Sunday in the countryside with the Impressionists. This has not been a creative act in the way that many of my films are. It's a liberty I can't have. I can free-associate with what the images are telling me, but in the end I cannot present the imagery of the story in a free-association way on the grounds that it is interesting to me. I have to get back to historic grounds. I have no decision at all—that is the work of the Content Committee and the survivors.[3]

Smith's adherence to historic grounds and his assertion that his decisions have no impact on how that history is staged uphold the enforced divisions between the presumed appropriate factuality of museum presentations and the supposed fictionality of more "creative" presentations. This is probably why Smith exhibited anxiety around an artist's project such as Boltanski's, in which the artist's mock artifacts and reconceptualized photographs provoke facile accessibility to events by deceiving the assigned borders between the anthropology museum, historical proof, and artistic artifice. The Holocaust museum's explicit mandate to bear witness and its understandable investment in authenticity often blind it to its own acts of staging history that, like the artist's works, must inevitably "play with the reality of the past."

To critically analyze artists' projects that rethink photographic representation in juxtaposition with the museum's stagings is not to draw simple equations between the different functions and cultural status of historical documents and so-called aesthetic objects, but it is to question the boundaries built around them. In part, such a separation between historical "fact" and artistic "fiction" serves to create hierarchies in who owns the proper truth and which truth is more legitimate. Rather, thinking of artistic uses of photography and the museum's representations of photographic realism in relation to each other is to create analogies between what can be reconsidered as retrospective evidence. Jacef Nowakowski, the exhibition team member referred to at the museum as their "artifact hunter," conceded that in the next generation the museum will have to include artists' projects about the Holocaust in their permanent exhibitions.[4] The import of Nowakowski's concession here is that after all direct witnesses are gone, the second generation's indirect witnessing will necessarily become more valid. By incorporating perspectives of those who did not directly experience the events into the permanent exhibition, it is not only a matter of going to the next best register of proof. Such an incorporation would acknowledge that the museum's presentations of history, like the artists' projects, are but tentative representations and that neither can claim to comprehensively or comprehensibly recount the events. As restagings, they both inevitably rework the actualities of the past. To acknowledge their

mutual work in attempting to approach the events does not discount that they offer divergent means of access for different audiences.

Indeed, to admit to the disabilities and inequities of retelling this history does not mean that the project of evidence, of bearing witness, has deceived itself. As Claude Lanzmann wrote about his film *Shoah* (1985), a relentless chronicle about the Holocaust told through contemporary interviews with perpetrators and the testimonies of survivors, "I have precisely begun with the impossibility of telling this story. I have made this very impossibility my point of departure."[5] Elsewhere, Lanzmann further elaborates on his choices to obscure "understanding" in relationship to representation:

> It is enough to formulate the question in simplistic terms—Why have the Jews been killed?—for the question to reveal right away its obscenity. There is an absolute obscenity in the very project of understanding. Not to understand was my iron law during all the eleven years of the production of *Shoah*. I had clung to this refusal of understanding as the only possible ethical and at the same time the only possible operative attitude.[6]

Lanzmann's "refusal to understand" becomes a space for listening, for filtering through the interviews with perpetrators, and for taking in the testimonies of survivors. To listen is a pathway for allowing unspeakable stories to be told. It prepares a space to be beckoned by the other, creating the grounds for alterity.

Similarly, Dori Laub, a psychoanalyst who works with people who lived through the Holocaust, recounts the inaccurate precision of one survivor's testimony as an eyewitness to the Auschwitz uprising: "All of a sudden, we saw four chimneys going up in flames, exploding. The flames shot into the sky, people were running. It was unbelievable."[7] Laub recounts how this woman's videotaped testimony, played months later at a conference of historians, psychoanalysts, and artists, generated controversy over what can be accepted as evidence:

> The testimony was not accurate, historians claimed. The number of chimneys was misrepresented. Historically, only one chimney was blown up, not all four. Since the memory of the testifying woman turned out to be, in this way, fallible, one could not accept—nor give credence to—her whole account of the events. It was utterly important to remain accurate, least [lest] the revisionists in history discredit everything.[8]

Laub, as he put it, "profoundly disagreed." He countered the insistences and refusals based on utter accuracy with the force of the woman's testimony:

> The woman was testifying not to the number of the chimneys blown up, but to something else, more radical, more crucial: the reality of an unimaginable

occurrence. One chimney blown up in Auschwitz was as incredible as four. The number mattered less than the fact of the occurrence. The event itself was almost inconceivable. The woman testified to an event that broke the all compelling frame of Auschwitz, where Jewish armed revolts just did not happen, and had no place. She testified to the breakage of a framework. That was historical truth.[9]

Laub highlights here how the discrepancy between this woman's memory of the Auschwitz uprising and the actual events would, in some arenas, discount her representation of the events as inappropriate for acceptance into the historical record. He crucially interprets that this discrepancy does not render the event inauthentic. Indeed, this woman's lapse in accuracy signals that the processes of bearing witness to trauma are not easily integrated into narrative memory—that is, integrated into a completed story of the past. The gap in this woman's inability to recount the complete story is precisely what Lanzmann emphasizes through his insistence on the impossibility of telling the events. The inabilities need not become alibis for lapsing into fantasy, as Martin Smith feared. Nor should the difficulty of transforming the telling of the events into representations necessarily become the justification for refusing to face this history, and for thus turning away from its visual acknowledgment. This is not to say that contemporary artists' projects attempting to approach the Holocaust and a survivor's testimony function, or malfunction, on the same ontological register; but the discrepancy of the woman's testimony about the Auschwitz uprising dramatizes that the past is not a stable or fixed category, that the force of memories and images—if not altogether accurate or in narrative sequence— nonetheless has enormous bearing on historical representation.

Indeed, what would it mean to create a representation of the Holocaust that would render it accessible, easily understandable? Among the many dangers of such an impossible formulation would be to place the events in the framework of the normal, as if they could be historically assimilated. If the Holocaust could be falsely assimilated through too facile explanations, it risks being explained away, covered over. The impulse may well be to do the events justice lest they remain in obscurity, but the gap between the acts of cruelty and their vindications is too vast for justice to fall into any sense of its normal place. Hence, Lyotard's notion of the differend, the sign, and the reminder that justice in the case of the Holocaust goes far beyond any justice that could be granted through legal procedures and either-or modes of argumentation. Trauma's paradox of "the truth of an event and the truth of its incomprehensibility" recalls the differend's desire to acknowledge and inscribe the event's occurrence. The Shoah challenges representation because it exceeds to such an extreme degree the rela-

tionship between signified and signifier. And yet, the abysses in doing justice to the events murmur that something is asked for. They demand different ways to account for the gaps. The stories, memories, and histories call for reconfigured approaches to measuring the incisions and traces of the incommensurable. It is not a matter of negating the possibility of retelling, of refuting narrative. Indeed, it is out of respect for the workings of trauma and the inabilities it signals that care must be taken not to represent the events in ways that purport to fully communicate while paradoxically covering them over.

Trauma creates an impermeable net that traps the event, making access to it difficult and uncontrollable. Trauma's filtering and breaking-through mechanisms seem to function as protective and confrontational devices. The workings of trauma signal a warning to those who would attempt to represent the Shoah. Its protective mechanisms, which attempt to ward off access to the memory of the events for the individual, can be interpreted as a sign to be on guard against equating disclosure of the events with lucid understanding, as Claude Lanzmann's approach in his film *Shoah* suggests. For Saul Friedländer, "working through" the events for the historian involves

> the imperative of rendering as truthful an account as documents and testimonials will allow, without giving in to the temptation of closure. Closure in this case would represent an obvious avoidance of what remains indeterminate, elusive and opaque. Put differently, working through means for the historian to face the dilemma which, according to Jean-François Lyotard, we try to escape in the face of "Auschwitz": "The silence," writes Lyotard, "that surrounds the phrase 'Auschwitz was the extermination camp' is not a state of mind (état d'âme), it is a sign that something remains to be phrased which is not, something which is not determined." [10]

The paradoxical workings of trauma dovetail in crucial ways with postmodern approaches to photography and representation. Where the surfacing of traumatic events is involuntarily trapped between inaccessibility and unconscious recall or understanding, postmodernist perspectives consciously warn against the presumption that history can be comprehensively narrated. Postmodernism's concern about what is often excluded, what stories do not fit into the master narrative, further aligns it with warnings about representing the Shoah. Indeed, it is precisely the issue that the telling of the events *cannot* fit into a cohesive narrative that is at stake. Friedländer offers the act of self-aware commentary—a methodology that distinguishes many postmodern artists' projects—as a way out of closure, as a way to guard against facile explanations while striving toward historical linkages:

The commentary should disrupt the facile linear progression, introduce alternative interpretations, question any partial conclusion, withstand the need for closure.[11]

It is precisely postmodern thinkers', writers', and artists' embrace of commentary and self-reflexive approaches to the difficulties of representation that invest them in what Friedländer aptly refers to as the indeterminate, elusive, and opaque. That is, postmodernists acknowledge that closure, the final word on the event, would be premature, if not disrespectful. Yet it is crucial not to confuse difficult attempts to represent the Shoah and other traumatic events with an a priori set of assumptions that no retelling is possible. The question is not that there are no facts, that there is no truth; rather, the dilemma lies in formulating approaches to representing the unreal realities. When postmodern warnings about representation are brought to bear on the Shoah, they bring an even greater pressure on the contemporary demand to bear witness.

Friedländer's warning to historians is also imperative for artists: representations of the Shoah must retain an aspect of traumatic reenactment, deeply imprinted on the psyche but beyond facile understanding. Although there can be no definitive "solutions" to the imperative to respectfully memorialize yet unflinchingly confront the realities of the Shoah, photographic representations must remain infused with the crucial opaqueness that Friedländer has written about, which I refer to as "translucent mimesis," and which Andreas Huyssen has aptly characterized as "mimetic approximation":

> No matter how much representation of the Holocaust may be fractured by geography or subject position, ultimately it all comes down to unimaginable, unspeakable and unrepresentable horror. Post-Holocaust generations, it seems to me, can only approach that core by what I would call mimetic approximation, a mnemonic strategy which recognizes the event in its otherness and beyond identification or therapeutic empathy, but which bodily innervates some of the horror and pain in the slow and persistent labor of remembrance.[12]

The questions propelling this book are precisely those that coalesce in elucidating what appropriate approaches to the Shoah through photography might be, where documentary's realism functions respectfully with the necessary translucent mimesis of the events. I have focused on photographic installations and attempts at intersubjectivity in exhibitions at the United States Holocaust Memorial Museum and in artists' works that seek to buffer the abject photographic postmemories of the victimized people in favor of more dignified and loving representations. If it is easier to identify the dangers of documentary in contemporary witnessing, it is all the more

difficult to dictate "successful solutions" to this perilous task. Indeed, documentary itself is not a single term or mode that can be easily set against another monolith, such as art or fiction. A complete refutation of documentary's factual strivings would only replicate dialectic moves toward totalizing schemes that reinstate new limitations.

In Claude Lanzmann's film *Shoah*, he plays out the devastation and the impossibility of comprehending, what Art Spiegelman refers to as the inability to "make sense," through his refusal to employ the overburdened photographic and cinematic signifiers of the extermination. The film is singularly characterized by the striking absence of documentary photographs or, for that matter, any other archival images from the period—except for revisiting the actual sites and thus giving veiled evidence of the haunted landscapes of extermination. *Shoah*'s raison d'être is to relay, through a filtered web of faces, voices, and translators, that the extermination camps existed in full force in Poland. In strategic countermoves aimed at the revisionist lie that the death camps never existed because none of the victims who met their deaths in them can testify—a claim that relies on the most extreme logic of historical inquiry and makes it an obscene farce—Lanzmann's subtle and piercing filmic essay fixes the irrationality of the claim without ever bringing in familiar documentary images. As film historian and critic Gertrud Koch writes, "Lanzmann marks the boundary between what is aesthetically and humanly imaginable and the unimaginable dimension of the annihilation. Thus the film itself creates a dialectical constellation: in the elision, it offers an image of the unimaginable."[13] Koch also claims that *Shoah*'s refusal to rely on documentary material allows it to avoid "lapsing into the embarrassments of gruesome shock effects."[14] Indeed, Lanzmann creates a stunning contemporary document—stunning in the sense of its being both arresting and, in moments, sublimely and mournfully beautiful. *Shoah* allows accessibility to the events by avoiding sickening or numbing the viewer with images of the human extermination itself. The perpetrators' words and facial expressions and the victims' testimonies carry the weight of the atrocity instead of documentary images, moving the structural elements of anti-Semitism into the realm of the present rather than lingering in the abysmal and unapproachable realm of the past.

Lanzmann's prohibition against archival documentary images works profoundly well for the goals of his film. To take his aesthetic and ideological choice as dogma, however, is to create another register of taboos. It must be taken into account that the photograph's role to bear witness is profoundly more difficult to fulfill than a filmic representation. The demand placed on the photographic document, not unlike the modernist art conception of the photographic print, is that it perform as a singular and often

isolated marker. Although I have in part been arguing against the relentless employment of documentary photographs, and how this approach is echoed in the display of artifacts—against the traditional ways they are heaped one on another—to write them out of the staging is to discount some of the most important, albeit difficult, imagery. If trauma's filtering and protective mechanisms issue a warning that the representation of events cannot be completely lucid or easily accessible, trauma's confrontational dynamics also insist on their breaking through this web of opacity. Thus, perhaps it is time to gather in rather than shy away from documentary images, from what Koch refers to as the "embarrassments of gruesome shock effects." To allow into contemporary representations of the Holocaust just such embarrassments. Not to embarrass or hinder so as to completely numb feeling and blind vision, but to perplex in order to form pathways to feeling. To embarrass so as to cause temporary loss of self-possession from an overwhelming vision of someone else's presence. To embrace the temporary loss of self to reach out to an unknown other. To make space for alterity.

Lévinas's notion of alterity is crucial to the project of retrospective witnessing and of facing known and unknown others because the issue at stake is precisely the ability to respond, or the challenge to response-ability, on the part of the post-Auschwitz generation toward those who were wholly or partially effaced. As this study has demonstrated, the photographic act of representation as an (im)possible deed to mourning and naming offers riddled bridges to alterity, to facing the other. Photography has been employed as the presupposed code, the law, the very genre that encodes both history and memory. These different institutions of meaning converge in the place of the photograph as a historical signifier and as a signifying act of mourning. Yes, documentary photographs of the Holocaust risk revictimizing the victims and projecting postmemories of abject identities. Yet, if they do their work slowly, not in mass groups or without completely overwhelming, they might also cut through those walls of passivity and indifference. Recall the unconventionally oversized scale of the photograph at the entrance to the permanent exhibition at the United States Holocaust Memorial Museum. This nontraditional employment of documentary photography exceeds the normal relations of empathy constructed between the passivity of the viewed and the viewer. Notwithstanding a different selection of photographs that are less nationalistically imploded, this setup intrudes in proper places.

Given less monumental representations that shift the traditional documentary eye/I, we are faced, too, with vibrant yet mundane, innocent, and fertile images of people, especially children, before the events transformed them. Looking at more intimate photographs meant to memorialize the

everyday moments of living, perhaps all we can do is allow a deep sigh of grief and sorrow to travel tensely through our lungs to our chests and through the innermost places of our bodies, all the way to the tips of our fingers and toes—to allow the sigh to escape from our wounded yet still intact bodies and psyches. Both weakened and strengthened from the photographic encounter, the distant empathy it elicits begs us to ask whether such seemingly peaceful, deeply melancholic images are more productive inscriptions of light and life than the blinding postmemories of the worst of the documentary images. At the least, we need these gentle images in abundance because the memories they evoke fade so much easier than the memories produced by the brutal photographs. The domestic portraits and the documents of genocide are like bookmarks at two opposite ends of the stories. They bracket the innumerable, difficult memories of what is between the mundane and the shock of the real. As the artists' and the museum's projects treated in this book demonstrate, these divergent modes of photographic representation and the histories they index must crisscross and reference each other in order to be truly effective. As a last glimpse into this subtle, telling, and forceful strategy of juxtaposition before provisionally closing, allow me to reference Serge Klarsfeld's miraculous book, *French Children of the Holocaust,* a painstakingly researched labor of love and resistance that gives faces and specific histories to the Nazis' elaborate lists of the children deported from France, the majority of whom were destroyed.[15] The very last photograph in the main section depicting the children, "The Children of the UGIF [Union Générale des Israélites de France] Center of Neuilly" shows ten kids aged around two to three years old in a sunny outdoor scene with two nurses, one wearing her Jewish star around her neck like a pendant. Klarsfeld and his editors have placed another, very different photograph directly opposite this strangely serene image. Facing this one on the opposite page is a photograph whose caption reads, "Officials Responsible for Anti-Jewish Actions in France." The perpetrators are thus also framed and named as responsible; their mundane faces mark the more difficult visibilities of the crimes they inflicted, and their victims stand retrospectively before them. Perhaps for second, third, and future generations, we need the caress of the estranged family snapshot and the cut of the documentary image, despite the inevitable clichés that both risk developing.

In the gray zones between elaborate historical reconstruction that is the domain of the museum and the not-so-antithetical territory of artistic re-creation, the trauma of the experiences and the trauma in which the photograph intervenes both signal warnings. The photograph is only a trace of the trauma of the Holocaust; it is precisely in its critical trace that

it should not be vainly employed to reconstruct inconceivable yet very real realities. Neither, however, can the photographic artifact be revoked. The precious photographic documents—snapshots and studio portraits taken before the worst occurred and archival ones that insist on the horror— offer translucent mimesis of the events. If the images cannot tell the "full" story, they can be retrieved to work as traces of both lived and projected postmemory. To refuse to claim mastery over the impossible through photography is a necessary acceptance of the events' essential incomprehensibility as well as a tender rejection of the self's ability to take in the other's psychic and bodily sufferings. The fragile possibilities and the poignant risks facing those who attempt to translate Holocaust-related photographs reside in their ability to restage history as a pathway toward retrospective and contemporary alterity, toward an otherness that envisions respectful distance and invites partial palpability.

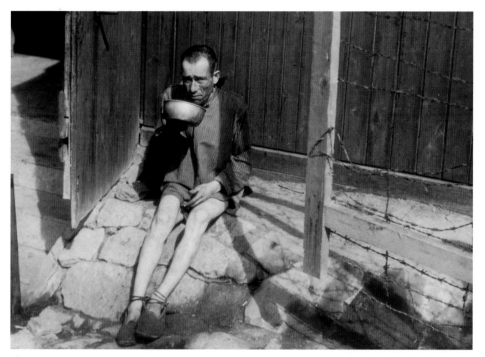

Plate 1. Photograph of survivor at Buchenwald, Germany, 1945. Photograph on entrance wall of the United States Holocaust Memorial Museum. National Archives, courtesy of the United States Holocaust Memorial Museum Photo Archives.

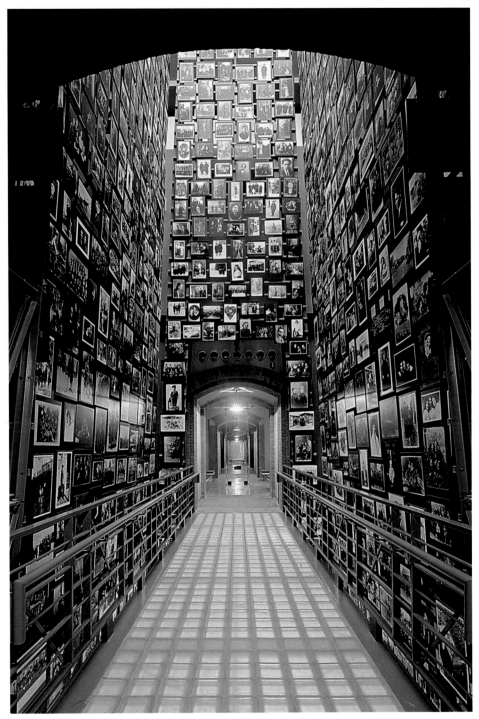

Plate 2. Tower of Faces. Photograph by Timothy Hursley.

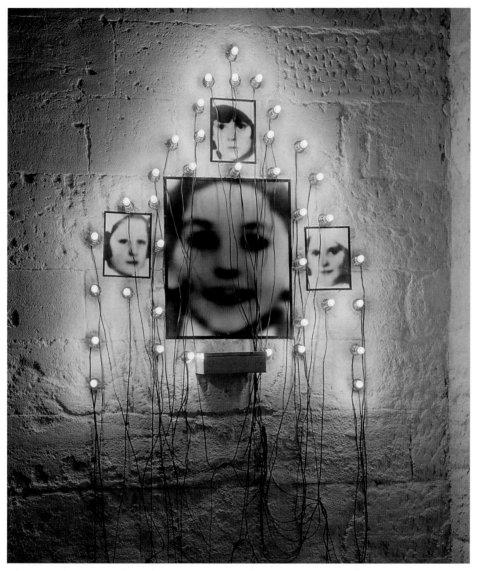

Plate 3. Christian Boltanski, *Monument Odessa*, 1989. Four black–and–white photographs, metal boxes, bulbs, and lights. Overall dimensions: 150 cm x 120.59 cm x 47.24 cm. Courtesy of the Marian Goodman Gallery, New York.

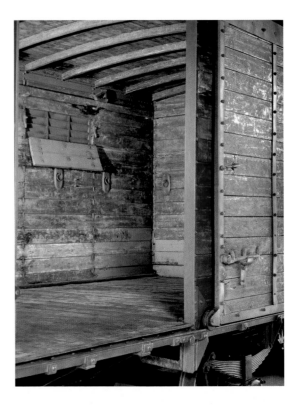

Plate 4. Fifteen-ton freight car of the Karlsruhe model, one of several types used to deport Jews. On display at the United States Holocaust Memorial Museum, donated by the Polish State Railways. Courtesy of the United States Holocaust Memorial Museum Photo Archives.

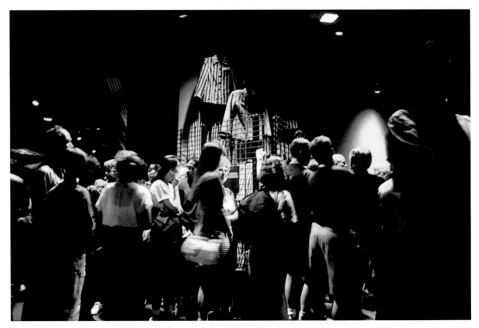

Plate 5. Display of camp uniforms at the United States Holocaust Memorial Museum. Courtesy of Michael Dawson.

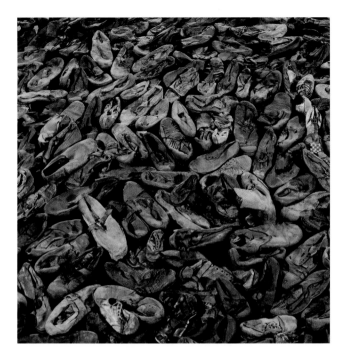

Plate 6. Installation of shoes confiscated from prisoners at the Majdanek concentration camp, Poland, at the United States Holocaust Memorial Museum. On loan from the State Museum of Majdanek. Courtesy of the United States Holocaust Memorial Museum Photo Archives.

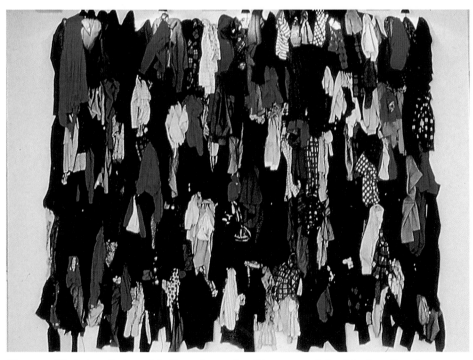

Plate 7. Christian Boltanski, *Canada*, 1989. Courtesy of the Marian Goodman Gallery, New York.

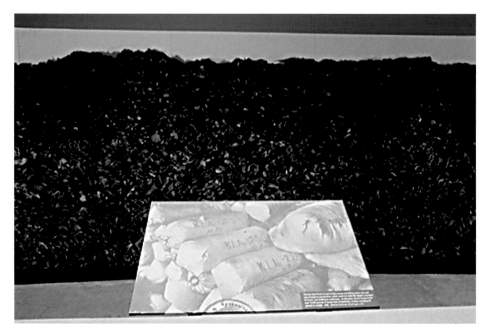

Plate 8. Photomural of hair shorn from prisoners in Auschwitz–Birkenau on display at the United States Holocaust Memorial Museum. The actual hair is on display at the State Museum of Auschwitz. Courtesy of Michael Dawson.

Plate 9. Suzanne Hellmuth and Jock Reynolds, *In Memory: A Bird in the Hand*, installation detail, 1987. Courtesy of the artists.

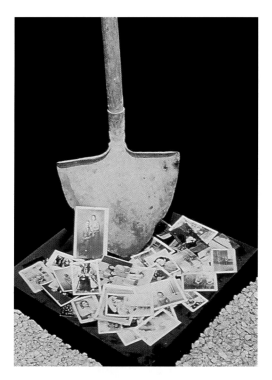

Plate 10. Suzanne Hellmuth and Jock Reynolds, *In Memory: A Bird in the Hand,* installation detail, 1987. Courtesy of the artists.

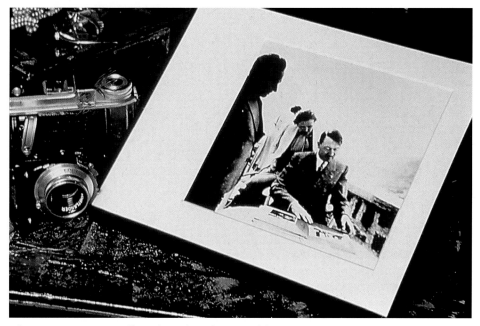

Plate 11. Suzanne Hellmuth and Jock Reynolds, *In Memory: A Bird in the Hand,* installation detail, 1987. Courtesy of the artists.

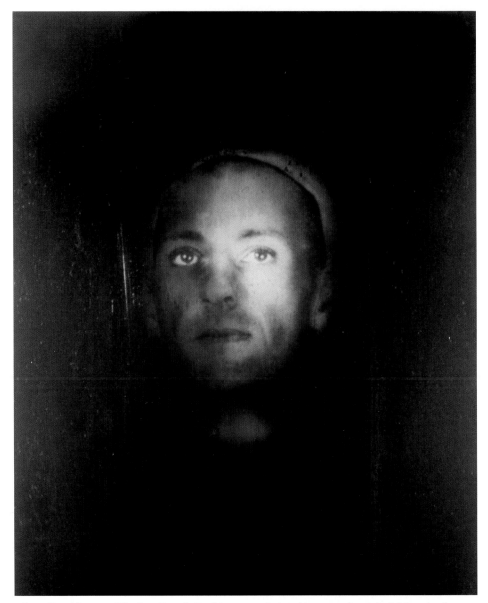

Plate 12. Aharon Gluska, *Jacob Dykierman*, from three works titled *Man and Name* in the *Reframing and Reclaiming* series, 1996. Archival photograph, paint, and gel, 80" x 54". Collection Museum of Yad Vashem, Jerusalem. Courtesy of Penny Liebman—Contemporary Art, New York.

Notes

Introduction

1. What the literature highlights, however, is that documentary is never a transparent claim to truth despite its attempt to set up a universalized one-point perspective. For incisive criticisms of aspects of the documentary tradition, see especially Roland Barthes, "The Rhetoric of the Image," in *Image-Music-Text* (New York: Hill and Wang, 1977); Pierre Bourdieu, *Un art moyen: Essai sur les usage sociaux de la photographie* (Paris: Editions de Minuit, 1965); Pierre Bourdieu, with Luc Boltanski, Robert Castel, Jean-Claude Chamboredon, and Dominique Schnapper, *Photography: A Middle-Brow Art*, trans. Shaun Whiteside (Stanford, Calif.: Stanford University Press, 1990); Victor Burgin, ed., *Thinking Photography* (London: Macmillan, 1982); T. V. Reed, "Unimagined Existence and the Fiction of the Real: Postmodern Realism in *Let Us Now Praise Famous Men*," *Representations* (Fall 1988), 156–76; Martha Rosler, "In, Around, and Afterthoughts on Documentary Photography," in *Martha Rosler: Three Works* (Halifax/Cape Breton, Nova Scotia: Press of Nova Scotia College of Art and Design, 1981); Allan Sekula, "Dismantling Modernism, Reinventing Documentary (Notes on the Politics of Representation)," *Massachusetts Review* 19:4 (Winter 1978) and reprinted in *Photography against the Grain* (Halifax/Cape Breton, Nova Scotia: Press of Nova Scotia College of Art and Design, 1984); Abigail Solomon-Godeau, "Who Is Speaking Thus? Some Questions about Documentary Photography," in *The Event Horizon: Essays on Hope, Sexuality, Social Space and Media(tion) in Art*, ed. Lorna Falk and Barbara Fischer (Toronto: Coach House Press, 1987); Sally Stein, "Making Connections with the Camera: Photography and Social Mobility in the Career of Jacob Riis," *Afterimage* 10:10 (May 1983); William Stott, *Documentary Expression and Thirties America* (Oxford and New York: Oxford University Press, 1973); and John Tagg, *The Burden of Representation: Essays on Photographies and Histories* (Amherst: University of Massachusetts Press, 1988).
2. Quoted in William Stott, *Documentary Expression and Thirties America*, 9.
3. Recent scholarship has attempted to address the wider scope of the New Deal's photographic programs. See especially Pete Daniel, Merry A. Foresta, Maren Stange, and Sally Stein, *Official Images: New Deal Photography* (Washington, D.C., and London: Smithsonian Institution Press, 1987).
4. For an analysis that looks closely at the actual workings of the Farm Security Administration's economic programs, see Maren Stange, "'Symbols of Ideal Life': Tugwell, Stryker, and the FSA Photography Project," in *Symbols of Ideal Life: Social Documentary Photography in America, 1890–1950* (New York and London: Cambridge University Press, 1989). In her study, Stange points out that the government actually gave assistance to those least in need—the landowners, for example—rather than the countless people photographed through the agency's photographic units.
5. My thanks go to Meg Partridge, who supplied me with the script to her film, *Dorothea Lange: A Visual Life*, 1994, distributed by Pacific Pictures, Valley Ford, Calif.
6. Martha Rosler, "In, Around and Afterthoughts," 306.
7. Halla Beloff, *Camera Culture* (Oxford: Basil Blackwell, 1985), 125.
8. Ibid., 120–21.
9. Ibid., 128–30.
10. See especially Saul Friedländer, *Reflections of Nazism: An Essay on Kitsch and Death*, trans. Thomas Weyr (Bloomington: Indiana University Press, 1984); Anton Kaes, *From Hitler to "Heimat":*

The Return of History as Film (Cambridge, Mass., and London: Harvard University Press, 1989); Thomas Elsaesser, "Myth as the Phantasmagoria of History: H. J. Syberberg, Cinema and Representation," *New German Critique* 24–25 (Fall/Winter 1981–82), 108–54; Eric L. Santner, *Stranded Objects: Mourning, Memory, and Film in Postwar Germany* (Ithaca, N.Y., and London: Cornell University Press, 1990) and note his extensive bibliographic references; and
Susan Sontag's less critical, indeed, wholesale enthusiasm for the film in "Syberberg's Hitler," in *Under the Sign of Saturn* (New York: Farrar, Straus, and Giroux, 1980).

11. For provocative discussions of Lanzmann's film, see especially Gertrud Koch's essays "The Aesthetic Transformation of the Image of the Unimaginable: Notes on Claude Lanzmann's *Shoah*," *October* 48 (Spring 1989) and "The Angel of Forgetfulness and the Black Box of Facticity: Trauma and Memory in Claude Lanzmann's Film *Shoah*," *History and Memory* 3:1 (Spring 1991); Michel Deguy, "A Draft of Several Reflections: A Contribution to a Collective Work "On the Subject of *Shoah*," *Sulfur* 25 (Fall 1989); Bernard Cuau et al., eds., *Au Sujet de Shoah: Le film de Claude Lanzmann* (Paris: Editions Belin, 1990); and Shoshana Felman, "The Return of the Voice: Claude Lanzmann's *Shoah*," in Shoshana Felman and Dori Laub, *Testimony: Crises of Witnessing in Literature, Psychoanalysis, and History* (New York and London: Routledge, 1992). For studies on a range of films dealing with the Holocaust, see Ilan Avisar, *Screening the Holocaust: Cinema's Images of the Unimaginable* (Bloomington: Indiana University Press, 1988) and Annette Insdorf, *Indelible Shadows: Film and the Holocaust* (New York: Vintage Books, 1983).

12. For a dissenting opinion on *Shoah* in relation to how Lanzmann "extracted" these testimonies, see James E. Young's discussion of videotaped interviews of survivors in his *Writing and Rewriting the Holocaust: Narrative and the Consequences of Interpretation* (Bloomington: Indiana University Press, 1988), 168–69. See also Nora Levin, "Some Reservations about Lanzmann's *Shoah*," *Sh'ma: A Journal of Jewish Responsibility* 18 (April 1986), 92.

13. See especially Perry Hoberman, "*Schindler's List*: Myth, Movie, and Memory," *Village Voice*, 29 March 1994, 31. Yet my thoughts on this film differ in part from the majority of postmodern criticisms. I would argue that there are important moments that break through its predictable Hollywood narrative based on the opposition of good and evil through its palliative theme of redemption. One striking moment is during the liquidation of the Kraków ghetto when children are desperately trying to seek hiding places; they enter a sewer filled with waste. When another child attempts to seek refuge there, too, the first group of children tell him there is no room and cast him out. There is no sentimentality in this crucial scene. Another moment that importantly differentiates this narrative from other commercial productions is when a group of women who know each other well, who are from the same town, have been rounded up and are together in a deportation camp. They talk among themselves about how they have heard about harsher camps, concentration camps, even camps where people are murdered (they don't call them extermination camps). The scene shows them dismissing such talk as rumors. This dialogue helps break down the stereotype that "they went like sheep" and shows that not everyone knew what was to happen. In fact, when I saw the movie in a theater, I remember hearing a teenage girl behind me say, "Oh Mom, they didn't know."

14. It is also entirely possible that part of President Carter's idea to create a memorial to the Holocaust in Washington, D.C., resulting in a Commission on the Holocaust in 1980, was motivated by his political need to appease a large segment of the Jewish community that supports Israel and that was outraged after Carter sold a fleet of F-15 fighter planes to Saudi Arabia in 1978.

15. Berenbaum made this statement in his keynote address at the conference "Articulations of History: Issues in Holocaust Representation," organized by the Photographic Resource Center and Boston University, Boston, 1–3 May 1995.

16. Irving Howe, preface to Janet Blatter and Sybil Milton, *Art of the Holocaust* (New York: Rutledge Press, 1981), 11.

1. Photography and Naming

1. Cusian and Knoblock's photographs, taken in the Warsaw ghetto during the spring of 1941, are reproduced in *The Warsaw Ghetto in Photographs*, ed. Ulrich Keller (New York: Dover Publications, 1984). The film rolls are housed at the Bundesarchiv, Koblenz. See also the chilling "report" by the Nazi commander of the Warsaw ghetto, *The Stroop Report: The Jewish Quarter of Warsaw Is No More!*, ed. and trans. Sybil Milton (New York: Pantheon, 1979); and Sybil Milton, "The Camera as Weapon: Documentary Photography and the Holocaust," Simon Wiesenthal Center Annual vol. 1 (Chappaqua, N.Y.: Rossel Books, 1984), 45–68.

2. This book, whose original subtitle is *A Report on the Collapse of Hitler's "Thousand Years,"* was published by Simon and Schuster, New York, in 1946. A German translation came out in 1979: *Deutschland: April 1945*, trans. Ulrike von Puttkamer (Munich: Schirmer/Mosel).

3. For a fuller representation of her wartime photography, see *Lee Miller's War: Photographer and*

Correspondent with the Allies in Europe, 1944–45, ed. Anthony Penrose (Boston: Bulfinch Press, Little, Brown, 1992).

4. The exhibition was held between 23 February and 11 May 1997. See the catalog to the exhibition, *Exiles and Emigrés: The Flight of European Artists from Hitler*, ed. Stephanie Barron with Sabine Eckmann (Los Angeles and New York: Los Angeles County Museum of Art and Abrams, 1997).

5. The exhibition, *19.9.1941, A Day in the Warsaw Ghetto: A Birthday Trip in Hell*, was organized by Yad Vashem and circulated in the United States by the Smithsonian Institution Traveling Exhibition Service from 1990 to 1995. See my essay "An Uneasy Witness," *Afterimage* (December 1991), 15–16, for a critical review of this exhibition. For more background on the ghetto and the people who became the camera's targets, including those Günther Schwarberg was able to trace after the war, see his remarkably researched *Das Getto* (Göttingen: Steidl Verlag, 1989).

6. Heydecker covered the trial of Nazi war criminals, resulting in his book, written with Johannes Leeb, *The Nuremberg Trial: A History of Nazi Germany as Revealed through the Testimony at Nuremburg*, ed. and trans. R. A. Downie (Westport, Conn.: Greenwood Press, 1962, 1975).

7. His long-coveted photographs were first published in São Paulo, Brazil, through Atlantis Livros. Heydecker moved to Brazil in 1960. Then the book came out in German, *Joe J. Heydecker: Das Warschauer Getto: Foto-Dokumente eines deutschen Soldaten aus dem Jahr 1941*, with a foreword by Heinrich Böll (Munich: Deutscher Taschenbuch Verlag, 1983). This book has been translated as *The Warsaw Ghetto: A Photographic Record, 1941–1944* (London: I. B. Tauris, 1990). For first-hand written accounts of the Warsaw ghetto and the Polish Underground Press along with more precious photographs, see *In the Warsaw Ghetto: Summer 1941*, photographs by Willy Georg with passages from Warsaw ghetto diaries, compiled and with an afterword by Rafael F. Scharf (New York: Aperture, 1993).

8. Z. Szner and A. Sened, eds., *With a Camera in the Ghetto: Mendel Grossman* (New York: Schocken Books, 1977).

9. James E. Young, *Writing and Rewriting the Holocaust*, 57–58.

10. Allan Sekula carefully lays out photography's "double system: a system of representation capable of functioning both *honorifically* and *repressively*." See his essay "The Body and the Archive," *October* 39 (Winter 1986); revised and reprinted in *The Contest of Meaning: Critical Histories of Photography*, ed. Richard Bolton (Cambridge, Mass., and London: MIT Press, 1989).

11. Many of the same dilemmas bearing on photography's doubled-crossed relations between representation and reality are endemic to debates on photographic depictions of people with AIDS. Douglas Crimp's seminal essay "AIDS: Cultural Analysis/Cultural Activism," *October* 43 (Winter 1987), mapped out photography's dual role to both mourn the deaths and take on a militant role of activism.

12. For a detailed historical and theoretical analysis of naming the events, see James E. Young's chapter "Names of the Holocaust," in *Writing and Rewriting the Holocaust*, 83–98; and Vivian M. Patraka, "Situating History and Difference: The Performance of the Term *Holocaust* in Public Discourse," in *Jews and Other Differences: The New Jewish Cultural Studies*, ed. Jonathan and Daniel Boyarin (Minneapolis: University of Minnesota Press, 1997).

13. Susan Sontag, *On Photography* (New York: Farrar, Straus, and Giroux, 1977), 20.

14. Julia Kristeva, "The Pain of Sorrow in the Modern World: The Works of Marguerite Duras," trans. Katharine A. Jensen, *PMLA* 102 (1987), 139.

15. Julia Kristeva, *Powers of Horror: An Essay on Abjection*, trans. Leon S. Roudiez (New York: Columbia University Press, 1982), 141.

16. Immediately after its utterance, Frohnmayer's statement reverberated in Washington's halls of justice, as well as in the popular press. Keith Donohue, a representative from Frohnmayer's agency, sent me a letter dated August 1990, which served as a model for responses to the chair's comments. This "letter of apology" states in part, "The reference was ill-chosen. . . . I certainly did not mean to suggest that the images of the Holocaust be relegated to obscurity. . . . My point, which I made badly if at all, had to do with confronting images or expressions that are shocking. The Holocaust was the most shocking human experience which came to mind."

17. Pierre Bourdieu, *Photography: A Middle-Brow Art*, 192, n.11.

18. Quoted in Carla Hall, "Celebrating the Will to Remember," *Washington Post*, 29 April 1987, Style Section, 1.

19. See Walter Benjamin, "The Work of Art in the Age of Mechanical Reproduction," in *Illuminations*, ed. Hannah Arendt (New York: Schocken Books, 1969).

20. This term is crucial in Benjamin's essay on pure and impure language, "On Language as Such and On the Language of Man," in *Reflections: Essays, Aphorisms, Autobiographical Writings*, trans. Edmund Jephcott, ed. Peter Demetz (New York and London: Harcourt Brace Jovanovich, 1978).

21. Ibid., 330.

22. Roland Barthes, *Camera Lucida: Reflections on Photography*, trans. Richard Howard (New York:

Hill and Wang, 1984). Although Barthes conflates the realist and commemorative status of photography with his own poignant need to recapture his bond with his deceased mother, he also considers the photograph's unsettling ability to disrupt the private sphere through its simultaneously disembodied public identity.

23. In *Spirit in Ashes: Hegel, Heidegger, and Man-Made Mass Death* (New Haven, Conn., and London: Yale University Press, 1985), Wyschogrod adds that this discourse on death is "dominated by a single pattern which depends upon interpreting the self as a cognition monad and the process of dying as requiring behavior appropriate to a rational subject." She suggests that philosophical perceptions of language, self, and society must be reevaluated in light of technologically accomplished mass death.

24. Judith Butler, book review of Wyschogrod's *Spirit in Ashes,* in *History and Theory* 27:1 (1986), 69.

25. Saul Friedländer, "The 'Final Solution': Unease in Interpretation," *History and Memory* 1:2 (Fall–Winter 1989), 75, n.14. In Friedländer's lucid and compelling essay, he cites impeccable Holocaust scholars including Arno Mayer, Charles Maier, and Raul Hilberg in reference to a common indismissible sense of their lack of understanding of the events despite or, rather, in the face of their relentless research.

26. Ibid., 61, emphasis added.

27. Jean-François Lyotard, *The Differend: Phrases in Dispute* (Minneapolis: University of Minnesota Press, 1988). Lyotard's earlier thinking on this subject appeared in "Discussions, or Phrasing 'after Auschwitz,'" which was first presented as a lecture in 1980 for the colloquium "Les fins de l'homme: À partir du travail de Jacques Derrida," at Cerisay-la-Salle. It was translated by Georges van den Abbeele and first published as Working Paper no. 2, 1986, for the Center for Twentieth-Century Studies, University of Milwaukee. It is reprinted in *The Lyotard Reader,* ed. Andrew Benjamin (Cambridge, Mass., and Oxford: Basil Blackwell, 1989), 360–92. This essay also appears in Lyotard's *The Differend* as part of the chapter "Result." In keeping with the tone and structure of *The Differend,* "Result" differs from "Discussions" in its more rhetorical insistence on the linking of one notice to another (all of them are numbered).

 For an excellent analysis of Lyotard's reintepretations of Kant, especially the relations that can be thought across aesthetics and politics, see David Carroll, "Rephrasing the Political with Kant and Lyotard: From Aesthetic to Political Judgements," *Diacritics* 14:3 (Fall 1984), 74–88. See also Geoffrey Bennington, *Lyotard: Writing the Event* (Manchester: Manchester University Press, 1988).

28. For a discussion on the history of "revisionism" in relation to the Holocaust and the often strange commingling of the far Right and the far Left in these affairs, see Pierre Vidal-Naquet, "Theses on Revisionism," in *Nazi Germany and the Genocide of the Jews,* ed. François Furet (New York: Schocken Books, 1989), 304–19; and Pierre Vidal-Naquet, *Les assassins de la mémoire: "Un Eichmann de papier" et autres essais sur le revisionnisme* (Paris: Editions La Découverte, 1987). See also Nadine Fresco, "Negating the Dead," in *Holocaust Remembrance: The Shapes of Memory,* ed. Geoffrey H. Hartman (Cambridge, Mass., and Oxford: Basil Blackwell, 1994), 191–203; Deborah Lipstadt, *Denying the Holocaust: The Growing Assault on Truth and Memory* (New York: Free Press, 1993); and Kenneth S. Stern, *Holocaust Denial* (New York: American Jewish Committee Imprint, 1993).

29. Lyotard, *The Differend,* 5.

30. Ibid., 56–57.

31. Ibid., 13, emphasis added.

32. See Theodor W. Adorno, "Valéry Proust Museum," in *Prisms,* trans. Samuel and Shierry Weber (Cambridge, Mass.: MIT Press, 1981).

2. The Identity Card Project and the Tower of Faces at the United States Holocaust Memorial Museum

1. The following discussion on the identity card project and the Tower of Faces is based in part on the museum's publicity as well as interviews I conducted with key planning members of the permanent exhibition team in Washington, D.C., in August 1990, March 1992, and April 1993; the last visit took place at the time the museum opened to the public (26 April). The United States Holocaust Memorial Museum is the nation's first officially sanctioned and federally mandated (but privately funded) institution in this country dedicated to the memory of and continued education about the Holocaust. The concept for the museum was instituted by an act of Congress on 7 October 1980, under the auspices of President Jimmy Carter. It is located adjacent to the Mall, between 14th Street and Raoul Wallenberg Place (formerly 15th Street), east of Independence Avenue and within view of the Washington Monument and the Jefferson Memorial.

2. Similar assumptions about ownership of a historical event also occur when the name of the museum appears abbreviated, in its perhaps unconscious act of conforming to the bureaucratized

economies of Washington, D.C. The museum's use of the acronym USHMM serves to neutralize the frenetic dynamics that the institution houses and animates. The presumptions of abbreviating only underline the authoritative and definitive name that inaugurates this institution. For a countermeasure in a very different genre, a literary act that names and safeguards reference to Holocaust memory without laying authoritative claim to it, see Jacques Derrida, *Feu la cendre* (Paris: Des Femmes, 1987). This book has been translated into English by Ned Lukacher as *Cinders* (Lincoln: University of Nebraska Press, 1991).

3. Berenbaum made these comments in his keynote address at the conference "Articulations of History."

4. Smith is known for his work with historical subjects and what he himself refers to as "difficult" material. His *The World at War* television special about World War II aired on U.S. television. His work at the museum was produced in tandem with exhibition designer Ralph Appelbaum. Ralph Appelbaum Associates, a New York City firm, specializes in the planning and design of natural, cultural, and social history museums. The firm designed the permanent exhibition at the newly renovated Jewish Museum in New York on four thousand years of Jewish culture and identity. Another of the firm's commissions is *A Vision of the Americas*, a new installation for the Smithsonian Institution, which the firm said will "challenge misconceptions about Native Americans." Some of their past projects include the permanent installation *Native Peoples of the Southwest* at the Heard Museum, Phoenix, Arizona (1984), and the traveling exhibition *Jackie Robinson: An American Journey* (1987) for the New York Historical Society.

5. Weinberg's comments were reported by Judith Weinraub, "Passing On the Memory of the Holocaust," *Washington Post*, 2 February 1990, C4.

6. From my interview with Martin Smith at the temporary offices of the United States Holocaust Memorial Museum in Washington, D.C., 22 August 1990.

7. Berenbaum made this statement in his keynote address at the Boston conference.

8. My thanks go to Raye Farr, who replaced Martin Smith as director of the permanent exhibition program, for giving me a tour of the museum model in early March 1992. Farr is currently director of the museum's film programs.

9. See Robert H. Abzug's compelling study *Inside the Vicious Heart: Americans and the Liberation of Nazi Concentration Camps* (New York and Oxford: Oxford University Press, 1985).

10. For a lucid and focused essay on the museum's attempt to transform the visitor's psychic identity and to stage the experience as a lesson in democracy, see especially Greig Crysler and Abidin Kusno, "Angels in the Temple: The Aesthetic Construction of Citizenship at the United States Holocaust Memorial Museum," *Art Journal*, special issue on Aesthetics and the Body Politic, ed. Grant Kester 56:1 (Spring 1997), 52–64. For more sympathetic readings of the museum's strategies, see Edward Linenthal's study *Preserving Memory: The Struggle to Create America's Holocaust Museum* (New York: Penguin, 1995). See also Harold Kaplan, *Conscience and Memory: Meditations in a Museum of the Holocaust* (Chicago and London: University of Chicago Press, 1994), which muses on the museum in Washington, D.C., as the backdrop to his contention that the museum will have a "civilizing" effect on its viewers and will achieve a kind of mourning and healing through its "democratic" principles. The museum has also published its own history of itself. See Michael Berenbaum, *The World Must Know: The History of the Holocaust as Told in the United States Holocaust Memorial Museum* (Boston: Little, Brown, 1993).

 See also the chapters "The Plural Faces of Holocaust Memory in America" and "Memory and the Politics of Identity: Boston and Washington, D.C.," in James E. Young, *The Texture of Memory: Holocaust Memorials and Meaning* (New Haven, Conn., and London: Yale University Press, 1993); and Peter Novick, "Holocaust Memory in America," in *The Art of Memory: Holocaust Memorials in History*, ed. James E. Young (Munich and New York: Prestel-Verlag and The Jewish Museum, 1994). The exhibition of the same name, curated by Young, was open at The Jewish Museum in New York from 13 March to 31 July 1994 and traveled to the Deutsches Historisches Museum, Berlin from 8 September to 13 November 1994, and to the Münchner Stadtmuseum, Munich from 9 December 1994 to 5 March 1995.

11. For a study attentive to the different ways that color photography creates meaning in American documentary conventions, see Sally Stein's forthcoming book *The Colorful and the Colorless: American Photography and Material Culture between the Wars* (Washington, D.C.: Smithsonian Institution Press).

12. Lyotard, *The Differend*, 13.

13. Adorno's phrase appears in Theodor W. Adorno, "Cultural Criticism and Society," in *Prisms*, 34; his later explanation appeared in Adorno, "Engagement," in *Noten zur Literatur III* (Frankfurt am Main: Suhrkamp Verlag, 1965), 125–27.

14. Interview with Martin Smith (emphasis is mine) (see note 6).

15. From a statement included in the museum's publicity packet.

16. Irving Howe, preface to Blatter and Milton, *Art of the Holocaust*, 11.

17. Interview with Martin Smith.

18. Jacques Derrida, *Mémoires for Paul de Man*, trans. Cecile Lindsay, Jonathan Culler, Eduardo Cadava, and Peggy Kamuf (New York: Columbia University Press, 1986), 34–35. I am moved by Derrida's reconfigured ideas on mourning in this text. I pointedly do not address the complex issue of Paul de Man and the politics of collaboration during World War II. In his study *Stranded Objects* (see note 10 in the Introduction), Eric L. Santner employs de Man's ideas on mourning and language as he excuses himself from dealing with the political ramifications of what he characterizes as de Man's contribution to "the cause of collaboration." He writes: "What interests me in the present context is the relation between a past scarred by these words, as few as they may be, and the subsequent writings of de Man which are informed by an uncompromising rigor" (15). In Shoshana Felman's writing, especially the essay "After the Apocalypse: Paul de Man and the Fall to Silence," in Felman and Dori Laub's *Testimony: Crises of Witnessing in Literature, Psychoanalysis, and History* (see note 11, Introduction), she continuously repeats the action of defending and justifying de Man. See Dominick LaCapra's astute essay "The Personal, the Political and the Textual: Paul de Man as Object of Transference," *History and Memory* 4:1 (Spring/ Summer 1991), in which, as the title of his piece suggests, he addresses the issue of de Man's early writings compared to those of the later de Man in terms of how they "involve an exchange between past and present that is best approached through the problem of transference and the manner in which one negotiates it. This transferential dimension has, I think, been largely ignored, denied, repressed or acted out rather than thematized in the attempt to work it through" (5).

19. Derrida, "Fors," foreword to Nicolas Abraham and Maria Torok, *The Wolf Man's Magic Word: A Cryptonomy*, trans. Nicholas Rand (Minneapolis: University of Minnesota Press, 1986), xvii.

20. Quoted in ibid.

21. Jonathan Rosen, "America's Holocaust," *Forward*, 12 April 1991.

22. James E. Young, *The Texture of Memory*, 344.

23. This observation about the blind spots in the mechanisms of the identity card have been most lucidly noted by Jonathan Rosen in "America's Holocaust," and by Liliane Weissberg in her essay "Memory Confined," *Documents* 4/5 (Spring 1994).

24. Articles on the Tower of Faces have appeared in both the popular press as well as in more specialized art, architecture, and cultural journals. Among these, see Andrea Liss, "Contours of Naming: The Identity Card Project and the Tower of Faces at the United States Holocaust Memorial Museum," *Public* 8 (1993), 108–34; Ziva Freiman, "Memory Too Politic," *Progressive Architecture* (October 1995), 62–69; and for essays that discuss the tower in relation to other contemporary art and installation projects, see Ken Johnson, "Art and Memory," *Art in America* (November 1993), 90–99; Lenore D. Miller, "Manipulated Environments: Photomontage into Sculpture," *Camerawork* 21:1 (Spring/Summer 1994), 22–27. For a range of the articles that appeared in the popular press, see the report in *Life* (April 1993); and Michael Kernan, "A New Monument to Remembering—with a Mission," *Smithsonian* 24:1 (April 1993), 50–60.

25. "A Tower of Faces, a Tower of Life," *The United States Holocaust Memorial Museum Newsletter* (March 1991), 5.

26. For studies on this issue, see Deborah Lipstadt, *Beyond Belief: The American Press and the Coming of the Holocaust* (New York: Free Press, 1986); David S. Wyman, *The Abandonment of the Jews: America and the Holocaust, 1941–1945* (New York: Pantheon, 1984); and Henry L. Feingold, *The Politics of Rescue: The Roosevelt Administration and the Holocaust, 1938–1945* (New Brunswick, N.J.: Rutgers University Press, 1970).

27. I deal in more length with the crucial theme of trauma and its relation to representation in later chapters, especially in chapter 4.

28. Ida Fink, *A Scrap of Time*, trans. Madeline Levine and Francine Prose (New York: Pantheon Books, 1987), 3.

29. Nathan Wachtel, "Remember and Never Forget," *History and Anthropology* (1986): 307–35.

30. From my interview with Yaffa Eliach in Brooklyn, 4 May 1993.

31. Eliach's grandmother took over the business after her husband passed away. Their assistants B. Szrejder and R. Lejbowicz also took photographs that were selected for the Tower of Faces from the Yaffa Eliach Shtetl Collection.

32. Walter Benjamin, "The Work of Art in the Age of Mechanical Reproduction," 226.

33. This text is part of Eliach's foreword to the book that accompanied an exhibition of photographs on the fate of children in Europe just before, during, and after the Holocaust, *We Were Children Just Like You* (Brooklyn, N.Y.: Center for Holocaust Studies, Documentation and Research, 1990), 6–7. The exhibition opened at the Milton Weill Art Gallery of the 92nd Street Y in New York City. Photographic collections included various files from Eliach's archives, including the Ejszyszki Shtetl Collection, as well as the collections from Beth Hatefutsoth, Hadassah Archives, HIAS, Yad Vashem, and YIVO, among them.

34. Sigmund Freud, "Mourning and Melancolia," in *General Psychological Theory: Papers on Metapsychology,* ed. Philip Rieff (New York: Macmillan, 1963), 164–79.
35. Emmanuel Lévinas, *Otherwise Than Being or beyond Essence,* trans. Alphonso Lingis (The Hague: M. Nihoff, 1981), 100–101.

3. Between Trauma and Nostalgia

1. *Christian Boltanski: Lessons of Darkness,* exhibition catalog, introduction by Mary Jane Jacob, essays by Lynn Gumpert and Christian Boltanski (Chicago: Chicago Museum of Contemporary Art, 1988). The exhibition was co-organized by the Chicago Museum of Contemporary Art, the Los Angeles Museum of Contemporary Art, and the New Museum of Contemporary Art, New York. It was on view at these sites as well as at the Vancouver Art Gallery, British Columbia, the University Art Museum, Berkeley, and the Power Plant, Toronto, where it closed in January 1990.
2. Nancy Marmer's essay "Boltanski: The Uses of Contradiction," *Art in America* (October 1989), 169–80, 233–35 addresses the complexities of the post-1968 artistic scene in France as well as takes a more critical and analytical stance toward Boltanski's work than was characteristic of other responses to the traveling exhibition. Rather then elide or simplify the contradictions in the artist's ideas and practice, Marmer acknowledges ambiguity as a willful and fruitful strategy in his work.
3. This story is told in *Lessons of Darkness.*
4. Marmer, "Boltanski: The Uses of Contradiction," 180. For a different, less innocent reading of Boltanski's photographs and installations, see Ernst van Alphen's lucid study *Caught by History: Holocaust Effects in Contemporary Art, Literature and Theory* (Stanford, Calif.: Stanford University Press, 1998).
5. Georgia Marsh, "The White and the Black: An Interview with Christian Boltanski," *Parkett* 22 (1989), 36.
6. Marmer, "Boltanski: The Uses of Contradiction," 170.
7. In a letter to Boltanski from a survivor, Leo Glueckselig, who is pictured in the photograph, Glueckselig notes that he recalls the proper spelling of his former high school is *Lycée Chajes,* not *Lycée Chases.* A discussion of this letter follows in this chapter.
8. My sincerest thanks to Robert Rainwater, Assistant Director for Art, Prints and Photography at the New York Public Library, who sent me a xerox copy of Glueckselig's letter, which I originally saw in the library's exhibition, *Christian Boltanski: Books, Prints, Printed Matter, Ephemera,* on view from 27 February to 15 May 1993.
9. This portfolio was printed and produced at Crown Point Press in San Francisco.
10. Marmer quotes Boltanski from an interview she conducted with him on 2 November 1988. See Marmer, "Boltanski: The Uses of Contradiction," 233.
11. Emmanuel Lévinas, *Totality and Infinity: An Essay on Exteriority,* trans. Alphonso Lingis (The Hague: M. Nijhoff, 1979), 194.
12. Quoted in Tamra Wright, Peter Hughes, and Alison Ainley, "The Paradox of Morality: An Interview with Emmanuel Lévinas," in *The Provocation of Lévinas: Rethinking the Other,* ed. Robert Bernasconi and David Wood (New York and London: Routledge), 170.
13. Jean-François Lyotard, *The Differend,* 57.
14. Jean-François Lyotard, "Answering the Question: What Is Postmodernism?" in *The Postmodern Condition,* trans. Geoffrey Bennington and Brian Massumi (Minneapolis: University of Minnesota Press, 1984), 181.
15. Marmer, "Boltanski: The Uses of Contradiction," 176.
16. Marsh, "The White and the Black," 38–39.
17. Donald Kuspit, review of Christian Boltanski exhibition at the Marian Goodman Gallery in *Artforum* (March 1991), 123.
18. Marsh, "The White and the Black," 39.
19. See note 22 to chap. 1.
20. From my interview with Yaffa Eliach, 4 May 1993.
21. Greig Crysler and Abidin Kusno, "Angels in the Temple," 61.
22. From my interview with Ralph Appelbaum at the United States Holocaust Memorial Museum, 4 May 1993.
23. Yaffa Eliach's book, *There Once Was a World* (Boston: Little, Brown, 1998), gives an in-depth history of the town as well as sustained readings of the different ideological perspectives of the photographers who took the portraits in the Tower of Faces.
24. Saul Friedländer, "Trauma, Transference and 'Working Through,'" *History and Memory* 4:1 (Spring/Summer 1992), 53. This essay was reprinted as "Trauma and Transference" in Friedländer's book *Memory, History, and the Extermination of the Jews of Europe* (Bloomington and Indianapolis: Indiana University Press, 1993), 117–37.

25. Both books were published by Pantheon Books, a division of Random House, Inc., New York, and simultaneously published in Canada by Random House of Canada Limited, Toronto. Subsequent references will appear parenthetically in the text.

26. Graham Smith, "From Micky to Maus: Recalling the Genocide through Cartoon," *Oral History Journal* 15:1 (Spring 1987), 28.

27. Marianne Hirsch, "Family Pictures: *Maus,* Mourning, and Post-Memory," *Discourse* 15:2 (Winter 1992–93), 28, n. 2. This lucid essay focuses on the crucial role of photographs in *Maus* as well as Spiegelman's attempt to recover his mother's lost legacy. For a discussion attentive to issues of gender and autobiography, see also Nancy K. Miller's essay "Cartoons of the Self: Portrait of the Artist as a Young Murderer, Art Spiegelman's *Maus,*" *M/E/A/N/I/N/G* 12 (November 1992), 43–54.

28. In this regard, I am also thinking of Abraham Ravett's remarkable film *Everything's for You,* (1989) about his father, also an Auschwitz survivor. Ravett interweaves his father's "heimische" (folksy) advice about life with the worst of the events. When the psychic strain is too difficult, Ravett substitutes the camera's gaze with sketched animations. Ravett's film also includes targeted use of both archival film footage and pre-Holocaust family photographs—in fact, one of the most effective employments of both in any contemporary representation of the Shoah. Tatana Kellner's handmade books *B-11226: Fifty Years of Silence* and *71125: Fifty Years of Silence,* both from 1992, tell her father's and mother's stories of survival in and out of Auschwitz through their own testimonies. Their words, in their own handwriting, are visible against the backdrop of pre-Holocaust family snapshots and archival photographs. The pages of each book are literally cut through by the cast of her mother's arm (in *71125*) and father's arm (in *B-11226*); the arm acts as the visible yet uncanny evidence through which every memory and document must be witnessed—in a way similar to Ravett's use of animation and Spiegelman's use of the family photos.

29. From my phone conversation with Art Spiegelman, 13 November 1994.

30. Jean Améry, *At the Mind's Limit: Contemplations by a Survivor on Auschwitz and Its Realities,* trans. Sidney Rosenfeld and Stella P. Rosenfeld (Bloomington: Indiana University Press, 1980).

31. Lawrence L. Langer, *Holocaust Testimonies: The Ruins of Memory* (New Haven, Conn., and London: Yale University Press, 1991), 67.

32. *Maus* is now available on CD-ROM, *The Complete MAUS,* from the Voyager Company. Among the multiple levels of the CD-ROM, it allows the "interactive" participant to compare the book's many preliminary sketches and different stages of progress with the finished pages of the book, and its video clips show the sites Vladek described in the books. The audio component is invaluable, giving us Vladek's voice and intonations from the extensive interviews.

33. This apt term is Spiegelman's, used during our phone conversation.

4. Artifactual Witnessing as (Im)Possible Evidence

1. Interview with Martin Smith, 22 August 1990.

2. Shoshana Felman, "Camus' *The Fall,* or the Betrayal of the Witness," in Laub and Felman, *Testimony,* 202.

3. For a description of the rates charged for the "journey" according to the "traveler's" age and how far he or she would travel and of the "credits" offered the SS for one-way transport, see Michael Berenbaum, *The World Must Know: The History of the Holocaust as Told in the United States Holocaust Memorial Museum* (Boston: Little, Brown, 1993): "Reichsbahn employees used the same forms and procedures to book tourists going on vacation as they did to send Jews to Auschwitz" (115).

4. Sigmund Freud, "Introductory Lectures on Psychoanalysis" (1916–17), in *The Standard Edition of the Complete Psychological Works of Sigmund Freud,* ed. and trans. James Strachey, 24 vols. (London: Hogarth Press, 1953–74), vol. 16, 275.

5. Sigmund Freud, *Beyond the Pleasure Principle,* in *The Standard Edition,* vol. 18, 29.

6. Ibid.

7. Cathy Caruth, "Introduction," special issue on "Psychoanalysis, Culture and Trauma: II," *American Imago* 48:4 (Winter 1991), 417. In Saul Friedländer's essay "Trauma, Transference and 'Working Through,'" the author takes issue with aspects of Caruth's thesis regarding the possibility of a delayed constitution of historical understanding, published in another essay by Caruth, "Unclaimed Experience: Trauma and the Possibility of History," *Yale French Studies* 79 (1991). However, if Friedländer questions what he calls Caruth's "redemptive theme" (following Freud's *Moses and Monotheism* [New York: Knopf, 1939]), in contrast with the lack of closure offered to survivors, he nonetheless acknowledges the central theme of trauma's inaccessibility to conscious recall. In his essay, Friedländer writes, "But neither the protective numbing nor the disruptive emotion is entirely accessible to consciousness" (51).

8. Caruth, "Introduction," 417, 419–20.

9. Ibid., 420.

10. Ibid., 421.

11. The information on the location of the inscribed arch is taken from Debórah Dwork and Robert Jan van Pelt's important study "Reclaiming Auschwitz," in *Holocaust Remembrance: The Shapes of Memory*, ed. Geoffrey H. Hartman (Cambridge, Mass., and Oxford: Basil Blackwell, 1994), 236–38.

12. See Philip Gourevitch's essay "Behold Now Behemoth, The Holocaust Memorial Museum: One More American Theme Park," *Harper's* (July 1993), 55–62. For a critical discussion of the spectator dynamics at work at the Museum of Tolerance, see Mark Durant's essay, "Exhibiting Tolerance," *Afterimage* (October 1993), 12–14.

13. Feminist historian of the Holocaust Joan Ringelheim was brought in to work with the permanent exhibition team to plan this audiotape installation. See her research in *A Catalogue of Audio and Video Collections of Holocaust Testimony* (New York: Greenwood Press, 1992), and her earlier essay directly dealing with women's experiences, "The Unethical and the Unspeakable: Women and the Holocaust," in *Simon Wiesenthal Center Annual*, vol. 1 (Chappaqua, N.Y.: Rossell Books, 1984).

14. For measured criticisms of audio Holocaust testimonies, see Geoffrey H. Hartman, "Preserving the Personal Story: The Role of Video Documentation," *Dimensions: A Journal of Holocaust Studies* 1:1 (Spring 1985), 14. For an embrace of videotaped testimonies, see James E. Young, *Writing and Rewriting the Holocaust*, 169–70.

15. From my phone conversation with Ralph Appelbaum, 30 March 1993.

16. Gertrud Koch, "The Angel of Forgetfulness and the Black Box of Facticity: Trauma and Memory in Claude Lanzmann's Film *Shoah*," 123.

17. Andreas Huyssen's, "Anselm Kiefer: The Terror of History, the Temptation of Myth," *October* 48 (Spring 1989), 25–45, is to my mind the best writing on Kiefer's paintings and earlier photographic works. Huyssen acknowledges his own national and generational affinities with Kiefer as a post-Auschwitz German, as well as his discomfort with and respect for the artist's varying strategies in alluding to the Holocaust in his work. I discuss Kiefer's early photographic series *Occupations* in the next chapter.

18. Theodor W. Adorno, "Valéry Proust Museum," 173–85.

19. Luiseño/Diegueño Indian artist James Luna's installation *The Artifact Piece* (1987) insightfully provokes these museologized lines that designate the past as near extinction in a present that seems to have no connection to that past. In *The Artifact Piece* Luna placed himself, clothed only in a breechcloth, in an exhibition vitrine set up in a room anthropologizing Native Americans at the Museum of Man in Balboa Park, San Diego. For literature on James Luna's work see especially the interview with the artist and Steven Durland, "Call Me in '93," *High Performance* 56 (Winter 1991); Andrea Liss, "The Art of James Luna: Postmodernism with Pathos," in *James Luna: Actions and Reactions: An Eleven Year Survey of Installation/Performance Work, 1981–1992*, exhibition catalog (Santa Cruz: University of California, Mary Porter Sesnon Art Gallery, 1992); and Judith McWillie's essay in *James Luna: Two Worlds*, exhibition catalog (New York: Intar Gallery, 1989).

20. Although it is not presently staged how the Nazis would have liked, their murderous museological plan nonetheless created an enormous "storehouse" or, in art historical terminology, "one of the most important collections of Judaica in the world." See *The Precious Legacy: Judaic Treasures from the Czechoslovak State Collections*, ed. David Altshuler (New York: Summit Books, 1983). See Lynn Gumpert, "The Life and Death of Christian Boltanski," in *Christian Boltanski: Lessons of Darkness*, for a comparison between the Nazis' acts of amassing objects in Prague with Boltanski's ironicized, obsessive archiving process.

21. Georgia Marsh, "The White and the Black: An Interview with Christian Boltanski," 39–40.

22. The following account is taken from an interview I conducted with Ms. Lawrence at the Ydessa Handeles Foundation, 3 September 1993.

23. Andrzej Paluch, "Konzentrationslager Auschwitz," in *Jewish Studies* (Kraków: Jagiellonian Research Center on Jewish History and Culture in Poland, 1992), 335.

24. The following sentiments were expressed to me during a conversation with Raye Farr and Arnold Kramer at the museum's temporary offices in Washington, D.C., in March 1992, when the museum was in its final stages of completion.

25. Elie Wiesel, "Art and the Holocaust: Trivializing Memory," *New York Times*, 11 June 1989, 38.

26. Umberto Eco, *Travels in Hyperreality*, trans. William Weaver (New York: Harcourt Brace Jovanovich, 1986), 8.

27. The sustained sociological study of the Disneyland in Anaheim as ideology and capital can be found in Louis Marin, *Utopies: Jeux d'espaces* (Paris: Minuit, 1973).

28. I want to differentiate my use of the "hyperreal" here from Jean Baudrillard's in *Simulations*, trans. Paul Foss, Paul Patton, and Philip Beitchman (New York: Semiotext[e], 1983), in which he writes, "Simulation is no longer that of a territory, a reverential being or a substance. It is the gen-

eration by models of a real without origin or reality: a hyperreal. The territory no longer precedes the map, nor survives it" (2). It is worth noting that Baudrillard does not mourn without regret what he conceives as the usurpation of reality by simulation: "Something has disappeared: the sovereign difference between them that was the abstraction's charm. For it is the difference which forms the poetry of the map and the charm of the territory, the magic of the concept and the charm of the real. This representational imaginary, which both culminates in and is engulfed by the cartographer's mad project of an ideal coextensivity between the map and the territory, disappears with simulation" (3). His use of the hyperreal shifts momentarily later in the book and is closer to the mechanisms at the museum: "This also means the collapse of reality into hyperrealism, in the minute duplication of the real, preferably on the basis of another reproductive medium—advertising, photo, etc. From medium to medium the real is volatilized; it becomes an allegory of death, but it is reinforced by its very destruction; it becomes the real for the real, fetish of the lost object—no longer object of representation, but ecstasy of denegation and of its own ritual extermination: the hyperreal"(141–42). Yet Baudrillard becomes so "engulfed," to use his term, in the collapse of the real that he gratuitously asserts that the interplay between the capital, crowds, and consumption of Disneyland creates a "contrast with the absolute solitude of the parking lot—a veritable concentration camp" (24).

29. Through its display of artifacts and photographs, the museum in Washington, D.C., is a hybrid form functioning somewhere between the ethnographic/anthropological model and the art museum. Although each kind of museum is separated by different yet intrinsically linked notions of the inherent cultural and aesthetic value in art objects, artifacts, and the like, the work of each of these museums—exemplified by the strategies through which their objects are displayed—is similar in their planners' desires to situate the viewer in complex positions of (mis)identifications, discipline, and mastery, depending on the particular narrative goal of the specific institution. Inasmuch as all museums carry multiple and conflicting narratives in which one dominant story often obscures other histories that would disrupt the unquestioned linear progression of modernity, not all are based on histories of trauma and the paradox of representing overwhelming if not incomprehensible atrocities.

Contemporary artist Andrea Fraser's performance "Museum Highlights: A Gallery Talk" (1990) insightfully targeted and analyzed the mechanisms of both frustrated desire and submission that the museum's founders and curators set into play between artifacts and visitors. Fraser dressed up as a docent at the Philadelphia Museum of Art and took groups of visitors on tour through the "museum's highlights." She appeared as a librarian-cum-shopkeeper dressed in a plain yet tasteful brown skirt and jacket, red lipstick, with her dark brown hair pulled into a tight bun. Fraser's witty script exposed the docent's vulnerability and desire to ascend the social ladder to become the model of purity and beauty exemplified by the art objects, which she progressively referred to through adoring and sexual terminology. She also revealed the implicit moral lessons and civic models the art was supposed to import to its lower-class viewers through explicit reference in her script to the primary sources of nineteenth-century reformism on which the founding of the museum was based.

For a comprehensive and incisive analysis of the historical, cultural, and psychic dimensions of the discipline of art history, and its bearings on what constitutes "art objects," see especially Donald Preziosi, *Rethinking Art History: Meditations on a Coy Science* (New Haven, Conn., and London: Yale University Press, 1989) and *The Art of Art History* (Oxford: Oxford University Press, 1998). For a focus on museums, see Preziosi's forthcoming *Brain of the Earth's Body*.

For an anthology dealing with the rhetoric and obfuscations of the traditional museum and the invisible presence of the curator between the visitor and the museum's objects, see *Exhibiting Cultures: The Poetics and Politics of Museum Display*, ed. Ivan Karp and Steven D. Lavine (Washington, D.C.: Smithsonian Institution Press, 1991).

5. The Provocation of Postmemories

1. Art Spiegelman, *Maus: A Survivor's Tale. II. And Here My Troubles Began* (New York and Toronto: Pantheon, 1991), 14.
2. I first used the term *postmemories* in referring to some of the most difficult of the Holocaust documentary photographs as "blinding post-memories" in my essay "Trespassing through Shadows: History, Mourning and Photography in Representations of Holocaust Memory," *Framework* 4:1 (1991), 30–39. Marianne Hirsch employs this term in the singular in her essay "Family Pictures: *Maus*, Mourning, and Post-Memory." Hirsch differentiates postmemory from Nadine Fresco's notion of "absent memory," writing that "post-memory is anything but absent or evacuated: It is as full and as empty as memory itself" (9).
3. A growing number of artists who work in photography, video, and installation have begun to focus on representation of the Holocaust. This chapter is not meant to be an encyclopedic listing, but a

focused investigation of how documentary and more intimate modes of photography are being reemployed to restore memories and histories of the Shoah. I want to note several recent exhibitions that take as their task the particular problems and possibilities of contemporary post-Holocaust representation: *Burnt Whole: Contemporary Artists Reflect on the Holocaust*, organized by the Washington Project for the Arts, Washington, D.C.; *Impossible Evidence: Contemporary Artists View the Holocaust* at the Freedman Gallery, Albright College in Reading, Pa.; *Witness and Legacy: Contemporary Art about the Holocaust* at the Minnesota Museum of American Art; *After Auschwitz: Responses to the Holocaust in Contemporary Art* at the Royal Festival Hall, London; *Between Spectacle and Silence: The Holocaust in Contemporary Photography* at the Photographic Resource Center, Boston. Except for the latter, a small but focused exhibition, and *Impossible Evidence*, none of the projects takes to task the assumptions and problematics of photography in Holocaust representation. *Burnt Whole* took place from 28 October–8 December 1994, and its catalog essays were written by curator Karen Holtzman and Sarit Shapira, Marek Bartelik, and Wolfgang Winkler; *Impossible Evidence* took place from 4 November–18 December 1994, and the catalog essays were written by curator Jill Snyder and Andrea Liss; my essay focused on the artists' use of photography as reconsidered evidence. The artists in question are Melissa Gould, Ellen Rothenberg, Nancy Spero, and Art Spiegelman; *Witness and Legacy* ran from 29 January–14 May 1995, and its catalog essays are written by curator Stephen Feinstein and Matthew Baigell and Yehudit Shendhar; *After Auschwitz*, curated by Monica Bohm-Duchen, ran from 23 February–29 May 1995 and is accompanied by a catalog; *Between Spectacle and Silence*, curated by Robert Seydel, 27 April–18 June 1995, had no catalog. The artists who were included are Joseph Biel and Richard Kraft, Aharon Gluska, Melissa Gould, Barbara Rose Haum, and Tatana Kellner; the exhibition *(Im)Possible Witnessing: Contemporary Photography and Holocaust Memory*, issuing in part from research on this book and curated by Andrea Liss, will have a catalog with essays by scholars, artists, and poets.

4. From my interview with the artists in Andover, Mass., 30 August 1990.
5. *Suzanne Hellmuth and Jock Reynolds: Documents and Documents, 1975–1985*, exhibition catalog (Santa Cruz: University of California, Santa Cruz, Mary Porter Sesnon Art Gallery, 1986), 38.
6. As recounted by Jean Lawlor Cohen in her article "War and Memory," on Hellmuth and Reynolds's installation, *Museum and Arts Washington* (August 1989), 32.
7. Susan Sontag, *On Photography*, 19.
8. This image was rephotographed by the artists from *We Will Not Forget*, a book published in the late 1950s by a survivors' committee from various nations with text in Polish, French, and English.
9. Marianne Hirsch, "Family Pictures," 7.
10. Nancy Marmer, "Boltanski: The Uses of Contradiction," 177.
11. See especially the documentation of Lodz ghetto's underground activities in Z. Szner and A. Sened, eds., *With a Camera in the Ghetto: Mendel Grossman*.
12. These photographic albums are now property of the U.S. government as remains of the spoils of war and are housed at the National Archives in Washington, D.C.
13. Axel Hecht and Werner Krüger, "L'Art actuel Made in German: Anselm Kiefer, un bout de chemin . . . avec le démence," *Art Press* 42 (November 1980), 15. Quoted in Mark Rosenthal, *Anselm Kiefer*, exhibition catalog (Chicago and Philadelphia: Art Institute of Chicago and Philadelphia Museum of Art, 1987), 17.
14. Andreas Huyssen, "Anselm Kiefer: The Terror of History, the Temptation of Myth." In this cogent essay Huyssen takes on an impassioned partisan stance, admitting that he, like Kiefer, is also heir to the ambiguities and painful self-confrontations of dealing with his shared German past. However, such a refreshing subjective position does not seduce him. Huyssen remains attentive to the risks inherent in Kiefer's themes of redemption, imagery that revives antiquity and the ploys of bombastic allegory.
15. In its focus on staging and re-creating original moments of history, Kiefer's *Occupations* recalls an important project by Shimon Attie, *Finistere Medine*, begun in 1991. Attie projected slides of pre-Holocaust scenes of this former lower-class unassimilated Jewish neighborhood in Berlin onto the same locations, or as close as he could find, today. The most immediate aspect of the project is as an on-site staging, when pedestrians witness the slide projections in real time. The encounters remain today in color photographs showing the impositions of the slides on the reconstructed neighborhood. See *The Writing on the Wall: Projections in Berlin's Jewish Quarter, Shimon Attie, Photographs and Installations*, with essays by Michael André Bernstein and Erwin Leiser (Heidelberg: Edition Braus, 1994).
16. Saul Friedländer, *Reflections of Nazism*, 80–81. As Friedländer further notes: "We have many indirect proofs of Hitler's intervention in the Final Solution and a number of references to his orders, coming mostly from Himmler. But, for Hitler, himself, we have only some laconic remarks to one or another of his intimates. Also a few sinister allusions in the Reichstag, but vague like those of September or November 1942. 'You will remember the session of the Reichstag when I said: If

by chance the Jews imagine they could wage international war to eliminate the European races, the result will be not the elimination of the European races but that of the Jews of Europe. Some mocked my prophecies. Among those who laughed yesterday, many are silent now, and those who will laugh will perhaps stop soon.'"

17. Judy Chicago, with photography by Donald Woodman, *Holocaust Project: From Darkness into Light* (New York: Penguin, 1993). Subsequent references will be cited parenthetically in the text.

18. Sally Eauclaire, "The Holocaust Project: A Controversial Artist's New Work Parallels Her Own Bittersweet Journey to Self-Discovery," *Chicago Tribune Magazine*, 17 October 1993, 17–20.

19. For compelling and complex discussions of the formation of Jewishness and its representation in visual art and culture, see especially *Too Jewish*, ed. Norman Kleeblatt (New York: Jewish Museum, 1996).

20. Quoted from my phone conversation with the artist, 7 June 1994.

21. For cogent discussions on the various methodologies and practices that underlie women's journal writing and projections of autobiography, see Bella Brodzki and Celeste Schenck, eds., *Life/Lines: Theorizing Women's Autobiography* (Ithaca, N.Y., and London: Cornell University Press, 1988); Margo Culley, ed., *A Day at a Time: The Diary Literature of American Women from 1764 to the Present* (New York: Feminist Press, 1985); Sidonie Smith, *A Poetics of Women's Autobiography: Marginality and the Fictions of Self-Representation* (Bloomington: Indiana University Press, 1987); Sidonie Smith and Julia Watson, eds., *De/Colonizing the Subject: The Politics of Gender in Women's Autobiography* (Minneapolis: University of Minnesota Press, 1992); Domna C. Stanton, ed., *The Female Autograph: Theory and Practice of Autobiography from the Tenth to the Twentieth Century* (Chicago and London: University of Chicago Press, 1984); and Elayne Zalis, *Leah P./Aleph*, a work in progress that simultaneously creates, re-creates, and analyzes the process of journal writing and memory.

22. Quoted in Perry Hoberman, "*Schindler's List*: Myth, Movie, and Memory, 31."

23. No photographs or artwork from the *Holocaust Project* are reproduced here because Chicago and Woodman did not grant the University of Minnesota Press permission rights.

24. See Elizabeth Hess, "Planet Holocaust," *Village Voice*, 2 November 1993. Although Hess's criticisms target some of the problems inherent in a victim-laden aesthetic, they blithely discredit all of Chicago's efforts without taking account of the particularly doubled problems of dealing with Holocaust representation in this context. Unfortunate, too, is the author's obvious dislike of Chicago as a person, and the petty ways she demeans the supporters of Chicago's project. Such an account only amplifies the divisions between a "chic" New York postmodernist reading and work that does not fall into the dictates of current fashion. For a different reading, not without its own biases toward Chicago, see Arlene Raven's essay "Judy Chicago: The Artist Critics Love to Hate," *On the Issues: The Progressive Woman's Quarterly* (Summer 1994), 36–40.

25. Recently, a memorial service for homosexuals was held at Yad Vashem, Israel's official memorial museum to the Holocaust. However, the event was not sanctioned by the institution. The short article covering the event in the *Los Angeles Times*, 31 May 1994, A8, reads, "Gay men and lesbians Monday held the first service at Israel's Holocaust Memorial to honor the tens of thousands of homosexuals murdered by the Nazis. But the Yad Vashem Holocaust Memorial in Jerusalem refused to officially sanction the event, and police detained four religious protesters who shouted 'No More Gays,' 'AIDS!' and 'Homos! May God Save You!' About 150 gays from 12 countries, mostly Jews from North America and Europe, hugged each other for comfort in the flame-lit Hall of Remembrance, where the names of Nazi death camps are etched into the stone floor. Some sobbed, others shouted the Kaddish prayer of mourning to drown out the dozen or so protesters, mainly Orthodox Jews, who said the Bible bans homosexuality and the gay service had no place at Yad Vashem."

The United States Holocaust Memorial Museum has a section of its permanent exhibition dedicated to elucidating the persecution of homosexuals. Klaus Müller worked as a consultant on gay and lesbian life in the Nazi era for the museum. See the article on him and his research in the *Los Angeles Times*, 4 December 1994, M3. The Museum of Tolerance in Los Angeles merely mentions homosexuals among the list of those the Nazis targeted for extinction.

26. I have taken these photographic identifications from the attributions listed at the end of the book. However, the photographic caption of the guard tower within the book (111) identifies it as being from Struthof.

27. Text from the exhibition brochure from the Spertus Museum.

28. In a project in which Chicago strains to emphasize that men—no matter their class or ethnicity—are the dominators of women, it is interesting to note that she ignores these oppressions in the case of homosexuals. In *Pink Triangle/Torture* and *Lesbian Triangle*, for example, we are presented with a schematic depiction of their treatment by the Nazis; absent, however, is any reference to divisions among Jews, then and now, in terms of homophobia. See note 25.

29. Elizabeth Gross, "What Is Feminist Theory?" in *Feminist Challenges: Social and Political Theory*, ed. Carole Pateman and Elizabeth Gross (Boston: Northeastern University Press, 1986), 192–93. I spell her last name *Grosz* in the text because the author changed the spelling of her family name back to *Grosz* from *Gross* after the book referred to here was in print.

30. For a discussion of both of these projects in relation to Hatch's more recent and related work, see Andrea Liss, "Sightlines and Surveys: Connie Hatch's Photographic Installations," in *Mapping Histories*, exhibition catalog (Newport Harbor, Calif.: Newport Harbor Art Museum, 1989), 42–49. For a lucid discussion of Hatch's approaches to rethinking a critical art practice, especially in terms of sexual politics, see Abigail Solomon-Godeau, "Reconstructing Documentary: Connie Hatch's Representational Resistance," *Camera Obscura* 13–14 (Spring/Summer 1985), 114–45. Three of Hatch's early projects are discussed here: *Form Follows Function*, a collaborative multimedia project on the gentrification of a neighborhood south of Market Street in San Francisco; *Serving the Status Quo: Stories We Tell Ourselves, Stories We Tell Each Other*, a slide-audio work; and *The De-Sublimation of Romance*, a large installation of paired photographs.

31. In this regard, I would especially like to note Jenni Lukač's beautiful, powerful project *Kaddish* (1995). This is a video installation that juxtaposes family photographs from seven collections of survivors and their families—Yaffa Eliach, Lilly Glass, Francisca Verdoner Kan, Elizabeth Koening, Genya Markon, Miriam Patipa, and George Wellwarth—with terse and potent words in four languages. A book of the same name was produced by the Visual Studies Workshop Press, Rochester, New York, 1995. Another effective video installation employing family photographs and informed by a feminist methodology, especially in relation to the formation of the female subject, is Susan Eve Jahoda's *The Unstable Subject* (1992). For a discussion of this work in relation to feminism, autobiography, Art Spiegelman's *Maus*, and Holocaust representation, see Andrea Liss, "Uncanny Signs of History: *The Unstable Subject*," in *Marxism in the Postmodern Age*, ed. Antonio Callari, Stephen Cullenberg, and Carole Biewener (New York: Guilford Press, 1995), 142–53.

 For recent scholarship focusing on the use of family snapshots by artists, not only in relation to the Holocaust, see Marianne Hirsch, *Family Frames: Photography, Narrative, and Postmemory* (Cambridge, Mass.: Harvard University Press, 1997); and *The Familial Gaze*, ed. Marianne Hirsch (Boston: University Press of New England, 1998), which came out of a conference at Dartmouth, "Family Pictures: Shapes of Memory," 24–26 May 1996.

 Also remarkable are several photographic installation projects by Judit Hersko, including *Before America Series* (1990) and *Where Are You?* (1993), in which she skillfully recontextualizes family photographs—both as projections and framed as actual images—to bring the viewer into a place of distanced empathy with those pictured. Lisa Lewenz's photographic tableau *A Letter without Words* (1989) is also pioneering in its use of rare film footage taken by her grandmother in Berlin during World War II. This project was the beginning of her painstakingly researched film, released in 1998, *A Letter without Words: A Film by Ella Arnhold Lewenz and Lisa Lewenz*.

32. From my interview with Yaffa Eliach, 4 May 1993.

33. See *Written in Memory: Portraits of the Holocaust*, photographs by Jeffrey Wolin, introduction by Charles Stainback (San Francisco: Chronicle Books, 1997).

34. Tamra Wright, Peter Hughes, and Alison Ainley, "The Paradox of Morality," 168, 169.

35. Emmanuel Lévinas, *Totality and Infinity*, 194.

36. Ibid.

In Lieu of a Conclusion

1. See Bessel A. van der Kolk and Onno van der Hart, "The Intrusive Past: The Flexibility of Memory and the Engraving of Trauma," in the special issue on "Psychoanalysis, Culture and Trauma: II," *American Imago* 48:4 (Winter 1991), 425–54.

2. From my phone conversation with Ralph Appelbaum, 30 March 1993.

3. From my interview with Martin Smith in Washington, D.C., 22 August 1990.

4. From my interview with Jacef Nowakowski in Washington, D.C., 10 March 1992.

5. Claude Lanzmann, "Le Lieu et la parole," in Bernard Cuau et al., eds., *Au Sujet de Shoah— Le film de Claude Lanzmann* (Paris: Editions Belin, 1990), 295.

6. Claude Lanzmann, "Hier Is Kein Warum," in Bernard Cuau et al., eds., *Au Sujet de Shoah*, 279.

7. Dori Laub, "Bearing Witness or the Vicissitudes of Listening," in Felman and Laub, *Testimony: Crises of Witnessing in Literature, Psychoanalysis, and History*, 59.

8. Ibid., 59–60.

9. Ibid., 60.

10. Saul Friedländer, "Trauma, Transference and 'Working Through,'" 53.

11. Ibid., 53.

12. Andreas Huyssen, "Monument and Memory in a Postmodern Age," *Yale Journal of Criticism* 6:2 (1993). In his remarkable essay, Huyssen continues: "The ultimate success of a Holocaust monument would be to trigger such a mimetic approximation, but it can achieve that goal only in conjunction with other related discourses operating in the mind of the spectator and in the public sphere" (259–60).

13. Gertrud Koch, "The Aesthetic Transformation of the Image of the Unimaginable: Notes on Claude Lanzmann's *Shoah*," 21.

14. Ibid., 23.

15. Serge Klarsfeld, *French Children of the Holocaust: A Memorial*, ed. Susan Cohen, Howard M. Epstein, Serge Klarsfeld, trans. Glorianne Depondt and Howard M. Epstein (New York: New York University Press, 1996).

Bibliography

Photographic Theory

Barthes, Roland. "The Rhetoric of the Image," in *Image-Music-Text*. New York: Hill and Wang, 1977.
———. *Camera Lucida: Reflections on Photography*, trans. Richard Howard. New York: Hill and Wang, 1984.
———. *Mythologies*, trans. Annette Lavers. New York: Hill and Wang, 1985.
Beloff, Halla. *Camera Culture*. Oxford: Basil Blackwell, 1985.
Benjamin, Walter. *Illuminations*, ed. Hannah Arendt, trans. Harry Zohn. New York: Schocken Books, 1973.
Berger, John. "Photographs of Agony" and "Uses of Photography," in *About Looking*. New York: Pantheon, 1980, 37–40, 48–63.
Bewell, Alan J. "Portraits at Greyfairs: Photography, History and Memory in Walter Benjamin." *Clio* 12:1 (1982).
Bourdieu, Pierre. *Un Art moyen: Essai sur les usages sociaux de la photographie*. Paris: Editions de Minuit, 1965.
Buchloh, Benjamin H. D. "Allegorical Procedures: Appropriation and Montage in Contemporary Art." *Artforum* (September 1982), 43–56.
Burgin, Victor, ed. *Thinking Photography*. London: Macmillan, 1982.
Harcourt, Peter. "The Cinema, Memory, and the Photographic Trace." *Ciné-Tracts* 17 (Summer/Fall 1982), 33–38.
Hirsch, Marianne. *Family Frames: Photography, Narrative, and Postmemory*. Cambridge, Mass.: Harvard University Press, 1997.
Kozloff, Max. *Photography and Fascination*. Danbury, N.H.: Addison House, 1979.
Krauss, Rosalind. "A Note on Photography and the Simulacra." *October* 31 (Winter 1984).
Levine, Lawrence W. "The Historian and the Icon: Photography and the History of the American People in the Thirties," in *Documenting America, 1935–1943*, ed. Carl Fleischhauer and Beverly W. Brannan. Berkeley, Los Angeles, and London: University of California Press, with the Library of Congress, 1988.
Owens, Craig. "The Allegorical Impulse: Toward a Theory of Postmodernism," in *Art after Modernism: Rethinking Representation*, ed. Brian Wallis. New York: New Museum of Contemporary Art, 1984.
Reed, T. V. "Unimagined Existence and the Fiction of the Real: Postmodern Realism in *Let Us Now Praise Famous Men*." *Representations* (Fall 1988), 156–76.
Rosler, Martha. "In, Around, and Afterthoughts (On Documentary Photography)," in *Martha Rosler: Three Works*. Halifax/Cape Breton, Nova Scotia: Press of the Nova Scotia College of Art and Design, 1981.
Sekula, Allan. "Dismantling Modernism, Reinventing Documentary (Notes on the Politics of Representation)." *Massachusetts Review* 19:4 (Winter 1978), 859–83; reprinted in *Photography against the Grain*. Halifax/Cape Breton, Nova Scotia: Press of the Nova Scotia College of Art and Design, 1984.
———. "The Body and the Archive." *October* 39 (Winter 1986).
Solomon-Godeau, Abigail. "Who Is Speaking Thus? Some Questions about Documentary Photography," in *The Event Horizon: Essays on Hope, Sexuality, Social Space and Media(tion) in Art*, ed. Lorna Falk and Barbara Fischer. Toronto: Coach House Press, 1987.

———. *Photography at the Dock: Essays on Photographic History, Institutions, and Practices*. Minneapolis: University of Minnesota Press, 1991.

Sontag, Susan. *On Photography*. New York: Farrar, Straus and Giroux, 1977.

Stein, Sally. "Making Connections with the Camera: Photography and Social Mobility in the Career of Jacob Riis." *Afterimage* 10:10 (May 1983), 14.

Stott, William. *Documentary Expression and Thirties America*. Oxford and New York: Oxford University Press, 1973.

Tagg, John. *The Burden of Representation: Essays on Photographies and Histories*. Amherst: University of Massachusetts Press, 1988.

Tucker, Marcia. "Introduction," *The Art of Memory: The Loss of History*, exhibition catalog. New York: New Museum of Contemporary Art, 1987.

Holocaust Representation and Theory: Photography, Museums, Memorials, Art, and Film

Adorno, Theodor W. "Erziehung nach Auschwitz," in *Stichworte: kritische Modelle II*. Frankfurt am Main: Suhrkamp Verlag, 1963, 85–101.

———. *Negative Dialectics*, trans. E. B. Ashton. New York: Seabury Press, 1973.

———. "Cultural Criticism and Society," in *Prisms*, trans. Samuel and Shierry Weber. Cambridge, Mass.: MIT Press, 1981, 173–85.

Altshuler, David, ed. *The Precious Legacy: Judaic Treasures from the Czechoslovak State Collections*. New York: Summit Books, 1983.

Amishai-Maisels, Ziva. *Depiction and Interpretation: The Influence of the Holocaust on the Visual Arts*. Oxford and New York: Pergamon Press, 1993.

Avisar, Ilan. *Screening the Holocaust: Cinema's Images of the Unimaginable*. Bloomington: Indiana University Press, 1988.

Blanchot, Maurice. *The Writing of the Disaster*, trans. Ann Smock. Lincoln and London: University of Nebraska Press, 1986.

Bourke-White, Margaret. *"Dear Fatherland, Rest Quietly": A Report on the Collapse of Hitler's "Thousand Years."* New York: Simon and Schuster, 1946.

Braham, Randolph L. "Photographer as Historian: The Auschwitz Album." *Shoah* (Fall/Winter 1983–84), 20–23.

Crysler, Greig, and Abidin Kusno. "Angels in the Temple: the Aesthetic Construction of Citizenship at the United States Holocaust Memorial Museum." *Art Journal* (Spring 1997), 52–64.

Cuau, Bernard, et al., eds. *Au sujet de Shoah: Le film de Claude Lanzmann*. (Paris: Editions Belin, 1990).

Deguy, Michel. "A Draft of Several Reflections: A Contribution to a Collective Work 'On the Subject of Shoah.'" *Sulfur* 25 (Fall 1989), 69–98.

Derrida, Jacques. *Feu la cendre*. Paris: Des femmes, 1987.

Donat, Alexander, ed. *The Death Camp Treblinka: A Documentary*. New York: Holocaust Library, 1979.

Eliach, Yaffa. *We Were Children Just Like You*, exhibition catalog. New York: Center for Holocaust Studies, Documentation and Research, 1990.

———. *There Once Was a World*. Boston: Little, Brown, 1998.

Ezrahi, Sidra DeKoven. "The Holocaust and the Shifting Boundaries of Art and History." *History and Memory* 1:2 (Fall/Winter 1989), 77–98.

Felman, Shoshana, and Dori Laub. *Testimony: Crises of Witnessing in Literature, Psychoanalysis, and History*. New York and London: Routledge, 1992.

Foley, George Barbara. "Fact, Fiction, Fascism: Testimony and Mimesis in Holocaust Narratives." *Comparative Literature* 34 (Fall 1982), 330–60.

Friedländer, Saul. *Reflections of Nazism: An Essay on Kitsch and Death*. Bloomington: Indiana University Press, 1984.

———. *Probing the Limits of Representation: Nazism and the "Final Solution."* Cambridge, Mass.: Harvard University Press, 1993.

Gourevitch, Philip. "Behold Now Behemoth, The Holocaust Memorial Museum: One More American Theme Park." *Harper's* (July 1993), 55–62.

Hartman, Geoffrey H. "Preserving the Personal Story: The Role of Video Documentation." *Dimensions: A Journal of Holocaust Studies* 1 (Spring 1985), 14–18.

Hirsch, Marianne. "Family Pictures: *Maus*, Mourning, and Post-Memory." *Discourse* 15:2 (Winter 1992–93).

Huyssen, Andreas. "Anselm Kiefer: The Terror of History, the Temptation of Myth." *October* 48 (Spring 1989), 25–45.

———. "Monument and Memory in a Postmodern Age." *Yale Journal of Criticism* 6:1 (1993), 249–61.

Insdorf, Annette. *Indelible Shadows: Film and the Holocaust*. New York: Vintage Books, 1983.

James, Caryn. "Putting the Unimaginable to Imaginable Use." *New York Times*, 1 March 1992, sec. 2, 1.

Kaes, Anton. *From "Hitler to Heimat": The Return of History as Film*. Cambridge, Mass.: Harvard University Press, 1989.

Kaplan, Alice Yaeger. *Reproductions of Banality: Fascism, Literature, and French Intellectual Life.* Minneapolis: University of Minnesota Press, 1986.

Keller, Ulrich, ed. *The Warsaw Ghetto in Photographs.* New York: Dover, 1984.

Koch, Gertrud. "The Aesthetic Transformation of the Image of the Unimaginable: Notes on Claude Lanzmann's *Shoah*." *October* 48 (Spring 1989), 15–24.

Lang, Berel. *Act and Idea in the Nazi Genocide.* Chicago and London: University of Chicago Press, 1990.

Langer, Lawrence L. "Preliminary Reflections on the Videotaped Interviews at the Yale Archive for Holocaust Testimonies." *Facing History and Ourselves News* (Winter 1985), 4–5.

———. *Holocaust Testimonies: The Ruins of Memory.* New Haven, Conn.: Yale University Press, 1991.

———. *Art from the Ashes: A Holocaust Anthology.* New York: Oxford University Press, 1995.

———. *Admitting the Holocaust.* New York: Oxford University Press, 1995.

Lanzmann, Claude. *Shoah: An Oral History of the Holocaust.* New York: Pantheon, 1985.

Linenthal, Edward. *Preserving Memory: The Struggle to Create America's Holocaust Museum.* New York: Penguin, 1995.

Lishinsky, Yosef. "Yad Vashem as Art." *Ariel* 55 (1983), 7–25.

Liss, Andrea. "Trespassing through Shadows." *Framework* 1:4 (1991), 30–40.

———. "An Uneasy Witness." Exhibition review of *19.9.1941, A Day in the Warsaw Ghetto: A Birthday Trip in Hell*, photographs by Heinz Jöst. *Afterimage* (December 1991), 15–16.

———. "Contours of Naming: The Identity Card Project and the Tower of Faces at the United States Holocaust Memorial Museum." *Public* 8 (1993), 108–34.

———. "(Im)Possible Evidence," in *Contemporary Artists View the Holocaust*, exhibition catalog. Reading, Pa: Freedman Gallery, 1994.

———. "Uncanny Signs of History: The Unstable Subject," in *Marxism in the Postmodern Age*, ed. Antonio Callari, Stephen Cullenberg, and Carole Biewener. New York and London: Guilford Press, 1994.

Livingston, Jane. *Lee Miller: Photographer.* London: Thames and Hudson, 1989.

Lustigman, Michael M. *Kindness of Truth and the Art of Reading Ashes.* New York: Peter Lang, 1988.

Lyotard, Jean-François. *The Differend: Phrases in Dispute.* Minneapolis: University of Minnesota Press, 1988.

———. "Discussion, or Phrasing 'after Auschwitz,'" in *The Lyotard Reader*, ed. Andrew Benjamin. Oxford and Cambridge, Mass.: Basil Blackwell, 1989.

Maier, Charles S. *The Unmasterable Past: History, Holocaust, and German National Identity.* Cambridge, Mass., and London: Harvard University Press, 1988. Esp. chap. 5, "A Usable Past? Museums, Memory, and Identity."

Milton, Sybil, ed. and trans. *The Stroop Report: The Jewish Quarter of Warsaw Is No More!* New York: Pantheon, 1979.

———. "The Camera as Weapon: Documentary Photography and the Holocaust." *Simon Wiesenthal Center Annual* 1. Chappaqua, N.Y.: Rossel Books, 1984, 45–68.

———. *In Fitting Memory: The Art and Politics of Holocaust Memorials.* Detroit: Wayne State University Press, with the Judah L. Magnes Museum, Berkeley, 1991.

Santner, Eric L. *Stranded Objects: Mourning, Memory, and Film in Postwar Germany.* Ithaca, N.Y., and London: Cornell University Press, 1990.

Schreiber, Rachel. "Photography, Memory and the Holocaust." *New Art Examiner* (April 1997), 22–25.

Schwarberg, Günther. *Das Ghetto.* Göttingen: Steidl Verlag, 1989.

Simon, Roger I. "Memories of 'That Which Has Never Been My Fault or Deed': Heteropathic Recollection and Transtemporal Aesthetics." Presented at a Modern Language Association conference, 8 April 1997.

Sontag, Susan. "Eye of the Storm." *New York Review of Books*, 21 February 1980; reprinted in *Under the Sign of Saturn* as "Syberberg's Hitler." New York: Farrar, Straus and Giroux, 1980, 137–65.

———. "Fascinating Fascism." *New York Review of Books*, 6 February 1975, 26; reprinted in *Under the Sign of Saturn*, 73–105.

———. "Under the Sign of Saturn," in *Under the Sign of Saturn*, 109–34.

Spiegelman, Art. *Maus: A Survivor's Tale. I. My Father Bleeds History.* New York and Toronto: Pantheon, 1986.

———. *Maus: A Survivor's Tale. II. And Here My Troubles Began.* New York and Toronto: Pantheon, 1991.

Stehle, Bernard F. *Another Kind of Witness.* Philadelphia: Jewish Publication Society, 1988.

Steiner, George. *Language and Silence: Essays on Language, Literature, and the Inhuman.* New York: Atheneum, 1967.

———. "The Long Life of Metaphor: An Approach to 'the Shoah.'" *Encounter* 68 (February 1987), 55.

Szner, Z., and A. Sened, eds. *With a Camera in the Ghetto: Mendel Grossman.* New York: Schocken, 1977.

The United States Holocaust Memorial Museum Newsletter. Washington, D.C.

van Alphen, Ernst. *Caught by History: Holocaust Effects in Contemporary Art, Literature and Theory.* Palo Alto, Calif.: Stanford University Press, 1998.

Vishniac, Roman. *Polish Jews: A Pictorial Record.* New York: Schocken Books, 1947.

Wiesel, Elie. "Trivializing the Holocaust: Semi-Fact and Semi-Fiction," *New York Times,* 16 April 1978.

Wieseltier, Leon. "After Memory: Reflections on the Holocaust Memorial Museum." *New Republic* (31 May 1993).

Wievorka, Annette. "Un Lieu de mémoire: Le mémorial du martyr juif inconnue." *Pardès* 2 (1985), 329–43.

Wyschograd, Edith. *Spirit in Ashes: Hegel, Heidegger, and Man-Made Mass Death.* New Haven, Conn., and London: Yale University Press, 1985.

Young, James E. *Writing and Rewriting the Holocaust: Narrative and Consequences of Interpretation.* Bloomington: Indiana University Press, 1988.

———. "The Biography of a Memorial Icon: Nathan Rapoport's Warsaw Ghetto Monument." *Representations* 26 (Spring 1989), 69–106.

———. *The Texture of Memory: Holocaust Memorials and Meaning.* New Haven, Conn., and London: Yale University Press, 1993.

———, ed. *The Art of Memory: Holocaust Memorials in History,* exhibition catalog. Munich and New York: Prestel-Verlag and Jewish Museum, 1994.

Zurof, Efraim. "Yad Vashem: More Than a Memorial, More Than a Name." *Shoah* 1:3 (Winter 1979), 4–9.

Holocaust Historiography

Adorno, Theodor W. "What Does Coming to Terms with the Past Mean?" in *Bitburg in Moral and Political Perspective,* ed. Geoffrey Hartman. Bloomington: Indiana University Press, 1986, 114–29. First published in Adorno's *Gesammelte Schriften,* vol. 10, pt. 2 (Frankfurt am Main: Suhrkamp Verlag, 1977), 555–72.

Arendt, Hannah. *Eichmann in Jerusalem.* New York: Viking, 1963.

Bauer, Yehuda. *The Holocaust in Historical Perspective.* Seattle: University of Washington Press, 1978.

———, with Nili Keren. *A History of the Holocaust.* New York: Franklin Watts, 1982.

Berenbaum, Michael. "On the Politics of Public Commemoration of the Holocaust." *Shoah* (Fall/Winter 1982), 6–37.

———. *The World Must Know: The History of the Holocaust as Told in the United States Holocaust Memorial Museum.* Boston: Little, Brown, 1993.

Friedländer, Saul. *When Memory Comes.* New York: Avon Books and Farrar, Straus and Giroux, 1979; originally published as *Quand vient le souvenir . . .* Paris: Editions du Seuil, 1978.

———. "Some German Struggles with Memory," in *Bitburg in Moral and Political Perspective,* ed. Geoffrey Hartman. Bloomington: Indiana University Press, 1986, 27–42.

———, and Martin Broszat. "A Controversy about the Historicization of National Socialism." *New German Critique* 44 (Spring/Summer 1988), 85–126.

———. "The 'Final Solution': On the Unease in Historical Interpretation." *History and Memory* 1:2 (Fall/Winter 1989), 61–76.

———. "Trauma, Transference and 'Working Through.'" *History and Memory* 4:1 (Spring/Summer 1992), 39–55.

———. *Memory, History and the Extermination of the Jews of Europe.* Bloomington: Indiana University Press, 1993.

———. *Nazi Germany and the Jews, Volume 1: The Years of Persecution, 1933–1939.* New York: HarperCollins, 1996.

Furet, François, ed. *Unanswered Questions: Nazi Germany and the Genocide of the Jews.* New York: Schocken Books, 1989.

Habermas, Jürgen. *The New Conservatism: Cultural Criticism and the Historians' Debate.* Cambridge, Mass.: Harvard University Press, 1989.

———. "Concerning the Public Use of History." *New German Critique* 44 (Spring/Summer 1988), 40–50.

Hartman, Geoffrey H., ed. *Bitburg in Moral and Political Perspective.* Bloomington: Indiana University Press, 1986.

———. "The War against Memory." *Orim: A Jewish Journal at Yale* 1 (Spring 1986), 27–33.

———. *The Longest Shadow: In the Aftermath of the Holocaust.* Bloomington: Indiana University Press, 1996.

———, ed. *Holocaust Remembrance: The Shapes of Memory.* Cambridge, Mass., and Oxford: Blackwell, 1994.

Hilberg, Raul. *The Destruction of European Jewry.* Chicago: Quadrangle Books, 1965.

Kershaw, Ian. *The Nazi Dictatorship: Problems and Perspectives of Interpretation.* London: Edward Arnold, 1989.

Klarsfeld, Serge. *French Children of the Holocaust: A Memorial*, ed. Susan Cohen, Howard M. Epstein, and Serge Klarsfeld, trans. Glorianne Depondt and Howard M. Epstein. New York: New York University Press, 1996.

LaCapra, Dominick. *Representing the Holocaust: History, Theory, Trauma*. Ithaca, N.Y.: Cornell University Press, 1996.

Lacoue-Labarthe, Philippe, and Jean-Luc Nancy. "The Nazi Myth." *Critical Inquiry* 16 (Winter 1990), 291–312.

Linden, R. Ruth. *Making Stories, Making Selves: Feminist Reflections on the Holocaust*. Columbus: Ohio State University Press, 1993.

Mayer, Arno J. *Why Did the Heavens Not Darken?* New York: Pantheon Books, 1988.

Ringelheim, Joan Mirian. "The Unethical and the Unspeakable: Women and the Holocaust." *Simon Wiesenthal Annual* 1 (1984).

———. "Woman and the Holocaust: A Reconsideration of Research." *Signs: Journal of Women in Culture and Society* 10:4 (Summer 1985).

Tal, Uriel. "Excursus on the Term: Shoah." *Shoah* 1:4 (1979), 10–11.

History and Theory of the Modern Museum

Adorno, Theodor W. "Valéry Proust Museum," in *Prisms*, trans. Samuel and Shierry Weber. Cambridge, Mass.: MIT Press, 1981, 173–85.

Breitbart, Eric. "The Painted Mirror, " in *Presenting the Past: History Museums in the United States*, ed. S. Benson, S. Brier, and R. Rosenzweig. Philadelphia: Temple University Press, 1986.

Crimp, Douglas. "On the Museum's Ruins." *October* 13 (Summer 1980), 41–58.

———. "The Postmodern Museum." *Parachute* 46 (March-May 1987), 61–69.

Duncan, Carol, and Alan Wallach. "The Museum of Modern Art as Late-Capitalist Ritual: An Iconographic Analysis." *Marxist Perspectives* (Winter 1978), 29–51.

Holdengräber, Paul. "A Visible History of Art: The Forms and Preoccupations of the Early Museums." *Studies in 18th Century Culture* 17 (1987), 107–17.

Impey, Oliver, and Arthur MacGregor. *The Origins of Museums: The Cabinet of Curiosities in Sixteenth- and Seventeenth-Century Europe*. Oxford: Clarendon Press, 1985.

Karp, Ivan, and Steven D. Lavine, eds. *Exhibiting Cultures: The Poetics and Politics of Museum Display*. Washington, D.C.: Smithsonian Institution Press, 1991.

Lugli, Adalgisa. "Inquiry as Collection: The Athanasius Kircher Museum in Rome." *RES* 12 (Fall 1986), 109–24.

Mainardi, Patricia. "Postmodern History at the Musée d'Orsay." *October* 41 (Summer 1987), 31–52.

Preziosi, Donald. *Rethinking Art History: Meditations on a Coy Science*. New Haven, Conn., and London: Yale University Press, 1989.

———. *The Art of Art History*. Oxford: Oxford University Press, 1998.

———. *Brain of the Earth's Body*. Forthcoming.

Sherman, Daniel J., and Irit Rogoff, eds. *Museum Culture: Histories, Discourses, Spectacles*. Minneapolis: University of Minnesota Press, 1994.

Sherman, Tom. "Museums of Tomorrow." *Parachute* 46 (March-May 1987), 78–81.

Construction of the Subject

Bataille, Georges. *L'Erotisme*. Paris: Minuit, 1957.

———. *Guilty*, trans. Bruce Boone. Venice, Calif., and San Francisco: Lapis Press, 1988; originally published as *Le Coupable*, Editions Gallimard, 1961.

———. *The Tears of Eros*. San Francisco: City Lights, 1989.

Baudrillard, Jean. "L'Histoire: Un scénario rétro." *Ça cinéma* (1976) 16–19.

———. *L'Effet Beaubourg*. Paris: Galilée, 1977.

———. *Simulations*, trans. Paul Foss et al. New York: Semiotext(e), 1983.

———. "The Trompe-l'Oeil," in *Calligram*, ed. Norman Bryson. Cambridge: Cambridge University Press, 1988, 53–62.

Bentham, Jeremy. *Le Panoptique*. Paris: Editions Belfond, 1977.

Bersani, Leo. *The Culture of Redemption*. Cambridge, Mass.: Harvard University Press, 1990.

Bloomer, Kent C., and Charles W. Moore. *Body, Memory, and Architecture*. New Haven, Conn.: Yale University Press, 1977.

Carroll, David. *The Subject in Question: The Languages of Theory and the Strategies of Fiction*. Chicago: University of Chicago Press, 1982.

Caruth, Cathy, ed. *Trauma: Explorations in Memory*. Baltimore and London: Johns Hopkins University Press, 1995.

Chalier, Catherine. *Figures du féminin: Lecture d'Emmanuel Lévinas*. Paris: La nuit surveillé, 1982.

Cohen, Richard A., ed. *Face to Face with Levinas*. New York: State University of New York Press, 1986.

Coward, Rosalind, and John Ellis. *Language and Materialism: Developments in Semiology and the Theory of the Subject.* London: Routledge and Kegan Paul, 1977.

Crary, Jonathan. *Techniques of the Observer: On Vision and Modernity in the Nineteenth Century.* Cambridge, Mass., and London: MIT Press, 1990.

Critchley, Simon. "The Chiasmus: Levinas, Derrida and the Ethical Demand for Deconstruction." *Textual Practice* 3:1 (Spring 1989).

Derrida, Jacques. *Schibboleth pour Paul Celan.* Paris: Galilée, 1986.

———. *Mémoires for Paul de Man,* trans. Cecile Lindsay, Jonathan Culler, Eduardo Cadava, and Peggy Kamuf. New York: Columbia University Press, 1986.

Eco, Umberto. *A Theory of Semiotics.* Bloomington and London: Indiana University Press, 1976.

———. *Travels in Hyperreality,* trans. William Weaver. New York: Harcourt Brace Jovanovich, 1986.

Ellis, John. *Visible Fictions.* London and Boston: Routledge and Kegan Paul, 1982.

Freud, Sigmund. "Remembering, Repeating, and Working-Through," in *The Complete Psychological Works,* trans. and ed. James Strachey, vol. 12. London: Hogarth Press and Institute of Psychoanalysis, 1966, 147–66.

———. *Essays on Sexuality: Three Essays on the Theory of Sexuality,* trans. and rev. James Strachey. New York: Basic Books, 1962.

———. "Mourning and Melancholia (1917)," in *Freud: General Psychological Theory,* ed. Philip Rieff. New York: Macmillan, 1963.

Friedländer, Saul. *History and Psychoanalysis: An Inquiry into the Possibilities and Limits of Psychohistory.* New York and London: Holmes & Meier, 1980.

Gallop, Jane. *Reading Lacan.* Ithaca, N.Y., and London: Cornell University Press, 1985.

Greimas, A. J. "Elements of a Narrative Grammar" and "A Problem of Narrative Semiotics: Objects of Value," in *On Meaning,* trans. Paul J. Perrin and Frank H. Collins. Minneapolis: University of Minnesota Press, 1987.

Grosz, Elizabeth. "The 'People of the Book': Representation and Alterity in Emmanuel Levinas." *Art & Text* 26 (September–November 1987), 32–40.

Hirst, Paul Q. "Constructed Space and the Subject," in *Power & Knowledge: Anthropological & Sociological Perspectives,* ed. Richard Fardon. Edinburgh: Scottish Academic Press, 1985, 171–89.

Kristeva, Julia. *La Révolution du langage poétique.* Paris: Seuil, 1974.

———. *Powers of Horror: An Essay on Abjection,* trans. Leon S. Roudiez. New York: Columbia University Press, 1982.

Lacan, Jacques. *The Four Fundamental Concepts of Psycho-Analysis,* trans. Alan Sheridan. New York and London: Norton, 1978; originally published as *Le Seminaire de Jacques Lacan,* Livre XI, "Les Quartre concepts fondamentaux de la psychanalyse." Paris: Editions du Seuil, 1973.

———. *Écrits: A Selection,* trans. Alan Sheridan. New York and London: Norton, 1977; selections from *Écrits* (Paris: Seuil, 1966).

Lévinas, Emmanuel. *Existence and Existents,* trans. Alphonso Lingis. The Hague and Boston: M. Nijhoff, 1978.

———. *Totality and Infinity: An Essay on Exteriority,* trans. Alphonso Lingis. The Hague and Boston: M. Nijhoff, 1979.

———. *Otherwise Than Being or Beyond Essence,* trans. Alphonso Lingis. The Hague and Boston: M. Nijhoff, 1981.

MacCannell, Juliet Flower. *Figuring Lacan: Criticism and the Cultural Unconscious.* Lincoln: University of Nebraska Press, 1986.

Rickels, Laurence A. *Aberrations of Mourning: Writing on German Crypts.* Detroit: Wayne State University Press, 1988.

Ronell, Avital. *The Telephone Book: Technology, Schizophrenia, Electric Speech.* Lincoln and London: University of Nebraska Press, 1989.

Sartre, Jean-Paul. *Anti-Semite and Jew,* trans. George J. Becker. New York: Schocken Books, 1972. First published in 1946.

Saussure, Ferdinand de. *Course in General Lingistics,* ed. Charles Bally and Albert Sechehaye with Albert Riedlinger, trans. Wade Baskin. New York: Philosophical Library, 1959.

Stoekl, Allan. *Politics, Writing, Mutilation: The Cases of Bataille, Blanchot, Roussel, Leiris, and Ponge.* Minneapolis: University of Minnesota Press, 1985.

Žižek, Slavoj. *The Sublime Object of Ideology.* London and New York: Verso, 1989.

Feminist Theory and Ethics

Braidotti, Rosi. "The Politics of Ontological Difference," in *Between Feminism and Psychoanalysis,* ed. Teresa Brennan. New York and London: Routledge, 1989.

Brennan, Teresa, ed. *Between Feminism and Psychoanalysis.* New York and London: Routledge, 1989.

Brown, Laura S. "Not Outside the Range: One Feminist Perspective on Psychic Trauma." *American Imago* 48:1 (Spring 1991), 119–33.

Butler, Judith. "Gender Trouble: Feminist Theory, and Psychoanalytic Discourse," in *Feminism/ Postmodernism*, ed. Linda J. Nicholson. New York and London: Routledge, 1990.
———. *Gender Trouble: Feminism and the Subversion of Identity*. New York and London: Routledge, 1990.
———. *Bodies That Matter*. New York and London: Routledge, 1993.
Cornell, Drucilla. *Beyond Accommodation: Ethical Feminism, Deconstruction, and the Law*. New York and London: Routledge, 1991.
———. *Transformations: Recollective Imagination and Sexual Difference*. New York and London: Routledge, 1993.
Gross, Elizabeth. "What is Feminist Theory," in *Feminist Challenges: Social and Political Theory*, ed. Carole Pateman and Elizabeth Gross. Boston: Northeastern University Press, 1986.
Grosz, Elizabeth. *Sexual Subversions*. Sydney: Allen & Unwin, 1989.
Minh-Ha, Trinh T. "The Totalizing Quest for Meaning," in *When the Moon Waxes Red: Representation, Gender and Cultural Politics*. New York and London: Routledge, 1991.
Plaskow, Judith. "Toward a New Theology of Sexuality," in *Standing Again at Sinai: Judaism from a Feminist Perspective*. San Francisco: Harper & Row, 1990, 170–210.
Spivak, Gayatri Chakrovorty. "Displacement and the Discourse of Woman," in *Displacement: Derrida and After*, ed. Mark Krupnick. Bloomington: Indiana University Press, 1983.
Theweleit, Klaus. *Male Fantasies. Vol. 1. Women, Floods, Bodies, History*, Stephen Conway, trans., in collaboration with Erica Carter and Chris Turner. Minneapolis: University of Minnesota Press, 1987.
Williams, Patricia J. "On Being the Object of Property." *Signs* 14:1 (Autumn 1988).
Women and Memory, eds. Margaret A. Lourie, Donna C. Stanton, and Martha Vicinus, *Michigan Quarterly Review* 26:1 (Winter 1987).

Theories of History, Narrative, and Cultural Memory

Adorno, Theodor W., and Max Horkheimer. *Dialectic of Enlightenment*. New York: Herder and Herder, 1972.
Appighanesi, Lisa, ed., *Postmodernism*. London: ICA Documents, Free Association Press, 1989.
Arac, Jonathan, ed. *Postmodernism and Politics*. Minneapolis: University of Minnesota Press, 1986.
Auerback, Erich. *Mimesis*. Princeton, N.J.: Anchor, 1957.
Belsey, Catherine. *Critical Practice*. London and New York: Methuen, 1980.
Benjamin, Andrew, ed. *The Lyotard Reader*. Cambridge, Mass., and Oxford: Basil Blackwell, 1989.
Benjamin, Walter. *Illuminations*, ed. Hannah Arendt, trans. Harry Zohn. New York: Schocken Books, 1973.
———. *The Origin of German Tragic Drama*, trans. John Osborne. London: New Left Books, 1977.
———. *Reflections: Essays, Aphorisms, Autobiographical Writings*, ed. Peter Demetz, trans. Edmund Jephcott. New York and London: Harcourt Brace Jovanovich, 1978.
Bennett, Tony. "The Exhibitionary Complex." *New Formations* 4 (Spring 1988), 73–102.
Bennington, Geoffrey. *Lyotard: Writing the Event*. Manchester: Manchester University Press, 1988.
Bersani, Leo. *The Forms of Violence: Narrative in Assyrian Art and Modern Culture*. New York: Schocken Books, 1985.
Bourdieu, Pierre. *Outline of a Theory of Practice*. Cambridge: Cambridge University Press, 1977.
Carroll, David. "The Alterity of Discourse: Form, History, and the Question of the Political in M. M. Bakhtin," *Diacritics* 13 (Summer 1983), 65–83.
———. *Paraesthetics*. London and New York: Methuen, 1987.
Caruth, Cathy. *Unclaimed Experience: Trauma, Narrative and History*. Baltimore and London: Johns Hopkins University Press, 1996.
Cohen, Sande. *Historical Culture: On the Reading of an Academic Discipline*. Berkeley, Los Angeles, and London: University of California Press, 1986.
Crimp, Douglas. "AIDS: Cultural Analysis/Cultural Activism." *October* 43 (Winter 1987), 3–16.
de Certeau, Michel. "The Gaze of Nicholas of Cusa." *Diacritics* 17:3 (Fall 1987), 2–38.
———. "Writing vs. Time: History & Anthropology in the Works of Lafitau," *Yale French Studies* 59 (1980), 37–64.
———. *Heterologies: Discourse on the Other*, trans. Brian Massumi. Minneapolis: University of Minnesota Press, 1986.
———. *The Writing of History*, trans. Tom Conley. New York: Columbia University Press, 1988.
de Man, Paul. "Conclusions: Walter Benjamin's 'The Task of the Translator,'" in *The Resistance to Theory*. Minneapolis: University of Minnesota Press, 1986.
Derrida, Jacques. "La Mythologie blanche," in *Marges: De la philosophie*. Paris: Minuit, 1972.
———. *Glas*. Paris: Galilée, 1974.
———. *Of Grammatology*, trans. G. C. Spivak. Baltimore and London: Johns Hopkins University Press, 1976.
———. *Writing and Difference*, trans. Alan Bass. Chicago: University of Chicago Press, 1978.

———. "Violence and Metaphysics: An Essay on the Thought of Emmanuel Levinas," in *Writing and Difference*.
———. "The *Retrait* of Metaphor." *Enclitic* 2 (1978), 5–34.
———. "Economimesis," *Diacritics* 2:2 (Summer 1981), 3–25.
———. *L'Oreille de l'autre*, ed. Claude Lévesque and Christie V. McDonald. Montreal: VLB Editeur, 1982.
———. "Of an Apocalyptic Tone Recently Adopted in Philosophy." *Oxford Literary Review* 6:2 (1984).
———. "Des Tours de Babel," in *Difference in Translation*, ed. Joseph F. Graham, trans. Joseph F. Graham. Ithaca, N.Y.: Cornell University Press, 1985.
———. *The Truth in Painting*. Chicago: University of Chicago Press, 1987; originally published as *La Vérité en peinture*, Paris: Flammarion, 1978. Esp. chap. 3, "Cartouches."
———. *Psyché: Inventions de l'autre*. Paris: Galilée, 1987.
———. *Of Spirit: Heidegger and the Question*, trans. Geoffrey Bennington and Rachel Bowlby. Chicago and London: University of Chicago Press, 1989; originally published as *De l'Esprit*, Paris: Editions Galilée, 1987.
Fabian, Johannes. *Time and the Other*. New York: Columbia University Press, 1983.
Fishkin, Shelley Fisher. *From Fact to Fiction: Journalism and Imaginative Writing in America*. Baltimore and London: Johns Hopkins University Press, 1985.
Foley, Barbara. *Telling the Truth: Theory and Practice of Documentary Literature*. Ithaca, N.Y.: Cornell University Press, 1986.
Foster, Hal. *The Anti-Aesthetic: Essays on Postmodern Culture*. Port Townsend, Wash.: Bay Press, 1983.
———. *Recodings: Art, Spectacle, Cultural Politics*. Port Townsend, Wash.: Bay Press, 1985.
Foucault, Michel. *Archaeology of Knowledge*, trans. A. M. Sheridan Smith. New York: Harper and Row, 1972..
———. interview in *Cahiers du Cinéma* 251 (1974).
———. "Film and Popular Memory: Cahiers du Cinéma/Extracts." *Edinburgh Magazine* 2 (1977), 20–25.
———. *Discipline and Punish*, trans. A. M. Sheridan Smith. New York: Pantheon, 1977.
———. *Language, Counter-Memory, Practice: Selected Essays and Interviews*, ed. Donald F. Bouchard, trans. Donald F. Bouchard and Sherry Simon. Ithaca, N.Y.: Cornell University Press, 1977.
———. "Panopticism," reprinted in *The Foucault Reader*, ed. Paul Rabinow. New York: Pantheon Books, 1984, 206–13.
———. "Space, Knowledge, and Power," in *The Foucault Reader*, 239–56.
Fussell, Paul. *The Great War and Modern Memory*. London: Oxford University Press, 1975.
Griswold, Charles L. "The Vietnam Veterans Memorial and the Washington Mall: Philosophical Thoughts on Political Iconography." *Critical Inquiry* 12 (Summer 1986), 688–719.
Habermas, Jürgen. *The Philosophical Discourse of Modernity*. Cambridge, Mass.: Harvard University Press, 1990.
Halbwachs, Maurice. *The Collective Memory*, trans. Francis J. Ditter and Vida Yazdi Ditter. New York: Harper & Row, 1980.
Hernandi, Paul. "Re-presenting the Past: A Note on Narrative Historiography and Historical Drama." *History and Theory* 15 (1976), 45–51.
Hutton, Patrick H. "Collective Memory and Collective Mentalities: The Halbwachs-Ariès Connection." *Historical Reflections/Réflexions historiques* 15:2 (Summer 1988), 311–22.
Jameson, Fredric. *The Political Unconscious: Narrative as a Socially Symbolic Act*. Ithaca, N.Y.: Cornell University Press, 1981.
Kant, Immanuel. *The Critique of Judgement*, trans. J. H. Bernard. New York: Hafner Press, 1974.
Knapp, Steven. "Collective Memory and the Actual Past." *Representations* 26 (Spring 1989), 123–49.
LaCapra, Dominick. *Rethinking Intellectual History: Texts, Contexts, and Language*. Ithaca, N.Y.: Cornell University Press, 1983.
———. *History and Criticism*. Ithaca, N.Y.: Cornell University Press, 1985.
———. *Soundings in Critical Theory*. Ithaca, N.Y.: Cornell University Press, 1989.
Levin, Thomas Y. "Walter Benjamin and the Theory of Art History." *October* 47 (Winter 1988), 77–83.
Lewis, Thomas E. "Reference and Dissemination: Althusser after Derrida." *Diacritics* 15:4 (Winter 1985), 37–56.
Lukács, George. *The Historical Novel*. Boston: Beacon, 1963.
Lyotard, Jean-François. "Presenting the Unpresentable: The Sublime," trans. Lisa Liebmann. *Artforum* 20:8 (1982), 64–69.
———. "The Sublime and the Avant-Garde." *Artforum* 22:8 (1984), 36–43; revised and reprinted in *Paragraph* 6 (1985), 1–18.
———. *The Postmodern Condition: A Report on Knowledge*. Minneapolis: University of Minnesota Press, 1984.
Lyotard, Jean-François, and Jean-Loup Thebaud. *Just Gaming*. Minneapolis: University of Minnesota Press, 1988.

Marin, Louis. *Utopiques: Jeux d'espaces*. Paris: Minuit, 1973.

———. "The Inscription of the King's Memory." *Yale French Studies* 59 (1980), 17–36.

Minh-Ha, Trinh T. "Critical Reflections." *Artforum* (Summer 1990), 132–33.

Minh-Ha, Trinh T., and Russell Ferguson, Martha Gever, and Cornel West, eds. *Out There: Marginalization and Contemporary Cultures*. New York: MIT Press and New Museum of Contemporary Art, 1990.

Mitchell, W. J. T., ed. *On Narrative*. Chicago and London: University of Chicago Press, 1980.

———. *Iconology: Image, Text, Ideology*. Chicago and London: University of Chicago Press, 1986.

Mosès, Stéphane. "The Theological-Political Model of History in the Thought of Walter Benjamin." *History and Memory* 2:2 (Fall/Winter 1989), 5–34.

Pefanis, Julian. *Heterology and the Postmodern: Bataille, Baudrillard, and Lyotard*. Durham, N.C.: Duke University Press, 1991.

Nägele, Rainer. "The Scene of the Other: Theodor W. Adorno's Negative Dialectic in the Context of Poststructuralism," in *Postmodernism and Politics*, ed. Jonathan Arac. Minneapolis: University of Minnesota Press, 1986.

Nietszche, Friedrich. *Beyond Good and Evil*. New York: Vantage Books, 1966.

Niranjana, Tejaswini. "Deconstructing Translation and History: Derrida on Benjamin." *Strategies* 1 (1988), 100–19.

Nora, Pierre. "Between Memory and History: Les Lieux de Mémoire." *Representations* 26 (Spring 1989), 7–25.

Owens, Craig. "Detachment from the *Parergon*." *October* 9 (Summer 1979), 42–50.

———. "Representation, Appropriation and Power." *Art in America* (May 1982), 9–21.

Preziosi, Donald. *The Semiotics of the Built Environment*. Bloomington: Indiana University Press, 1979.

Ricouer, Paul. *Time and Narrative*, trans. Kathleen Blamey and David Pellauer. Chicago and London: University of Chicago Press, 1988.

Rosenberg, Sharon. "Intersecting Memories: Bearing Witness to the 1989 Massacre of Women in Montreal." *Hypatia* 11:4 (Fall 1996), 119–29.

Rothenberg, Jerome and Diane. *Symposium of the Whole: A Range of Discourse toward an Ethno-poetics*. Berkeley and Los Angeles, Calif.: University of California Press, 1983.

Shapiro, Gary, ed. *After the Future: Postmodern Times and Places*. Albany: State University of New York Press, 1990.

Steiner, George. *Extra-Territorial: Papers on Literature and the Language Revolution*. New York: Atheneum, 1971.

Sturken, Marita. *Tangled Memories: The Vietnam War, the AIDS Epidemic, and the Politics of Remembering*. Berkeley and Los Angeles: University of California Press, 1997.

Tafuri, Manfredo. *The Sphere and the Labyrinth*. Cambridge, Mass.: MIT Press, 1987.

Terdiman, Richard. "Deconstructing Memory: On Representing the Past and Theorizing Culture in France since the Revolution." *Diacritics* 15:4 (Winter 1985), 13–36.

Vidler, Anthony. "The 'Art' of History: Monumental Aesthetics, from Winckelmann to Quatremère de Quincy." *Oppositions* 25 (Fall 1982), 53–67.

Weber, Samuel. "Closure and Exclusion." *Diacritics* 10:2 (Summer 1980).

———. "Genealogy of Modernity: History, Myth and Allegory in Benjamin's *Origin of the German Mourning Play*." Unpublished manuscript, 1990.

White, Hayden. *Metahistory: Historical Imagination in 19th-Century Europe*. Baltimore: Johns Hopkins University Press, 1973.

———. *Tropics of Discourse: Essays in Cultural Criticism*. Baltimore: Johns Hopkins University Press, 1978.

———. *The Content of the Form: Narrative Discourse and Historical Representation*. Baltimore: Johns Hopkins University Press, 1987.

Wohlfarth, Irving. "On Some Jewish Motifs in Benjamin," in *The Problems in Modernity*. New York and London: Routledge, 1989.

Yates, Francis A. *The Art of Memory*. Chicago: University of Chicago Press, 1966.

Yerushalmi, Yosef Hayim. *Zakhor: Jewish History and Jewish Memory*. Seattle: University of Washington Press, 1982.

Index

opaqueness, 120; on self-aware commentary, 53–54, 119–20; on silence, 98; on sublime, 7; on testimonials, 119
Frohnmayer, John E., 5, 6

Gas chambers, 75
Ghettos, 1. See also specific ghettos
Glueckselig, Leo, 43–44
Gluska, Aharon: on knowing vs. representing, 113; Man and Name, 110; Reframing and Reclaiming, xvi, 110, 113–14
Gourevitch, Philip, 75
Grierson, John, xiii–xiv
Grieving. See Mourning
Grossman, Mendel, xv, 3
Grosz, Elizabeth, 106
Grynblat, Rena, 111
Gumpert, Lynn, 40

Hartman, Geoffrey H., 85
Hatch, Connie, xvi, 106–10, 113–14; After the Fact, 106. See also Forced to Disappear
Hatefutsoth, Beth, 110
Hellmuth, Suzanne: xvi, 87–96, 113–14; Speculation, 89. See also In Memory
Hersko, Judit, 137n31
Heydecker, Joe J., 3
Hirsch, Marianne, 93, 137n31
Hitler, Adolf: Final Solution of, 1, 29, 48; photographs of, 95
Holocaust Memorial Museum. See United States Holocaust Memorial Museum
Holocaust Project (Chicago and Woodman), xvi, 98–106, 113–14; as autobiography, 99; book accompanying project, 99; gender divisions in, 105; homosexuals, representation of, 104; methodology of, 99; photography and painting in, 104–5; self-projection in, 102
Holocaust (television series), xix
Homosexuals: memorial service for, 136n25; persecution of, 104
Howe, Irving, xix, 20
Humanism, liberal. See Liberal humanism
Huyssen, Andreas: on Kiefer, 96, 98, 135n14; on mimesis, 120, 138n12
Hyperreality, 83, 133–34n28

Identity card project, 13–26, 32, 14, 15, 26, 108–9; and bonding, 19; historical status of, xv–xvi; intersubjectivity of, 50; and mourning, 36; as personalizing history, 104; purpose of, 24
In Memory (Hellmuth and Reynolds), xvi, 87–96, 88, 92, 113–14; analysis of, 88–89; conception of, 87; exhibition announcement, 90, 92; family photographs in, 91, 93–94; and human memory, 88; interior flow of, 87–88; leitmotif, 90–91; as mediated exhibition, 87; methodology of, 89, 90, 94; as reminder, 93; reworked photographs in, 90–91; and testimonial labor, 96
Incorporation, 24–25
Intersubjectivity, xv, 7; in exhibitions, 50, 120; and feminism, 110; and postmemories, 114. See also Subjectivity; Objectivity

Introjection, 24–25, 35
Irony: and nostalgia, 94; and satire, 98; as unnecessary prerequisite, 102–3

Jahoda, Susan Eve, 137n31
Jöst, Heinz, 2–3
Juxtaposition, 123

Kant, Immanuel: on negative presentation, 8; on signs of history, 9; on theory of sublime, 7
Kellner, Tatana, 132n28
Kernweis, Haskel, 21–22
Kiefer, Anselm, xvi, 78, 96–98, 113–14. See also Occupations
Klarsfeld, Serge, 123
Knoblock, Erhard Josef, 2
Koch, Gertrud, 78, 121, 122
Kramer, Arnold, 82
Kristeva, Julia, 4–5
Kundera, Milan, 51
Kuspit, Donald, 49

Labeling, 15
Lange, Dorothea, xiv
Langer, Lawrence L., 68
Lanzmann, Claude, xvii, 117, 119, 121–22
Laub, Dori, 117–18
Lawrence, Tracey, 81
Lévinas, Emmanuel, xvi; on face as epiphany, 48; on otherness, 36–37, 50, 84, 107, 112–13, 122
Lewenz, Lisa, 137n31
Liberal humanism, xv
Life, 2
Literalness: of documentary, 90; in documentary photography, 1; and metaphor, 1, 6, 20, 89
Lodz ghetto, 3
Los Angeles County Museum of Art, 2
Lukač, Jenni, 137n31
Luna, James, 133n19
Lyotard, Jean-François: on differend, 8, 9, 71; Differend, 8–9, 118, 119; on negative presentation, 8

Majdanek concentration camp: photographs of, 104; shoes from, 78
Marmer, Nancy, 40–41, 49, 94–95
Marsh, Georgia, 50
Maus series: (Spiegelman), xvi, 52–69; as autobiographical genre, 68; family dynamics in, 57; Maus I, 54, 55, 57, 60; Maus II, 54, 55, 61, 68, 56, 62–64, 66, 76, 109; personalization of history in, 58, 67
Meah Shearim, 103
Metaphor: in documentary photography, 1; and literalness, 1, 6, 20, 89
Metonymy, 78
Miller, Lee, 2
Mimesis, 138n12; in documentary photography, 1, 68; translucent, 120. See also Opaqueness
Moana (film), xviii
Morris, Robert, 48
Mourning, 23–24, 36; aesthetic ritual of, 78; of incorporation, 24; introjective, 35; and language,

ANDREA LISS is the contemporary art historian and cultural theorist in the Visual and Performing Arts Program at California State University, San Marcos. Her teaching focuses on contemporary representations of history and memory; the history and criticism of photographically based artwork; and feminist art and theory. She is currently curating the exhibition and catalog *(Im)Possible Witnessing: Contemporary Photography and Holocaust Memory,* and writing *Bodies in Evidence: Rethinking the Maternal Gaze,* a book on contemporary representations of feminist motherhood.